Marketing for the Crea Cultural Industries

Developing and executing marketing strategies is a vital aspect of any business and few books currently cover this with relation to creative industries. This textbook provides students and managers in the creative industries with a solid grounding in how to maximize the impact of their marketing efforts across a range of business types in the creative and cultural industries.

The author, an experienced cultural marketing educator, provides sector-contextual understanding to illuminate the field by:

- taking a strategic approach to developing marketing plans;
- bringing together strategic planning, market research, goal setting, and marketing theory and practice;
- explaining how content marketing on social media encourages a relationship with consumers so that they co-promote the creative product.

With a range of learning exercises and real-life examples throughout, this text shows students how to create successful marketing plans for their creative businesses. This refreshed edition is a valuable resource for students and tutors of creative, cultural and arts marketing worldwide.

Bonita M. Kolb is Professor Emeritus of Business at Lycoming College, USA.

Discovering the Creative Industries

Series Editor: Ruth Rentschler

The creative and cultural industries account for a significant share of the global economy. Gaining and maintaining employment and work in this sector is a challenge and chances of success are enhanced by ongoing professional development.

This series provides a range of relatively short, student-centred books which blend industry and educational expertise with cultural sector practice. Books in the series provide applied introductions to the core elements of the creative industries. In sum, the series provides essential reading for those studying to enter the creative industries as well as those seeking to enhance their career via executive education.

Titles in this series include:

Managing the Cultural Businesses: Avoiding Mistakes, Finding Success
Edited by Michela Addis and Andrea Rurale

Marketing Strategy for the Creative and Cultural Industries, Second Edition
Bonita M. Kolb

Indian Movie Entrepreneurship: Not Just Song and Dance
Rajeev Kamineni and Ruth Rentschler

Entrepreneurship for the Creative and Cultural Industries, Second Edition
Bonita M. Kolb

For more information about this series, please visit: www.routledge.com

Marketing Strategy for the Creative and Cultural Industries

Bonita M. Kolb

Second edition

Routledge
Taylor & Francis Group

LONDON AND NEW YORK

Second edition published 2021
by Routledge
2 Park Square, Milton Park, Abingdon, Oxon OX14 4RN

and by Routledge
52 Vanderbilt Avenue, New York, NY 10017

Routledge is an imprint of the Taylor & Francis Group, an informa business

First edition published by Routledge in 2016

British Library Cataloguing-in-Publication Data
A catalogue record for this book is available from the British Library

Library of Congress Cataloging-in-Publication Data
Names: Kolb, Bonita M., author.
Title: Marketing strategy for the creative and cultural industries / Bonita M. Kolb.
Description: 2nd edition. | Abingdon, Oxon; New York, NY: Routledge, 2021. |
Series: Mastering management in the creative and cultural industries | Includes bibliographical references and index.
Identifiers: LCCN 2020016779 (print) | LCCN 2020016780 (ebook) | ISBN 9780367419769 (hbk) | ISBN 9780367419776 (pbk) | ISBN 9780367817077 (ebk)
Subjects: LCSH: Arts—Marketing. | Performing arts—Marketing. | Cultural industries—Management.
Classification: LCC NX634 .K65 2021 (print) | LCC NX634 (ebook) | DDC 700.68/8—dc23
LC record available at https://lccn.loc.gov/2020016779
LC ebook record available at https://lccn.loc.gov/2020016780

ISBN: 978-0-367-41976-9 (hbk)
ISBN: 978-0-367-41977-6 (pbk)
ISBN: 978-0-367-81707-7 (ebk)

Typeset in Calvert
by codeMantra

Contents

Introduction

Technology, particularly social media, has fundamentally changed marketing strategy. Consumers can now access information that in the past was only known to the organization. Consumers also have the ability to communicate with each other about organizations and products. How has marketing changed? Products are now being designed with direct consumer input as to the benefits desired. Promotion and the marketing message are no longer in the control of the organization. Pricing must be transparent as consumers both understand the costs of production and what is being charged for other products. Finally, distribution must be provided through more than one channel. These changes also provide an opportunity for creative and cultural organizations.

Consumers of creative and cultural products want to become emotionally involved with the organization. Organizations can help them do so through social media by allowing them to both co-produce and co-promote the idea. This book will explain how these new online behaviors can be utilized by the organization to achieve their strategic goals. Therefore a book is needed that helps to develop strategic marketing goals based on the unique talents of the employees and reflecting the mission and values of the organization.

Because communicating a creative idea is the heart of the organization's mission, they already have a connection with their current and potential customers. Marketing strategy for such a company must consider market opportunities, but never if they are at conflict with the values of the organization and their creative mission.

STRATEGIC FOCUS

Marketing Strategy for the Creative and Cultural Industries will take a strategic approach to developing a marketing plan. While marketing answers the question: "How do we produce and sell a product needed by consumers?" marketing strategy asks the question: "How do we use marketing to meet

organization's mission?" To do so, the book will bring together information on strategic planning, social media, market research, goal setting, and marketing theory and practice. The book will walk readers through the process of developing a strategic marketing plan. By following the directions at the end of each chapter, at the conclusion of the book, the reader will have written a complete strategic marketing plan. The plan will include a marketing goal along with the objectives and tactics needed for its achievement.

TARGET MARKET

There are several groups that would benefit from reading *Marketing Strategy for the Creative and Cultural Industries* including students in arts and cultural management programs, students in creative industries, programs, practitioners in the creative and cultural industries, and business professors. The book can be used as a textbook for advanced marketing classes at universities or colleges with undergraduate or graduate programs in arts administration or cultural management. In addition, it can be used for a marketing class offered in programs in creative fields such as design, visual arts, media, and music production. Current practitioners and business people who are trying to initiate a new strategy for their creative company or cultural organization will find the book useful. Finally, the book could be used by any marketing professor wanting a new approach to teaching a standard marketing strategy class.

UNIQUE FEATURES

Marketing Strategy for the Creative and Cultural Industries is the first book targeted at this new market segment. It will be the only marketing strategy book specifically targeted at creative and cultural industries that:

- Integrates marketing theory into the process of organizational strategic planning.
- Provides information on the market and consumer research that is necessary to gather the data needed for making strategic choices.

- Combines the latest developments/trends in social media such as content marketing and the co-production and co-promotion of products with traditional theory and methods.
- Contains information on the organizational changes necessary to implement the strategic marketing plan.

CLASSROOM AIDS

Each section in each chapter starts with an example of current marketing thought and practice. At the end of the example is a "Question to Consider" that will help the reader understand the relevance of the example to their own current or future professional practice. These questions can also be used to engage students in discussion.

Each chapter section also has a "Think—Act—Plan" exercise. The "think" portion challenges the student to answer a question about their consumer or marketing actions. The "act" portion provides instructions on an action that should be taken to learn more. Finally the "plan" portion requires the student to produce written work. All of these can be used as homework, classroom exercises, or both.

At the end of the chapter are directions on what sections of the marketing plan the student is now prepared to write. At the end of the book is an outline for a complete plan. If the directions are completed at the end of each chapter the result will be the completed plan. This can be used as a semester-long project. The completed plan can be developed for an existing organization or a new organization the student wishes to start. If the reader is a student who will be seeking employment in the future, the plan will be useful to show during an employment interview.

In addition, an accompanying website will include supplementary information. PowerPoint slides for all chapters will be included. Even with all the information presented in the book, students can still find writing a marketing plan a daunting task. Therefore additional worksheets using a question and answer format will be included that can assist with the writing process.

THE AUTHOR

The author of the book also maintains a blog on her website where she addresses current marketing issues faced by creative and cultural organizations. She is also willing to answer questions from students, professors, and other readers. Finally, she will be pleased to post examples of students' work that they wish to share on her other social media sites.

Marketing strategy in a social media age

Chapter 1

This chapter will answer the following questions

- What are the **sectors** of the creative and cultural industries?
- How has **social media** changed consumers?
- How has social media affected the **promotion and production of products?**
- How does an organization identify its **mission, vision and values statements?**

CATEGORIZING THE CREATIVE AND CULTURAL INDUSTRIES

Cultural or creative: where did the terms come from?

The terms cultural and creative industries are used so frequently, and sometimes interchangeably, that they may be losing their meaning. However, marketing should understand how these terms developed.

The arts: There have always been the arts, which were considered the visual and performing arts, museums, and

galleries. Because they were unable to sustain themselves through sales, they were subsidized with government funds. This was done because it was believed that the existence of arts was beneficial to everyone in society, even if they did not attend or purchase personally.

Cultural industries: When the cultural industries first developed they were seen as distinctive from the arts. The cultural industries produced commercial entertainment such as films, books, and recorded music. Since consumers were willing to pay enough to cover the cost of producing the product no government funding was needed. Because of consumer demand the cultural industries grew providing economic benefits to the community.

Creative industries: The arts community decided to take a lesson from the cultural industries and became the creative industries. As taxpayers wanted to pay less tax, government funding for the arts was cut. If taxpayers did not want to pay for the arts, the argument that the existence of the arts was enough justification for funding became less effective. Therefore, the argument became that the arts also provide economic benefits, just like any other industry. Thus, the arts became the creative industries.

Galloway and Dunlop 2007

QUESTION TO CONSIDER: How would I explain the justification for the existence of art?

The creative and cultural industries can be difficult to define. Some definitions focus on the product that is produced and simply define a creative industry as one that produces creative products, whether the product is a movie aimed at the mass market or cutting-edge digital art. This definition does not take into account whether the creative product is handcrafted or mass-produced. Other definitions focus on the people working in the organization. Under this definition if the people working in the organization use their unique creative talent to produce a product, then the industry is creative. There is a third way to view the creative industries. In this view it is both the product

Marketing strategy in a social media age

and the people that define a creative industry. Whether the product is a physical object or a service it can only be produced using the unique talents of individuals. Since creative talent is rare, the people who produce the product may be more valuable to the company than those who manage the organization. In addition, another defining feature of a creative or cultural industry is that it creates intellectual property that must be protected.

One final defining factor of the creative industries is that they provide not only products but also experiences. This is obviously true when considering services but also true when considering physical objects. While home décor can be purchased at many discount retail establishments, when buying home décor directly from the designer, the experience is part of the purchase.

People involved in the industries—everyone has talent

A single creative or cultural organization will employ people with many different skills. Some of these skills, such as accounting or facilities management, can be seen as similar to skills needed in any business. In this case the job tasks required will be similar no matter what product is produced and the people who perform the tasks may have similar personalities and interests. While there are routine tasks that must be performed, the most valuable employees are those who have the talent needed to create the product.

Creative industries are differentiated from other businesses by the people they employ because production of the product requires some form of human creativity. As a result, the product produced by these talented employees embodies a symbolic or personal meaning. This personal meaning can cover a broad range of possibilities. For example, the creator may produce the product to communicate a personal vision without regard to how it will be received. In contrast, another creator may create a product in the hope that it will trigger a specific emotional response in the purchaser. Either way, because the product embodies a unique symbolic meaning, intellectual property is created, which will be part of the product's competitive advantage and be promoted as justifying the cost of purchase.

Organization and management structure—to each, its own

Both creative and cultural industries are similar to any other type of business organization in that they use resources to produce a product that will be purchased by customers. However, nonprofit cultural organizations are uniquely defined as producing a product for which there is insufficient consumer demand. As there will never be enough customers purchasing the product to cover the costs of production, it will never generate excess revenue to produce a profit. These nonprofit organizations supplement the insufficient revenue from customers through individual donations and government grants. While not dependent on customers for all their revenue, they still must market as part of their mission is to expose as many people as possible to their product. In addition, if they can use marketing to increase revenue they receive from customers, they will be less reliant on donations and grants.

Creative and cultural organizations vary as to their organization and management structures. They may be organized as either nonprofits, commonly called organizations, or for-profits, commonly called businesses. However, the distinction does not depend on the type of product. For example, one cinema may be run as a nonprofit because it shows independently made foreign films for which there is limited demand while a nearby for-profit cinema shows popular Hollywood blockbusters. The movie goer is usually uninterested in the organizational structure of the cinema, as he or she is only interested in seeing the film of their choice.

In addition, the management structure will vary. The organization might be managed by a single person, which is called a sole proprietorship, such as an individual artist selling his or her work. The organization might be established by two or more people as a partnership where each has an equal share of ownership. A larger for-profit creative organization might also decide to be a corporation because of tax and liability issues. Finally, the organization structure might be a cooperative where there is not only shared ownership but also shared responsibility for running the business.

Basically, a creative or cultural organization can be defined by whether it is for-profit or nonprofit. It can also be characterized by its management structure, whether a sole proprietorship, partnership, corporation, or cooperative. Whether a nonprofit organization or a small for-profit business, or a corporation with many employees, all cultural or creative industries need to have a marketing strategy.

Sectors of creative and cultural production—nine from the UK

There is no single definition of the creative and cultural industries that will apply to every type of product. However, the UK's Department of Culture Media and Sport has divided the creative and cultural industries into nine sectors (Smith 2018). The first is the designing of everything from interiors to toys. The next is the sector of publishing and print that would also include authors. The third sector is visual art, which includes painting, sculpture, and photography. Cultural sites such as museums, libraries, and historical attractions make up the fourth sector. Traditional art such as crafts, festivals, and celebrations may not have been created by formally trained creative talent and yet are certainly a sector of the creative industries. The sector of the performing arts is broadly defined to include not just dance and theatre but also puppet shows and circuses. The seventh sector would be audio-visual, which includes television, radio, films, and other types of broadcasts. New media is comprised of video games, software development, and other creative content that has been digitalized. The last sector is creative services such as architecture, advertising design, and recreation.

Sectors of creative production
1. Design: of any product.
2. Publishing and print: both creators and producers.
3. Visual art: of any media.
4. Cultural sites: of all types.
5. Traditional art: created by the public.
6. Performing arts: from ballet to circuses.

7. Audio-visual: all broadcasts.
8. New media: digital products.
9. Creative services: creating ideas for others.

With such a wide range of types of products and services it can be seen why it is difficult to develop a single definition of the creative and cultural industries. However, reviewing the sectors listed above, it can be seen that in each the distinguishing factor is the unique talent of the individual involved in production of the product.

Historically the cultural industries were considered to be only the fine arts which were categorized as visual art, theatre, music, and literature. However, the division was complicated by the fact that not all forms of these arts were considered to be part of the cultural industries. For example, popular theatrical productions, whether vaudeville or Broadway shows, were not considered part of the cultural industries as they could make a profit selling tickets. Likewise popular music and novels were not considered part of the cultural, but rather creative industries. Products, even if part of the fine arts, which could support their costs through revenue from ticket sales, were considered part of the creative industries.

Now the definitions are used interchangeably, although there are still those that argue that the cultural industries are a subset of the larger creative industries. An example of the difficulty is the categorization of the film industries. Most would place them in the creative but not the cultural group. However, if a specific genre is considered part of a nation's cultural heritage, then that fact would place them in the cultural group even if the film company is a for-profit business.

THINK-ACT-PLAN: Creative and cultural industries

Think: Think about a sector of the creative economy which you find interesting. Are you part of the creative talent? If not, do you understand what motivates creative people to produce the product?

Act: Interview someone who produces a creative product different from one with which you are familiar. Ask them if they ever think about what will become of the product after it is completed. Are they concerned with who will own the product or how it will be used?

Plan: List the types of creative and cultural industries active in your area and then decide to which group you belong.

SOCIAL MEDIA'S EFFECT ON CONSUMERS

The public's attitude toward culture has moved away from a perception of culture based on stratification. In the past, the type of culture in which people engaged was said to demonstrate their social ranking. However, access to information online has demystified culture; so now, rather than designating culture as either providing high or low status, consumers simply choose based on personal preference. In addition, when they decide to consume a cultural product, rather than simply being purchasers or audience members, they want to be considered equal partners with the organization. There has been a change from consuming culture passively to new forms of cultural participation.

Social media has made managing a cultural or creative business more challenging. Consumers are more knowledgeable about products than in the past and do not defer to the opinions of the producer. When researching products online consumers know that there will always be another choice available on the screen if they just keep scrolling. This increase in product availability means that every business is now competing globally, not just in their own community. The purchase decision criteria have also changed. Consumers may decide against purchasing a product if it does not have the benefits they desire. Even when the product does have the benefits, they may decide not to buy because of an action the company has, or has not taken. As a result companies must keep up to date with both social and cultural trends.

Businesses must know what benefits consumers desire from their products. Now businesses must also understand the wider social concerns of consumers (Jenkins 2014). If there is a social

concern, such as affordable housing, that is of interest to their consumers the organization must explain what actions they are taken to solve the problem. If they do not do so the consumer will assume they do not care, or even worse, assume they are part of the problem.

What's good? What's bad?

Social media has changed not only the way individuals interact but also society as a whole. Here are examples of how it has both helped and hurt.

The good …

Access: First we have access to any type of content in real time because everything is now posted online. If something is happening somewhere, someone is Tweeting about it.

Connection: We now have a variety of ways to stay connected with individuals and we use them simultaneously. The connection is immediate and personal. We now know who is calling before we say hello.

Global: Time and distance are no longer a hindrance to communication in a way that would have been unimaginable only a decade ago.

The bad …

Selfies: While we can now connect with others, we have become obsessed with inundating others with information about ourselves. Social media can turn us inwards as much as outwards.

Tirades: Because we not communicating face-to-face, we can easily become judgmental and attack others simply because they have different beliefs than we do. We forget that the word social is included in social media.

#Activism: Social media allows us to share awareness and also allows us to vent. However, both can be used as an excuse for not taking action in the real world.

Like any other form of communication or connection, social media can be used for both good and bad. It is up to us how it will be used.

Landry 2014

QUESTION TO CONSIDER: What negative behaviors that social media exacerbates do I exhibit?

Culture and the public—the relationship has changed

There has been a fundamental change in the public's attitude toward culture and art that started long before the development of social media. Starting with the rising influence of popular culture, there has been a growing disregard for the historical distinction between the status of cultural products (DiMaggio 2000). This has altered the relationship between the creative and cultural organizations that present traditional art products and the public. Now much of the public no longer believes there is a cultural hierarchy where high art has an intrinsic worth that popular culture does not have (Johnson 2006).

The traditional hierarchy of the distinction between "high" art and "popular" culture was disappearing by the end of the twentieth century because more people, unconcerned with value judgments regarding the relative worth of each, consumed both. The view of today's consumer is that life is enriched by more and varied experiences of any type, which they now want to share with others using social media. They believe that the social act of sharing an experience with their online community is as important as the experience itself. In fact, many consumers do not see the difference, as social sharing is part of any experience.

Changing the dynamic—the public is now in control

Advertising has always existed in that businesses have always needed to communicate to the public that they had a product to sell. It was in the 1800s that advertising became widespread because of the use of newspapers and posters. It was not uncommon for sales people to make outragious claims about the effectiveness of their products. Remedies were sold that could

cure any disease that might exist. Consumers had no way to verify the effectiveness or even safety of the product. The claims became so outrageous and the products so dangerous that citizen groups and government became involved to expose the lies.

Businesses learned that they must be truthful about their product claims, but they continued to keep secrets. It was difficult or even impossible for an individual to discover facts about the company and the ingredients in the products. Companies spent a great deal of money on advertising to promote trust in a brand name. The theory was that if the brand was trusted no questions would be asked.

Because of social media it is now impossible for a company to keep secrets. Consumers expect to know all about the product ingredients and how, where, and when the product is produced. They also expect to know everything about the company including how it treats its employees, the company's involvement in the community, and even the personal lives of the managers. Companies can no longer easily lie or have secrets.

Social media has resulted in a third profound change in how businesses interact with the public. They are no longer in control of company public relations or the marketing message. A company may try to hide information from the public about a product failure. They may even try to put a positive spin on the mishap. But all it takes is one disgruntled employee posting the information online and everyone will believe the individual instead of the company's sophisticaed public relations effort. The company can certainly post marketing messages about product benefits. Unfortunately, few consumers are listentting. Fifty-five percent of surveyed residents in the UK are indifferent to marketing messages (Hammett 2019). And even if the messages are heard they are not believed as only 30 percent of consumers trust the advertising industry, which is lower than any other industry.

Social media has also had a profound impact on consumer behavior. Rather than merely being a passive recipient of marketing messages, the consumer is now part of the promotion process. While there has always been word-of-mouth promotion, this was limited to only the few people a purchaser could influence personally. Now a consumer can go online to promote the product either positively or negatively. The consumer can

become even more involved with the organization by altering or even co-producing the product. The purchaser may modify the product after purchase and then use social media to promote to others how this can be done. Or, they may provide ideas to the producer of the product on how it should be changed. These actions mean that the organization is no longer solely in control of the production and promotion of the product.

There are now companies that have formalized this co-production process as part of their business model by bringing together product developers and members of the public (Kuang and Fabricant 2019). The inventors, who may be professionals or simply members of the public, post their product ideas online. Other members of the public are then asked for suggestions on how the idea can be improved. These crowdsourced products are then sold online or in stores. Social media is even changing the distribution model in traditional retail stores. What products are placed on the store shelves was formerly a decision of the store manager. Now the manager may be using social media to ask the store's customers what products to stock.

New forms of participation—whatever you do, your customers think they can do it too

Participation online can be broadly categorized into four methods: affiliation, expression, collaborative problem solving, and circulation (Jenkins et al. 2009). *Affiliations* are not new to the art and culture world. Culture organizations have long had "friend" groups that they used to build loyalty. These groups often received special benefits and were made to feel a part of the organization in the hope that they would not only attend but also become donors. What is different is that affiliations formed online are not sponsored or formed by the cultural organization. Instead they are organized by the public using social media and as a result they cannot be controlled by the organization. Nevertheless, cultural organizations should be involved in the online communities that are centered on an interest in the cultural organization's art form.

Social media has resulted in a world where the *expression* of creativity is now available to everyone. Rather than the cultural

organization alone posting artistic content, cultural participants are creating their own content and posting it online using social media sites. They create fan fiction, take existing art work and add their own ideas, upload their own creative visual work and produce their own music and videos. By doing so they are stretching the definition of art. After creating their own cultural products, just like an established artist, they then want to share this work with the world. Cultural organizations can provide an opportunity for them to do so using their own social media sites.

Another online activity is *problem solving*. This involves people working together to meet a challenge. The challenge might be intellectual, such as writing content. It also might be practical where crowdsourcing is used so that more brainpower is brought to a problem. Cultural organizations should consider how fundraising might be changed if this framework is used. Questions regarding the best way to raise funds are usually discussed in meetings behind closed doors. Instead the organization can go directly to the public to ask what would motivate them to donate.

Finally, *circulation* involves the sharing of information through reviews and blogs. These are tools that can be used to extend the voice of the individual from those they personally know to anyone online who cares to listen. Information on cultural organizations and products is often shared using these tools. Rather than fight this trend because of a fear of negative postings, cultural organizations should be actively involved by responding to both positive and negative reviews. In fact they may wish to link review sites to their own webpage.

THINK-ACT-PLAN: Social proof

Think: For what types of products do you use social commerce or seek social proof?

Act: Choose a product and then go online and find at least three product review sites that provide information.

Plan: Determine what methods your organization will use to provide social proof of the benefits of your product.

SOCIAL MEDIA'S EFFECT ON PRODUCTS AND PROMOTION

From commenting to distributing

The ability of individual consumers to affect an entire industry has grown. This is particularly true of industries where individuals have a high emotional involvement, such as fashion. In the past the only way that people could learn about fashion outside of direct information from the company were fashion magazines.

A dramatic change in the designer-consumer dynamic came about at the beginning of the century with the start of blogs by people interested in fashion. These were quickly followed by video and photo sharing sites where consumers could upload their own fashion looks. The fashion industry reacted in two different ways; they either resisted or embraced.

Resisted: Some companies decided to emphasize their company's role in determining fashion. They did so by promoting their own blogs and communicating that consumer-run blogs and sharing sites lacked legitimacy.

Embraced: The other approach was to embrace social commerce. They did so by sending new fashions directly to private bloggers. They learned that the images posted on sharing sites of less than perfect-looking consumers wearing their fashions were more effective marketing than the images of perfect models provided by fashion designers.

Dolbec and Fischer 2015

QUESTION TO CONSIDER: How can our company work in partnership with our emotionally involved consumers to promote our products?

Social media has resulted in the organization no longer being the sole provider of marketing messages. They are now only one of many voices providing information on the product. An even

more profound change is that consumers now want to be involved in the design of the product. They are no longer content to let the organization make the decision as to what product benefits should be provided.

Co-promotion of the product—everyone is talking about everything

In the past an organization communicated a carefully designed marketing message that promoted the product benefits to a specific target market segment. While such a traditional media strategy continues to be important, equally, or even more important, are promotional messages that are communicated from one consumer to another. While this type of word-of-mouth communication has always taken place, it was limited to those whom a consumer knew personally. Now this type of consumer promotion takes place online and its reach may exceed the reach of the organization's promotional message. This consumer-to-consumer promotion can take place by posting messages on review sites and social media networking sites and through writing and commenting on blogs.

Blogging started as an activity for individuals to share their opinions, often about products, with the public. Bloggers have numerous motivations for spending unpaid time to produce online content. These motivations include helping others, emotion management, and building community (Sepp, Liljander, and Gummerus 2011). Such bloggers feel good about providing product information that helps others. Therefore, if they find a product that solves a problem for them, they want to share this information with others who may have the same problem. Likewise if they are unhappy with a product, a way to deal with the frustration is to share their unhappiness with a product with others through their blog. Another gratification for bloggers is to build a community. Humans have a need to connect with others and interacting online is simply another way to achieve this connection.

The issue for those in marketing is how to get the bloggers to talk about their product. Some companies try the direct approach of providing a free product to bloggers. However, some bloggers feel that by accepting products they will be accused of providing biased information. Rather than provide products,

some organizations provide content that will be of interest to bloggers. Traditional promotional messages will rarely be used by bloggers, therefore, the content the organization is hoping that the blogger will share with others, must be either entertaining, informative, or both. For example, the organization may produce clever promotional videos using real people that are posted on both their sites and other social media in the hopes that it may be noticed and shared by bloggers interested in the product.

Co-creation of the product—everyone is creating

In the past an organization controlled the production of a product that was then sold to a consumer. After purchase, the consumer used the product as it was created and intended to be used. It would not have occurred to the consumer that they should be part of the production process.

However, now the boundary between producer and consumer has blurred. Rather than being at the end of the production process, they now join the process (Hartley et al. 2013). For example online products, such as video games, can be co-created by players as they add their own content to the storyline. Online sites that showcase photos and videos can be added to by both professionals and anyone with a cellphone. Digital content can be added to and commented on by anyone who goes online. This ability to co-create has been easily accepted by consumers.

The type of co-creation can vary. It can be as limited as a consumer posting a comment on a product color idea on the organization's website. Or, it can be as involved as specifying the organization should manufacture the product with a specific design. While employees in organizations are paid to research and develop new ideas for products, members of the public do so without any financial reward. They may be involved because they are altruistic and feel their ideas will lead to producing a product that will solve a social problem. They may also suggest ways to customize a product because the final result will be something they desire. However, one of the major reasons for co-creating products is simply social involvement and the feeling that their ideas matter. Methods used for allowing this type of co-creation include involving user and crowdsourcing.

Consumer involvement can even involve other aspects of marketing such as pricing and distribution (Seth and Hellman 2018). Rather than only providing one final price the organization might provide a menu of pricing options. These might involve using the type of material or the delivery date to price either higher or lower. Consumers might be involved in distribution through the choice of a shipping method that will change the price. Rather than store pickup or delivery a third site, such as a local store, might be chosen for product pickup.

As a result of the move toward co-creation, consumers can no longer be thought of as passive consumers of goods provided by companies. This is especially true of creative products. Creative and cultural organizations will need to develop a deep understanding of the social needs of consumers. It has always been true that people bought creative products in order to express their individuality. However, now the creator of these goods needs to develop a means to involve the consumer in the creation of the product.

Social commerce—let's do it together

When people went to stores together to shop, purchasing products was always a social experience. They went with a friend for the companionship, but also for the advice that person would provide. Because social media now makes this same behavior possible online, it is not limited to someone the shopper knows personally. Social commerce refers to the change from e-commerce being the solitary activity of someone buying online to shopping online using the advice of other online shoppers. This behavior has grown as customers prefer buying from websites that allow such interaction between customers. As a result companies have had to redesign their website and e-commerce platforms to allow this interaction.

E-commerce was first developed to make the purchase process easier as customers would no longer need to go to a store. However, this model assumed that customers already knew what they wanted to purchase. If they did not know, they still needed to go shopping to physical locations to get advice from sales clerks or go shopping with a knowledgeable friend. Social commerce is the process of not only buying online but using other information posted by other online shoppers to make

the purchase decision. This might be done by sharing product photos, videos posted by consumers using products, and it might also be through reading comments on social networking sites. The photos, videos, and comments are not direct marketing messages from companies that produce the products; instead they are user-generated content showing or describing the product in use. This information then leads the viewer to want to learn more about the product and may end in purchase.

Social proof—it depends on who said what

A person engaged in online social commerce may then look for social proof that the product will provide the expected benefits. Social media is an excellent means for people to share stories about their life. When these stories contain information on product usage they become emotionally compelling and promote purchase in a way that facts and figures alone cannot do. Therefore, consumers now want to know how a product affected the life of the purchaser.

Besides using stories, organizations can provide social proof through expert and celebrity endorsements, which have a psychological basis for their success in motivating purchase (Hallen 2014). Using someone who is an expert or a celebrity to endorse a product provides social proof through what psychologists call the halo effect or cognitive bias. If someone has education or professional experience that makes them experts, consumers are then more likely to believe that the product will be what they need. Endorsements by celebrities work slightly differently. If a consumer admires a celebrity, they may believe that purchasing the endorsed product will provide them with some of the celebrity's qualities that they admire.

THINK-ACT-PLAN: Product co-creation

Think: Has anyone recommended that you change the way you look, such as your clothing or hairstyle? How is this part of the co-creation of you as a product?

Act: Go online and read reviews at a product review site for a creative or cultural product. Do any of them suggest

changes to the product? Look at video and photo sharing sites. Do they show people producing the creative product or using it in a unique way?

Plan: Decide how you will allow consumers to co-create your product at least in some small way.

WRITING THE ORGANIZATION'S MISSION, VISION, AND VALUE STATEMENTS

The mission statement of a creative or cultural organization will be based on the distinctive talents of its employees. However, this is not true of all organizations. For example, when a television is purchased the unique talents of the factory workers involved in the production are not part of the purchase decision. In fact, if a factory worker decided to "customize" the television by adding an etched pattern to the screen, rather than applaud the creativity, the consumer would return the product. While companies that produce mass-produced consumer products will have mission statements that explain what they do, the mission will not be based on the unique talents of individuals. For creative and cultural products, the talents of creative individuals are the reason for its existence.

Do words matter? virtues do!

While a mission statement describes why the organization exists and the vision statement describes where the organization wants to go, the value statement describes how the employees should behave.

Some people argue that values are learned in childhood, and that once we are adults working in an organization, it is too late to change the values of employees. The problem is that many value statements are too vague and simply state that the organization will "live up to the highest level of ethical standards." However, a value statement that focuses on virtues along with the leadership to exhibit these virtues can shape the behavior of adults.

Virtues can be described in a values statement using just a few carefully chosen words, such as *honesty, fairness, caring,* and *compassion.* These words are emotional but also imply action. They provide a guidance to employees when decisions need to be made.

Honest: The company will be honest in all transactions with customers.

Fair: The company will be fair to all suppliers.

Compassion: The company will show compassion to all community members in need.

However, virtues are words that must be practiced not just written.

Shyti 2014

QUESTION TO CONSIDER: What action words can be used to describe the virtues my organization demonstrates on a daily basis?

A well-written mission statement will explain what the company does, for whom it does it, and what else it cares about. When deciding to write a mission statement it might be tempting to simply go online to find excellent examples to copy. However, they will not be of use to the organization as what is written into the statement must be based on the beliefs and values of the organization. The statements can then be used to guide all future decision-making.

Mission statement—who you are

A mission statement explains what the organization does and for whom it does it. When writing the mission statement, it is useful to think of having a conversation with customers to explain how the organization's product can improve their life. However, because an organization has more stakeholders than just customers, it is even better to think that a mission statement should communicate to anyone why the existence of the organization is good for them personally and also for the rest of the community. It might seem that the mission statement would first communicate a description of the product that is produced.

However, this is not true, as what it first describes should be the benefits the product provides for customers.

The mission statement should then communicate how the benefit is provided. A creative organization that produces video family histories might start their mission statement with the words that they provide the benefit of saving memories forever. The second part of the mission statement would explain that they do so by producing videos using verbal testimony, photographs, and other memorabilia.

The third part of the statement would explain the customer that is being targeted. In the case of the example of video family histories it might be middle-aged children of parents celebrating a 50th wedding anniversary. Or, it might be older people who want to leave the video for their grandchildren. The organization might wish to do both in which case their statement would communicate that the videos are produced for anyone who wants to share their life with their families.

The last part of the mission statement explains how the product is informed by the values of the company. There is nothing wrong with starting a business to sell a needed product so as to make a profit. If a customer desires a product that a business wishes to sell, both have benefitted. However, creative and cultural industries, along with many other types of businesses, have a purpose beyond just producing a product. Instead they also believe they are improving the world in some way. For example the people who start the video family history business may strongly believe in the importance of family in creating strong societies. They may believe that strong families are not only good for the members but help to teach the values of the society to new generations.

Questions to answer when writing the mission statement

- What benefit do we provide to our customers?
- With what product do we provide the benefit?
- Who is the customer to whom we provide the benefit?
- What values do we live when producing the product?

Vision statement—where you want to go

The vision statement differs from the mission statement in that its focus is on what the company wants to be in the future. The vision statement is useful for management of the organization to articulate their long-term strategy and how it will be achieved. While a mission statement will be developed to communicate the organization's immediate goals, the long-range goals will be communicated in the vision statement. Writing the vision statement helps the organization to understand that strategic decisions made today can either help or hinder reaching these future goals. Both the mission and vision statements should be written and shared with all employees of the organization. It is difficult to expect employees to implement the organization's strategy, if it is not known. Therefore, the mission and vision statements should be communicated to everyone in the organization as the strategy can only be successful through the efforts of everyone in the company.

While a vision statement will explain where the company wants to be in the future, it should also state why it wants to be there. Such a vision statement is practical and also aspirational. For example, the vision statement of the company that produces family video histories may state that they plan to have their product available to more customers than are currently being served. The question is how this will be accomplished. Therefore, the statement might state that the company will target additional consumers by expanding to new geographic areas. A different vision statement might describe that the organization is going to develop a web-based product that would help families create their own family histories.

The value statement—what you believe

While the mission and vision statements describe what the organization does, the value statement describes what the organization believes. An individual's values, which are often learned early in life from family, schools, churches, and civic organizations, can change over time but do not often do so. The same is true of organizations. They do not change easily

as their values will be part of the organization's culture. While the management of the organization may not expressly describe their values in a statement, they still exist and will affect how employees, suppliers, and customers are treated. In addition, they will affect how the organization interacts with the community.

Organizations should write their value statements to assist both management and employees. First, writing the statement will force those who manage the business to articulate what they believe. It may be discovered that there are differences in values that need to be discussed. If this is not done, differences in values may not come out into the open until there is an ethical decision that needs to be made. These ethical decisions are difficult in business because making an ethical choice may result in less revenue. When the business is faced with this type of decision, such as whether to pay more for supplies from a company whose ethical or political stance the company agrees with, arguments can ensue. It is better if these differences are worked out ahead of time by writing a values statement. In addition the value statement will inform current and future employees of the ethical standards of behavior that are expected.

Assessing the impact of the value statement—everyone is watching

With people having access to information online, there is more attention being paid to an organization's responsibility to live up to its value statement. Many creative and cultural organizations may state that their organization improves their community in some way. However, the community now demands accountability. They want to know what actions the organization takes to implement its values and whether the action makes a difference. This should also be of interest to the organization. After all if its actions to improve the community are not effective they should be changed. The community is not interested in empty promises but, rather, in successful actions. The organization might provide tangible items to a community improvement effort such as funds, equipment, or supplies. In addition, the organization might provide intangible

benefits such as the knowledge or technical expertise of the organization's employees.

To understand if what an organization is providing is affecting the community positively, it must first determine what impact it wishes to have. This should have already been clearly stated in the values statement. The organization then must determine what it is able to contribute. For example a company that produces a fresh food product may state in its value statement that they wish to help alleviate hunger. To implement this value they may decide to donate any extra food that is produced. They also have employees who are willing to become involved by delivering the food to a shelter on their way home. An understanding of what the organization can offer will enable them to develop a vision that both describe the actions that will be taken and the result of the actions.

However, the most difficult task is to measure the impact of the plan. This might be done by calculating the cost savings to the shelter of not having to purchase the food. It might also compare the health benefits of the donated food in comparison to what was previously being served. The organization could even interview the residents of the shelter to assess their response to the food that was donated. If the donated food does not save the shelter money, does not improve the diet of the residents, and is not enjoyed by the residents, then, no matter the good intentions, the program is not effective.

The question might be asked if the time and expense of writing a values statement and also trying to live the values through the actions of the organization impacts their profitability negatively. In fact, the opposite was found to be true. A research study of organizations compared what was said in their statements and their profitability. It found that these statements are more than just words written to post on a website. While all the mission statements reviewed by the researchers mentioned customers and products, fewer discussed how the organization's values would improve the wider world. The research found that companies whose statements emphasize values were more profitable than companies that had statements that only focused on products and customers.

Creating the strategic marketing plan

You are now ready to add the mission, vision, and values statements for your organization to your marketing plan. Each should not exceed a paragraph and all should fit on a single page.

REFERENCES

DiMaggio, Paul. "Social Structure, Institutions, and Cultural Goods: The Case of the United States." *The Politics of Culture: Policy Perspectives for Individuals, Institutions, and Communities.* New York: The New Press, 2000.

Dolbec, Pierre-Yann and Eileen Fischer. "Refashioning a Field? Connected Consumers and Institutional Dynamics in Markets." *Journal of Consumer Research* 41.6 (April 2015): 1447–1468.

Galloway, Susan and Stewart Dunlop. "A Critique of Definitions of the Cultural and Creative Industries in Public Policy." *International Journal of Cultural Policy* 13.1 (2007): 17–31.

Hallen, Ed. "The Science of Social Proof: 5 Types and the Psychology Behind Each." *Buffer Social.* May 1, 2014. https://blog.bufferapp.com/the-ultimate-guide-to-social-proof. Accessed May 7, 2015.

Hammett, Ellen. "Ad Saturation and Over-targeting Damaging People's Trust in Brands." *Marketing Week.* April 4, 2019. https://www.marketingweek.com/ad-saturation-damaging-trust-in-brands/. Accessed November 19, 2019.

Hartley, John, Jason Potts, Stuart Conningham, Terry Flew, Michael Keanne, and John Banks. *Key Concepts in Creative Industries.* Los Angeles, CA: Sage, 2013.

Jenkins, Henry. "Participatory Culture: From Co-Creating Brand Meaning to Changing the World." *GfK Marketing Intelligence Review* 6.2 (2014): 34–39. doi:10.2478/gfkmir-2014-0096.

Jenkins, Henry, Ravi Purushotma, Margaret Weigel, Katie Clinton, and Alice J. Robison. *Confronting the Challenges of Participatory Culture: Media Education in the Twenty-first Century.* Cambridge: The MIT Press, 2009.

Johnson, Steven. *Everything that is Bad is Good for You: How Today's Popular Culture is Actually Making us Smarter.* New York: Riverhead Books, 2006.

Kuang, Cliff and Robert Fabricant. "User Friendly: How the Hidden Rules of Design are Changing the Way we Live, Work, and Play." *Publishers Weekly.* 266.38 (September 23, 2019): 71–72.

Landry, Tommy. "How Social Media Has Changed Us: The Good and the Bad." *Business 2 Community.* September 5, 2014. www.business2community.com/social-media/social-media-changed-us-good-bad-01000104. Accessed April 2, 2015.

Sepp, Marianne, Veronica Liljander, and Johanna Gummerus. "Private Bloggers' Motivations to Produce Content—A Gratifications Theory Perspective." *Journal of Marketing Management* 27.13/14 (2011): 1479–1503.

Seth, Jagdish N. and Karl Hellman. "Unleashing the Co-Creation of Value." *The Marketing Journal.* August 16, 2018. http://www.marketingjournal.org/unleashing-the-co-creation-of-value-jagdish-n-sheth-and-karl-hellman/. Accessed November 22, 2019.

Shyti, Dan. "Leadership Values and Virtues." *Leadership Excellence* 31.6 (2014): 24–25.

Smith, Jemma. "Overview of the Creative Arts Sector in the UK." *Prospect.* November 2018. https://www.prospects.ac.uk/jobs-and-work-experience/job-sectors/creative-arts-and-design/overview-of-the-creative-arts-sector-in-the-uk. Accessed November 18, 2019.

Planning marketing strategically

Chapter 2

The chapter will answer the following questions

- Why is allocating resources using **strategic planning** critical to marketing success?
- What is meant when it is said that an organization has a **marketing mindset?**
- How will using the **components of marketing** fulfill both the needs of the organization and those of the customer?
- Why should a business take the time and effort to write a **marketing plan?**

CHANGING ROLE OF MARKETING

Marketing mindset or marketing headspace?

Either term will do. Some artists find it difficult to think of marketing without thinking of the "hard sell" of trying to talk someone into buying something they do not want. Unfortunately, this is not an uncommon misconception of marketing. However marketing includes activities in which all artists engage on a daily basis. Marketing is part of everyday life not a dreaded activity!

 Telling: Marketing is about telling a story. In this case, the story the artist is telling is about passion and vision. An

artist already tells this story to other artists. Marketing is just a way of sharing this same information with the public. After all, artists can't expect non-artists to automatically understand their work.

Helping: Marketing takes this process one step further. While artists should share their passion and vision, they should also help the public understand how the art will benefit them. Will it help put their troubles into perspective? Will it make them question their basic assumptions? Will it lift their spirits? The artist needs to help the public understand how art will fit into their lives.

Researching: Marketing also involves researching the public to find if there is a group of potential customers who may be interested in what the art has to offer. While this may seem arduous separate activity, it simply means that artists should not isolate themselves among other artists. They need to interact with the general community and do so often.

If artists take these steps, the "sale" is simply an exchange where artists are happy to share their art and the customer is happy to exchange money for the benefits the art will provide.

Fredericks 2014

QUESTION TO CONSIDER: What activities do I do every day that could be considered marketing?

It has always been true that to be successful in providing a product for which members of the public are willing to pay, organizations must understand and be responsive to the consumer's needs and wants. While the consumer needs some products to meet the basic requirements of life, other products are wanted because, although not necessities, they add to the quality of life. The ability to provide these products in exchange for revenue is the process of marketing.

All marketers, including those in the creative and cultural industries, must now also understand how the role of marketing has changed the relationship between the organization and the consumer. This includes how the consumer buying process

has changed and the changing role of marketing within the organization and the community. The consumer will be concerned with product benefits but also the sources of the raw materials needed for production. They will want to know about the company's human resource policies. They will evaluate the environment impact of packaging. A recent change is consumer's expectation that the organization be a contributing member of the community in which it exists.

Consumer journey from need to purchase—it's not a straight line anymore

It is often said that marketing is a way of thinking as much as a list of tasks to accomplish. What is unique about having a marketing mindset is that it means the marketer is focused on the external environment, including competitors and customers rather than only internally on the organization and its product. It also means that the marketing department is focused on the impact the organization has upon the community (O'Brien 2019). Of course, the managers of a creative and cultural organization must focus internally on the process of producing a product along with ensuring that the people working in the organization are both productive and well treated. Marketing is a unique organizational function in that, while it does not ignore production and people, it also focuses equally on issues external to the organization.

Because there are so many creative and cultural products available, no one in the organization can assume that any product will be purchased simply because of its high quality. Therefore, the marketing mindset of taking consumer needs into consideration must be shared by everyone within the organization. This does not mean that the organization must only produce exactly what people want in a product. After all, sometimes people do not know what they want because it has not yet been experienced. When a new unique creative product is produced, communicating its benefits to potential customers is the responsibility of not just the marketing department but also of everyone else in the organization.

This process has become more challenging because of the changes in the purchase process caused by technology. For many years marketing textbooks would describe a consumer

purchase process that would start with the awareness of a need or want. The consumer would then research, evaluate choices, make a decision, and purchase. This purchase process has now become more complicated (McKinsey 2017).

The consumer may start the purchase process by researching a specific product. They want to find the best product, at the right price and a convenient location. This type of consumer purchase journey will include significant research of product benefits. It will also include thorough research of competing products that are available. What is new is that the consumer will also research the organization that produced the product. Deciding factors may include the ethics of company personnel and the mission of the organization. The consumer wants to not just love the product but also the producer.

The purchase journey may start differently. A consumer may see a photo of a product on a social media site, click on the photo, and click on the e-commerce link that pops up to purchase and have the product in hand in days or even hours. Little research and consideration are done.

In both situations marketing's role is to ensure that product information is available online in the form of photos, videos, comments, blogs, and reviews on every social media site where targeted consumers can be found. To be successful the marketer must have a deeper understanding of consumer motivation than in the past. Fortunately social media has resulted in an abundance of data on consumer expectations (Brenner 2019). Marketing research and analysis of consumers is now an ongoing requirement.

Planning process—in the end all your questions will be answered

Because of the complex role of marketing and the speed of technological change, planning is even more important than in the past. While in the past it was common for organizations to focus on long-range plans of up to five years, this is no longer true. The problem with long-term time frames of three, five, and ten years is that the organization may be then not be aware of change that happens during these periods (Webb 2019). Instead an organization should focus on shorter range strategies.

THINK-ACT-PLAN: Introduction

Think: Think about what you want to achieve in your life. Is it to be happy? Is it to make money? Is it to change the community or the world? Which goal has priority? How will it be achieved?

Act: Find a creative or cultural organization online or visit an organization with which you are familiar. Describe any evidence of marketing that you see or ask someone at the organization how marketing is used.

Plan: Write a short one-paragraph introduction to a marketing plan that explains why it is being written. Be prepared to read the introduction aloud during the next class.

PLANNING AND STRATEGY

Marketing is always changing

The fast pace of technological change means that what people purchase and how they purchase is also changing. Some of these changes may be short lived while some may be permanent. It is impossible to know for certain. What is certain is that it is no longer sufficient simply to create and communicate a marketing message to motivate purchase. Instead these three changes are affecting marketing.

Live experiences: Rather than any static message, people want an experience as part of marketing. This could be in person or online. Creating a marketing experience is a process of informing the potential customer of the experience, providing the experience, and then uploading images and comments on what happened.

Small screens: It is estimated that one fourth of all online experiences now happen on a phone. Therefore all marketing material must be designed with this is mind.

Storytelling that in the past used words now uses video because reading on a small screen is difficult.

Multitouch equality: Everyone uses more than one medium to obtain information about products. In the past the emphasis was placed on the last screen that was seen as this was considered what motivated purchase. Now it is known all contact with the consumer is equally important as the marketing journey is no longer linear

Glazer 2019

QUESTION TO CONSIDER: How will I analyze my e-commerce customers' online behavior?

Strategic planning is inherently uncertain and dynamic as customers and resources are constantly changing. The best an organization can do is to evaluate the possibilities for future consumer needs and how it might provide customers with products that meet these needs. Social media has now provided new channels for obtaining this information (Breakenridge 2018). Analyzing consumer comments on social media can help the organization better understand consumer desires. Social media also allows the organization to more easily keep abreast of competitor strategies so that they can counter any threats to sells of their own products. Consumer feedback and competitor changes must be incorporated into the organization's marketing strategy.

Marketing strategy involves more than just knowing the components of product, price, distribution, and promotion; it also involves understanding a process of planning the use of resources. No strategy can be accomplished without a plan on how to use the resources of time, people, and money. The marketing plan starts with writing the mission, vision, and values of the organization. The next step is to analyze the organization's internal resources such as people, money, and culture. Once this is done, the external environment is scanned to analyze how the economic, socio-cultural, technological, and demographic forces outside of the organization's control will affect the ability to reach its strategic goals.

Mission, vision, and values—telling everyone who you are and what you believe

Marketing is a strategic process that starts with the mission, vision, and values of the organization. People who do not understand business believe that people in a company will do anything to make money. First, this is untrue because there are legal protections for the consumer. Second, people are too knowledgeable to purchase a product that does not provide the benefits they desire, and if they make a mistake and do so, they will go online to warn everyone else to not purchase the product. Finally, most people have ethical values that they incorporate into all aspects of their daily lives, including their businesses.

By having clearly defined mission, vision, and values, an organization does not need to rely on each employee's legal knowledge, concerns about poor online reviews or personal values to act in the best interests of the customers and community. Instead, the founders or managers of the company should incorporate the purpose and values of the organization into clearly written statements. These statements should not just be a random listing of vague principles taken off the Internet about providing good products to customers. Instead, they should specifically state how the company believes it is not only providing value to consumers by producing products but also what it is doing to make their community and the world a better place. These statements should then be used to guide all the decisions made by the company.

Internal and external analysis—know thyself and others

It is critical that everyone in the organization lives up to the mission, but successfully implementing a mission requires a strategy based on available resources. Therefore, the next step in the planning process is to look internally at the resources the company already possesses. This analysis should, of course, include the talents of the people in the organization. The financial resources that are available should also be analyzed as implementing the plan will require money. Other financial assets, including cash, equipment, vehicles, retail stores, entertainment venues, or production facilities, should be analyzed. Finally, the internal culture of the organization needs to be assessed. The culture under which the organization is managed might focus

on accomplishing tasks, on maintaining personal relationships within the organization, or on both.

Undertaking an external analysis, referred to as environmental scanning, is as critical as the internal analysis. While those involved in the business will already be aware of their internal resources, this may not be true of the external environment. The organization must take the necessary time to research the demographic changes in the area where they do business. They must also research the socio-cultural changes as these will affect product preferences. Knowledge of the strength of the current economy is critical in making pricing decisions. Advances in technology will not only affect both how the product is produced but how it is distributed. Finally, knowledge of competitors is essential in designing an effective promotion strategy.

SWOT analysis—making sense of it all

After analyzing the company's internal resources and the external environment, the organization will have a large quantity of interesting information. The question is how to make sense of all the data. One tool that can help to do this is the SWOT analysis, which stands for strengths, weaknesses, opportunities, and threats. The information on internal resources will be analyzed to determine if it includes strengths, such as ready access to start-up funding, or weaknesses, such as lack of marketing knowledge. However, the distinction between something being a strength or weakness is not always so clear (Brandenburger 2019). For example, while an organization may have an office in an undesirable location, this is not a weakness if they will not be meeting potential customers at the location. Or it might not be a weakness because, although customers are coming to the location, they are the type of people who would not be attracted to a standard "corporate" type office setting. The determination of whether the presence or lack of a resource is a strength or weakness depends on the mission of the organization.

Opportunities and threats are determined from an analysis of the information uncovered in the environmental scanning of the external environment. For example, an analysis of the demographic characteristics of the community might discover that there are many new residents of a particular age group. It might be an opportunity to target them as potential customers

if they are attracted to the product's benefits. Another example would be socio-cultural changes. It might be learned that many residents are embracing a specific lifestyle, such as living in smaller homes. If this is true, and if the creative product that is produced is small, then there is an opportunity to target people who choose to live in small homes. Threats may be uncovered when analyzing the economic environment. If it is learned that economic growth is low and unemployment high, the threat is that potential customers will not be able to afford the product. The answer is not for the organization to stop producing the product but rather to either lower the price or develop a promotional message that explains why the product is worth the price.

Goals and objectives, and tasks—will get you where you want to go

The purpose of the SWOT analysis is to understand the company's internal strengths and then match a strength with an external opportunity. This match would then be stated in terms of a goal. A common saying is that a goal without a plan is a dream. Therefore the objectives needed to accomplish the goal must be determined. It is completing the tasks that will make the goal a reality. Each objective might require more than one task for completion. The strategic marketing plan will usually state the goals in terms of the marketing components that will be affected such as the target market, product, price, distribution, and promotion. An example, which is far from complete, is shown below.

Examples of a goal, objectives and tasks

Goal: Target a new customer segment of residents living downtown in small apartments with artwork used as home décor.

- *Objective 1:* Develop a product in a size easily displayed in a small home.
 - *Task:* Research number of small homes in the area.
 - *Task:* Work with designers to develop new product.
- *Objective 2:* Price the product comparable to other home décor.
 - *Task:* Research competing products.
 - *Task:* Determine fixed and variable costs of the new product.

- *Objective 3:* Distribute the product through downtown boutiques.
 - *Task:* Contact local boutiques.
 - *Task:* Negotiate agreements.
- *Objective 4:* Promote the product using the latest social media methods.
 - *Task:* Develop marketing message.
 - *Task:* Create social media sites.

While a larger company may have many goals, a small company with limited resources should have a single goal. The goal can have a short timeline for completion, which leaves the company then free to pursue a second goal. A common goal for an organization is to find and target a new segment of customers to increase sales. Another strategic marketing goal may involve developing a new product that provides desired benefits. It may also involve developing a new pricing model, such as producing a lower priced version of a product. In addition, the goal might be to create a new distribution channel such as selling online or entering the retail market. Finally, the goal might be the creation of a new promotional campaign.

Once completed, the strategic marketing plan needs to be implemented. This will involve a timeline of activities that must be performed that indicates who is responsible to ensure they are done. After the plan has been implemented, it will be reviewed to ascertain if the goal has been reached. If not, the reasons must be determined and the plan adjusted.

THINK-ACT-PLAN: Marketing plan

Think: Does the organization for which you work have a mission? What do you think it is trying to accomplish?

Act: Look at today's news headlines on a website. Find two or three that might impact an organization for which you have worked.

Plan: Write a short dialogue that you can use to convince someone they need a marketing plan. Be prepared to act out the scene in class.

Marketing mindset or marketing headspace?

Either term will do. Some artists find it difficult to think of marketing without thinking of the "hard sell" of trying to talk someone into buying something they do not want. Unfortunately, this is not an uncommon misconception of marketing. However according to author Amy Fredericks, marketing includes activities in which all artists engage. This way, marketing becomes part of everyday life rather than a dreaded activity!

Telling: Marketing is about telling a story. In this case, the story the artist is telling is about passion and vision. An artist already tells this story to other artists. Marketing is just a way of sharing this same information with the public. After all, artists can't expect non-artists to automatically understand their work.

Helping: Marketing takes this process one step further. While artists should share their passion and vision, they should also help the public understand how the art will benefit them. Will it help put their troubles into perspective? Will it make them question their basic assumptions? Will it lift their spirits? The artist needs to help the public understand how art will fit into their lives.

Researching: Marketing also involves researching the public to find if there is a group of potential customers who may be interested in what the art has to offer. While this may seem arduous, it simply means that artists should not isolate themselves among other artists. They need to interact with the general community and do so often.

If artists take these steps, the "sale" is simply an exchange where artists are happy to share their art and the customer is happy to exchange money for the benefits the art will provide.

Fredericks 2014

QUESTION TO CONSIDER: What activities do I do every day that could be considered marketing?

To be successful in providing a product for which members of the public are willing to pay, organizations must understand and be responsive to the consumer's needs and wants. While the consumer needs some products to meet the basic requirements of life, other products are wanted because, although not necessities, they add to the quality of life. The ability to provide these products in exchange for revenue is the process of marketing. It might be thought that all that people working in creative and cultural industries need to do is read a standard business book on the basic concepts of marketing in order to learn everything they need to know. However, there are unique features to the missions and structure of the creative and cultural organizations that require marketing to be adjusted so that the mission and creative product is always central to the strategy.

Thinking like a marketer—it is how you think about the world

It is often said that marketing is a way of thinking as much as a list of tasks to implement. What is unique about having a marketing mindset is that it means the marketer is focused on the external environment, including competitors and customers rather than only internally on the organization and its product. Of course, the managers of a creative and cultural organization must focus internally on the process of producing a product along with ensuring that the people working in the organization are both productive and well treated. Marketing is a unique organizational function in that, while it does not ignore production and people, it also focuses equally on issues external to the organization. The marketer needs to do so in order to advise the organization on how to produce a product that will be desired by potential customers. This does not mean that the desires of creative employees are ignored; only that the external factors are taken into consideration when making product decisions.

Because there are so many creative and cultural products available, no one in the organization can assume that any product will be purchased simply because of its high quality. Therefore, the marketing mindset of taking consumer needs into consideration must be shared by everyone within the

organization. This does not mean that the organization must only produce exactly what people want in a product. After all, sometimes people do not know what they want because it has not yet been experienced. When a new unique creative product is produced, communicating its benefits to potential customers is the responsibility of not just the marketing department but also of everyone else in the organization.

Community engagement—show the world you care

Another unique role of marketing is to ensure that the organization is a contributing member of the community in which it exists. It is also everyone's responsibility to engage not only with potential customers but also with the wider community to explain both the organization's product and its mission. Of course, this engagement is part of the process when selling the product directly to customers in a store, studio, craft or art fair, or any other public space. However, in addition, the organization should put its mission into action by engaging with other groups to help or improve the community in some way. For example the organization can use social media to ask for volunteers for a neighborhood park clean-up day.

Planning process—in the end all your questions will be answered

If an organization wishes to be successful in providing products for which customers are willing to pay, it must have a marketing plan. It is best if the plan is developed during an organization-wide strategic planning process. This process can be summarized using the words where, what, how, who, and when. The first step is to determine *where* the organization is now. This would include assessing current internal resources and the external environment. The next step would be to decide upon *what* goals need to be accomplished. The strategy then must provide details on *how* the goals will be achieved by listing specific objectives. If there are insufficient resources to accomplish the objectives, then the strategy will also explain *how* the resources currently missing will be obtained. Once the organization knows where it is, what its goals are, and how the goals will be achieved, the next step is *who*. Without accountability nothing will be accomplished so each task

must be assigned. The final step is to establish *when* each task must be completed by implementing a timeline of goals and accountability.

Steps in the marketing strategic planning process

- *Where:* Assessing the current state of the organization.
- *What:* Determining goals that must be completed.
- *How:* Developing the objectives and finding the resources needed to complete.
- *Who:* Assigning responsibility for completing objectives.
- *When:* Creating an implementation timeline.

THINK-ACT-PLAN: Introduction

Think: Think about what you want to achieve in your life. Is it to be happy? Is it to make money? Is it to change the community or the world? Which goal has priority? How will it be achieved?

Act: Find a creative or cultural organization online or visit an organization with which you are familiar. Describe any evidence of marketing that you see or ask someone at the organization how marketing is used.

Plan: Write a short one-paragraph introduction to a marketing plan that explains why it is being written. Be prepared to read the introduction aloud during the next class.

COMPONENTS OF MARKETING

Not everyone should receive the same message

Customizing a marketing message is easier if you know the customer. You can use demographic facts such as age and gender to customize a message or you can base the message on their interest and lifestyles. The problem with online shoppers: they are just a click on your website.

Because you know less about them it can be challenging to create a message that will motivate them to the action you desire. Because you can track their online shopping behavior you can use this information to develop and send a unique message.

First time shoppers: Welcome and introduction

Returning shopper who has never purchased: Discounts to motivate

Shoppers who have purchased: Suggestions on products of interest

Loyal shoppers: Gifts or rewards

Cart abandoners: Reminder messages

Sweet 2018

QUESTIONS TO CONSIDER: What messages would be appropriate for our e-commerce customers?

Customers—there is no business without them

There is an old saying that there is no business until something is sold. A creative product can be produced, but the organization becomes a business only when someone buys. A unique feature of creative and cultural organizations is that the producer wants the customer to experience the product not just so that revenue can be produced but because this sharing of the experience is part of their mission.

Even if the type of creative or cultural product is already the mission of the organization, the needs and wants of the customer are still critical to success. Personal characteristics of potential customers along with the benefits they desire from a product need to be carefully analyzed. Starting a business is expensive as it takes money to hire employees, find the needed facilities, and produce, distribute, and promote a product. This process should not be undertaken with only the hope that someone will purchase.

Massive amounts of information are now captured digitally online. On social media and review sites consumers will mention specific brands, product types, and product complaints and

praise. They will also discuss their reasons for purchasing a product and how it is being used. This data can be numerical, such as number of clicks and length of time online. This type of data can reveal product attitudes and customer values that were previously unknown that can be used as a basis for segmentation (Gunter 2016).

As part of this analysis, customers can be grouped together based on any shared trait, interest, or value. The most common characteristics used are demographic facts, geographic location, and psychographic characteristics. While it may be theoretically correct to say any consumer may be interested in purchasing the product, the marketer understands that some consumers are more likely to buy than others. These likely customers are only a segment of the entire consumer marketplace, most of which will not purchase. It is a more efficient use of an organization's limited resources to target the segment of likely purchasers with a promotional message.

Demographic factors, such as age, gender, income, education level, and ethnicity, are often the first characteristics taken into consideration when segmenting consumers as they affect what type of product is preferred. However, today more products, particularly creative and cultural products, are not looking to appeal specifically to groups based on demographic facts alone.

In the past one of the first issues to consider when segmenting consumers was their geographic location or where they live. This type of segmentation was necessary if a product was only sold in a physical location. There was no reason to spend time and money to promote a product to people who are too distant to come to the store to purchase. Of course with e-commerce, a company may decide to target a much broader geographic area. In fact, the organization can sell globally. However geographic reach must still be considered. Many product preferences are tied to the culture or climate of a geographic region.

Psychographic segmentation is the most relevant customer characteristic for creative and cultural industries. This type of segmentation is based on a person's values, attitudes, and lifestyles. It is these factors that determine if and what type of creative and cultural, if any, will be purchased. For example people who value cultural expression are more likely

to attend the fine arts. Potential Customers, who have an attitude that life would be better if people were more involved in their communities, are more likely to purchase locally made handcrafted products. Another example would be a person with an adventurous lifestyle may want to purchase products produced in a distant country.

Product—not as easy to describe as you might think

In marketing, the word "product" is not as simple to define as it first might seem. Of course, a product can be a tangible or physical good that can be seen and touched and even smelled such as a floral display. However a product can also be an intangible service such as the design of a home's interior. At a more complicated level a product can be an experience. Many creative or cultural organizations are involved in providing an experience that in some way changes a person's deeply held values or, perhaps, just the way they are experiencing the day.

A tangible good, service, or experience product might also contain elements that are digital. For example a product that in the past would have been in a physical form such as a portfolio of designs, a musical recording, or a ticket to an event might now be provided in a digital format. In this case the product is promoted in the same way. Only the distribution of the product is changed because it is not in physical form. Other creative products are digital such as digital art, video games, or phone apps and have never existed in the physical world. All digital products will also need to be marketed similar to all other products.

A single product might have all these attributes. Designs for a home might include the service of design, the purchase of furniture, the experience of interacting with the designer, and a digital representation of what the final rooms will look like.

Price—the costs are not just money

What the buyer is willing to give up in exchange for receiving the product is its price. Of course, the purchase will involve money, but there may also be a non-monetary cost if the product is inconvenient to purchase or takes time to experience. However, most decisions on price are based on the monetary cost of a product. With a manufactured product, the cost of

production for each product can be calculated along with the overhead costs of running the company. These costs are figured into the price of the product along with an additional amount for profit.

However, the pricing of creative and cultural products is not so simple. The monetary value of the talent that is necessary to produce the product can be difficult to calculate. Of course, the actual time it takes to produce a painting will be relevant to its cost of production. However, the innate talent of the artist, which is a rare commodity, along with the years of effort that has gone into developing the talent, may be the most critical cost when pricing.

Besides calculating the cost of production, which is difficult for a creative or cultural product, there are two other methods of pricing a product. One is based on analyzing competitors' prices. Consumers have always compared prices, and with technology, this has become standard behavior. Therefore, marketers must know what competitors charge when determining the correct price for their product. If the product price is higher than that of competitors, the company must explain to the consumer why the product is worth the extra cost. A different approach to pricing is non-price competition or value pricing. With this model, the consumer is willing to pay the asking price for the product because of the brand name of the producer and the status of ownership.

Distribution—getting your product into the hands of the customer

Distribution, which is how the product gets from the producer to the consumer, is often ignored when developing a strategic marketing plan. Potential customers see the product promotion, which includes information on the price. In contrast, distribution happens behind the scene.

For mass-produced manufactured products, distribution will involve the logistics of transportation from factory to warehouse and finally to retail sales location. For creative products, the process will be different as there is no warehouse or factory. Distribution for creative products involves the decision of where to sell the product. Some products are best sold in a location where the product can be physically seen and where someone

can explain the product. These types of products will be sold at events, at the organization's own retail store, or distributed through another retail company. Some products might only be sold online. While some products will be sold both at a physical location as well as online.

If the product is a service, the distribution decisions will involve where the service will be delivered. It could be at a location maintained by the organization or at a venue owned by others. In addition, it could be at the consumer's home or place of business. Finally the product may be digital in which case a unique distribution issue is how the product will be protected from unauthorized duplication once it is delivered electronically.

Promotion—more than just starting a Facebook page

Promotion is the component of the marketing mix that most people think of when marketing is mentioned. In fact they may use the words marketing, promotion, and advertising interchangeably. However, promotion is only one component of the marketing mix along with customers, product, price, and distribution. Another misunderstanding is that promotion is easy. After all, all that is needed is a website and social media. In reality promotion is much more complicated than simply creating a Facebook page. Promotion is the process of communicating both the benefits of the product and also the values of the organization to the consumer. This is done through a process of developing awareness, providing information to build interest and desire, and finally moving the consumer to the final step of action or purchasing the product.

While the traditional methods of promotional communication, including advertising, sales incentives, personal selling, and public relations, are still relevant, the advent of social media has caused the reclassification of media into the new categories of paid, owned, and earned. Paid media includes any form of promotion that is one-way communication that is controlled by the organization. Paid media is used to attract consumers to the organization's owned media, the organization's own social media platforms. Both paid and owned are used to gain earned media, which is when the product is discussed by the public on other social media outlets.

To gain earned media companies produced branded content. This content was not a direct product promotion message as people were no longer responding to traditional marketing messages. Instead it was entertainment aimed at a particular group of consumers with a specific interest or lifestyle (Hart 2016). These groups then responded with their own branded content creating earned media.

THINK-ACT-PLAN: Website analysis

Think: Look around you and find a physical product. Is it labeled as to where it was produced? Can you visualize the distribution process that got the product from the place where it was produced to where you are now?

Act: Look at a website for a creative or cultural product. Can you analyze the website to determine the segment of consumers the product is targeting? Do you think the price is appropriate? Are you impressed with their promotional message?

Plan: Now explain how you think the website can be improved so that the marketing is more evident. Be prepared to share the website and the suggested improvements with the class.

WRITING A MARKETING PLAN

A marketing plan doesn't have to be difficult to write

A marketing plan doesn't need to be a lengthy document. In fact, it is best if it isn't. Because business people are busy people they want plans that are short and to the point. Below are questions that were posted on the Etsy website to help with writing a plan. Some questions will be easy to answer while others will require some deep thought or even research.

Value proposition:	What do you offer?
Market need:	What problem does your product solve?
Product:	What does your product do?
Competition:	Who else sells a similar product?
Target market:	Who will buy your product?
Financials:	How much money will you need to make?
Marketing:	How will you promote your product?
Milestones:	What are your goals?

Cummings 2013

QUESTION TO CONSIDER: Which of the above questions can I answer immediately and for which will I need to conduct research?

Writing a marketing plan is not as exciting as producing a creative or cultural product. As a result, the task can be put off for another day when there is more time. However, the reasons for taking the time to write a marketing plan are numerous and include forcing the organization to answer difficult questions about their product, competitors, and potential customers. In addition, a marketing plan forces the organization to make choices by writing goals, which is necessary as with limited resources not all ideas can be implemented. Once the goals have been decided upon, the marketing plan provides a roadmap of what objectives must be accomplished and when they must be performed. In addition, it provides accountability by assigning tasks to the people to whom the tasks are best suited and giving a deadline for their implementation. Lastly a marketing plan provides a benchmark by which to gauge success.

Difficult questions and choices—what to do when you can't do it all

The members of any business or organization believe in the product they produce. Because of this belief they may be overly optimistic about the product's chances of being purchased. Often this optimistic view will result in failure. It is better to

answer difficult questions about the product before starting to sell it to the public. This process includes analyzing from the customer's viewpoint what benefits the product has to offer. The customer may purchase the product for different benefits than those considered by the creator. For example, the creator of the product may have as their mission selling products that contribute to social justice, while the consumer's primary motive for purchase may be because of the product's design and color.

The marketing plan will force the organization to answer difficult questions about their potential customers. While the organization may have a vague idea such as people who love music, the marketing plan will force them to develop a clear description including demographic facts, psychographic characteristics, and geographic location. Finally, writing the marketing plan will force the organization to answer questions about their competitors. As customers will certainly compare products, the organization must do so also. To answer all of these questions, research may be required.

One of the mistakes made by many small businesses is to try to do too much with too little. The organization may have ideas for new products, new locations, new audiences, and new promotion. While they may all be good ideas, they will all take time, money, and people to implement. A plan with too many goals will be unsuccessful because the available organizational resources are spread too thinly for successful implementation. Writing a marketing plan will force the organization to choose only one or, at most, two goals for which they have the resources of time, people, and money so as to ensure the goal is achieved. The chosen ideas will be expressed as marketing goals and objectives. Additional ideas can be saved for future marketing plans.

Purpose of the plan—a roadmap plus accountability leads to success

Once the organization has decided on a course of action, a well written, detailed marketing plan keeps everyone moving together toward the same goal. People will understand what actions must be taken in what order. In addition, people will understand which tasks they have been assigned to complete.

A marketing strategy that starts with producing the product and ends with the product in the home of a satisfied customer is a process that includes many steps. It may be that only those responsible for the marketing plan are able to understand the entire process, but the plan will keep everyone else in the organization on the task.

One of the key benefits of a marketing plan is that it provides for accountability and reduces duplication. Everyone knows the tasks that each of them must perform each day. To ensure success, the tasks are being given to those with the necessary skills. In addition, to ensure success, the tasks are tracked. If they are not completed, the marketing department will be able to remedy the situation. This does not mean that the marketing department should approach the process in a dictatorial fashion. Such an approach almost guarantees that people will not cooperate. Instead, before tasks are assigned, everyone in the organization should be able to provide inputs as to their preferences and give an estimate of the completion date.

Lastly, a marketing plan lets the organization know if it has been successful. The plan will set up specific goals that can be measured. These goals might pertain to the number of products sold or the amount of revenue generated. The goal might also be to attract a new segment of customers. In this case, the organization will want to track their customers to see if the new targeted customer is purchasing. Finally the goal might be to implement a new pricing strategy or promotion plan. In these cases, sales will be tracked to see what effect the actions had on sales revenue and the number of products sold.

Types of plans—how much should you do?

When the decision is made to write a plan, it is necessary to clarify what type is meant. First, plans can be divided by whether they are marketing or business plans. A marketing plan only covers the marketing mix of product, price, distribution, and promotion targeted at a specific group of consumers. It will cover an analysis of the product, a description of the target market segment, a pricing strategy, product distribution plan, and a promotional campaign.

While the goals written for the marketing plan will affect other functions of the organization such as finance and production, the implementation of any needed changes outside of marketing is not addressed. By contrast a business plan also will include goals for the areas of management, human resources, operations, and finance. For example, the plan might have as a goal hiring additional personnel. When writing a business plan, it is critical that all departments, including marketing, be involved. For example, if there are sufficient funds to hire additional staff, the marketing department might request a social media expert be employed.

A plan can also be tactical or strategic. A tactical plan starts with an assumption of what goal needs to be accomplished. A plan is then written on what specific actions need to be taken to achieve this goal. Such a tactical plan might cover the entire business or only the marketing function. Adding the word "strategic" to describe either a business plan or marketing plan, marks a crucial distinction. The word strategic means that the business or organization has decided not to base their plans on their current knowledge of the organization, customers, competitors, or environment but instead start with an internal and external analysis. A strategic plan requires a great deal of effort even before goals are formed. The organization will first review their mission, vision, and value statements to ensure they are still relevant. They will then assess the organization's internal resources including personal, financial, and the organizational culture. In addition, they will need to analyze the forces in the external environment to determine how they affect the organization. Using the information from the internal assessment and external analysis, the organization will decide on their goals. The remainder of the plan will then detail how these goals will be accomplished.

Implementing the marketing plan—getting it done right

Unfortunately, understanding that an organization should write a marketing plan does not guarantee that one will be written. In addition, writing a marketing plan does not guarantee that it will be implemented. Writing a marketing plan is easier than its

implementation where real limitations and challenges in staffing, money, and time must be overcome. Whether an organization can successfully implement their marketing strategy depends on the level of employee commitment. This commitment can only result from having top management support, an innovative organizational culture, and employees that can make autonomous decisions (Ramaseshan, Ishak, and Rabbanee 2013). Top management must be involved in the strategic planning process. If they are not involved, there will be less incentive for lower-level employees to carry out the necessary tasks. Another barrier to implementation is a lack of an innovative management culture that promotes the willingness to take chances. A strategic plan by definition means that new actions must be taken. After all, if everything currently being done by employees was perfect, there would be no need for a new strategy. However, there are no guarantees that the actions required by the plan will be successful. Only an organization with an innovative culture will have employees willing to take the risk of implementing new actions. If all employees are both involved in the process and innovative, they must be given the autonomy to make the decisions that implementation will require.

THINK-ACT-PLAN: Section headings

Think: Am I excited about writing a marketing plan? If not, what reasons make me unwilling to do so?

Act: Go online and find two different sample marketing plans. What are the similarities and differences?

Plan: Write the section headings that you will need for your marketing plan in outline form.

Creating the strategic marketing plan

You are now ready to create the title page for your marketing plan and also to write a short introduction. This introduction should include the organization's name and the

product produced. In addition, it will include the benefits that the product provides and the target market section that will be interested in these benefits. This information will probably need to be modified as the writing of the marketing plan proceeds.

REFERENCES

Brandenburger, Adam. "Are Your Company's Strengths Really Weaknesses?" *Harvard Business Review.* August 22, 2019. https://hbr.org/2019/08/are-your-companys-strengths-really-weaknesses. Accessed October 15, 2019.

Breakenridge, Deirdre. "Five Ways Social Media Makes Your Strategic Planning Process More Strategic." *PRSA Content Connection.* February 21, 2018. https://contentconnection.prsa.org/resources/articles/five-ways-social-media-makes-your-planning-process-more-strategic. Accessed December 14, 2019.

Brenner, Michael. "The Future of Marketing and the Changing Role of the CMO." *Marketing Insider Group.* July 21, 2019. https://marketinginsidergroup.com/strategy/the-future-of-marketing-and-the-changing-role-of-the-cmo/

Cummings, Caroline. "How to Write a Business Plan in Under an Hour?" *Seller Handbook.* August 15, 2013. https://articles.bplans.com/one-easy-trick-to-get-your-business-plan-done-in-under-an-hour/

Fredericks, Amy. "The Artist's Introduction to the Marketing Headspace." *National Arts Marketing Project.* December 17, 2014. http://artsmarketing.org/ resources/article/2014-12/artists-introduction-marketing-headspace. Accessed April 23, 2015.

Glazer, Robert. "These Three New Marketing Trends Will Transform Your Marketing Strategy." *Inc.* June 13, 2019. https://www.inc.com/robert-glazer/these-3-new-marketing-trends-will-transform-your-marketing-strategy.html. Accessed March 12, 2020.

Gunter, Barrie. *The Psychology of Consumer Profiling in a Digital Age.* London: Routledge, 2016.

Hart, Douglas. "Branding in the New Media." *Harvard Business Review.* March 2016. https://hbr.org/2016/03/branding-in-the-age-of-social-media. Accessed February 12, 2020.

McKinsey. "Ten Years on the Consumer Decision Journey: Where Are We Now?" *McKinsey & Company.* November 17, 2017. https://www.mckinsey.com/about-us/new-at-mckinsey-blog/ten-years-on-the-consumer-decision-journey-where-are-we-today. Accessed November 22, 2019.

O'Brien, Diana. "4 Ms of Marketing: Mindset, Meaning, Moments, Moves." *Wall Street Journal.* April 1, 2019. https://deloitte.wsj.com/cmo/2019/04/01/4-ms-of-marketing-mindset-meaning-moments-moves/. Accessed January 21, 2020.

Ramaseshan, Balasubramanian, Asmaï Ishak, and Fazlul K. Rabbanee. "The Role of Marketing Managers' Commitment and Involvement in Marketing Strategy Implementation." *Journal of Strategic Marketing* 21.6 (2013): 465–483.

Sweet, Katie. "7 Segments Every E-commerce Site Should Use for Personalization and Analysis." *Evergage.* April 10, 2018. https://www.evergage.com/blog/7-segments-every-e-commerce-site-use-personalization-analysis/. Accessed January 14, 2020.

Webb, Amy. "How to do Strategic Planning Like a Futurist." *Harvard Business Review.* July 30, 2019. https://hbr.org/2019/07/how-to-do-strategic-planning-like-a-futurist. Accessed December 22, 2019.

Analyzing internal resources and external forces

Chapter 3

This chapter will answer the following questions

- How does an organization analyze **internal resources,** including financial, human, and cultural?
- How should organizations answer questions using **secondary research** with already existing information?
- How does an organization scan for information on **people and competitors** in the external environment?
- How does an organization analyze the **external forces** affecting the organization including, economic, technological, and socio-cultural?

ANALYZING INTERNAL RESOURCES

From resource to plan

Conducting an internal analysis can be a daunting task. The internal environment consists of many different resources that need to be analyzed from money to people to

culture, all of which are needed by the organization to meet its marketing strategy goals. However, not all resources can be used as a competitive advantage upon which a strategic plan can be based. One way of evaluating internal resources is the VRIO approach. This approach asks the organization to analyze its resources based on four questions:

V: Is the resource *valuable?* A resource is only valuable if it increases the product's value to the consumer.

R: Is the resource *rare?* If the same resource is offered by many other organizations, it ceases to be valuable. If the organization has a resource that is both valuable and rare, they have a competitive advantage over other companies. However, this advantage may be only temporary.

I: Is the resource costly to *imitate?* Such as creative talent! If this is true, then the organization has a sustainable competitive advantage.

O: Is the resource *organized* to capture value? There must be production, distribution, and promotion strategies to get the value from the company to the customer. A competitive advantage alone is not enough. There must also be a means of exploiting this advantage which is the basis of the strategic marketing plan.

Barney 1991

QUESTION TO CONSIDER: What competitive advantage do I have that is valuable, rare, costly to imitate, and that I have organized to capture value?

Success in any organization depends on offering a product that meets a consumer need or solves a consumer problem better than other products. A product that does so is said to have a competitive advantage. All organizations have a product that they are selling whether it is a physical good, a service, an idea, or an experience. No matter how unique the product in a globally connected world, there will be a competing product available

from somewhere that will also solve the problem or meet the need. If the consumer doesn't see any difference between the products offered, they may choose the easiest to buy or the cheapest. The challenge in marketing a unique creative or cultural product is to inform the consumer of its value so that the purchase decision is made on the value provided by product benefits rather than just price or ease of purchase.

The first step is to analyze the value of the product that provides a competitive advantage over competing products. The value might come from better product design, performance, or quality. The value might also come from internal aspects of the organization such as community involvement, environmental concern, or human inclusion. These organizational values then attach themselves to the product (Butler 2018). A research study found that 92 percent of Millennials were more likely to trust a company that supports social causes and 68 percent were more likely to purchase their product. Of course, if competitors have products with similar benefits and are supporting the same social causes, then there is no competitive advantage. This does not mean that the product or cause is at fault, but rather that the company will not be noticed by consumers.

Finding the right competitive advantage starts will an analysis of the organization's internal environment. This internal analysis will examine the financial resources, human resources, and organizational culture of the company. The organization will need to determine if the financial resources needed for start-up funding, working capital, or future expansion are available. Human resources should be examined to determine if there are a sufficient number of people needed to run the company. In addition, the organization's human resources need to be analyzed to determine if the employees have the needed skills. Organizational issues that must be addressed include the culture of the organization along with risk tolerance. It is not enough for companies to have a product with a unique competitive advantage. The competitive advantage must also be difficulty to imitate. If they are not, competitors will do so and the advantage will be lost. Finally, the advantage must be organized around excellent promotion, correct pricing, and efficient distribution.

Financial resources—it will take money

The first step in analyzing financial resources is to review the organization's financial records to determine its assets and debts. Whether the organization has been in operation for years or is a new start-up, no marketing strategy can be successful without the needed funding. When a strategic plan is being written for a new organization, there is a danger that marketing may be insufficiently funded as a new business requires financial resources to purchase the raw materials needed for production, to pay salaries, and to run production or sales facilities. Therefore, a complete listing of financial assets that can be used to cover these costs is necessary.

Because of the financial demands required to start a business, marketing may be thought of as something that can be funded later. However, without a funded marketing plan to communicate to the target market segment the existence of the product and the benefits it provides, all the other spending may be in vain. Therefore, ensuring that there is adequate funding for marketing expenses is essential. Of course, if there is no funding for paying employees or producing the product, spending money on marketing will also be a waste. This is why assessing the internal financial resources of the entire organization is an essential part of a marketing strategy.

While a new organization needs to determine if it has adequate funding for both start-up costs and marketing expenses, it also needs to know if it will have enough working capital to pay the bills until there is sufficient profit to make the business self-sustaining. Once the business is started and generates sufficient profit to pay the bills, the question arises as to whether sufficient funds are available for new product development and possible expansion to a new location or to add distribution methods. All of these financial issues affect the development of a strategic marketing plan.

If there aren't enough funds available internally, the organization must determine if there are sources of external funding available. These might include personal funds, funding from government programs to assist business start-up or expansion, bank loans or loans from friends or family. The time to answer these questions is before the funding is needed rather

than writing a marketing plan that cannot be implemented because there is no money. It is better to know prior to money being needed if funding can be obtained from friends or family willing to invest in the business. In addition, exploring funding sources through a bank or government agency should be done early in the strategic process. There is no reason to develop plans that cannot be implemented due to lack of funds.

Steps in analysis

- Review financial records of organization listing assets and debts.
- List the personal financial assets that can be used to cover costs.
- Discuss with friends and family the possibility of loans.
- Talk with a local banker about possible loans.
- Contact government agencies about loan programs for new businesses.

Human resources analysis—it will take people

The second factor in the internal environment that needs to be analyzed is the availability of human resources. While it is assumed there are people in the creative or cultural organization who have the talent necessary to create the product, other skills will be needed to run the company. Therefore, an assessment of the marketing, management, and financial skills of current employees is needed. If these skills necessary to run the business are not available, the organization will face a choice. Someone in the company will need to learn the needed skills, they will be obtained through hiring a new employee, or the work will need to be outsourced to a professional.

The first step in analyzing whether the current employees have the needed skills is to conduct a job analysis. Each job needs to be analyzed to determine what skills are needed to implement the organization's overall strategy. This would include the talent needed to produce the creative product. However, it would also be necessary to determine which jobs at the organization will need management skills, financial ability, and marketing expertise. In addition, the job analysis should determine what level of skill is needed for each job. Of course, this information

will need to be reviewed throughout the process of developing and implementing the marketing strategy. It is only after the strategic plan is completed that it will be fully known what skills will be needed. The skills needed to accomplish the goals can then be compared with the employees' skills.

Therefore, it is necessary to not just analyze what the job requires, it is also necessary to analyze what specific skills, talents, and abilities the current employees already have. Rather than just state that an employee has marketing expertise, it is necessary to note that he or she can create advertisements or run Twitter campaigns. With finance, it is important to note that an employee can develop financial statements or write grant applications. For management, it is necessary to analyze whether an employee has previous experience in this capacity.

Before deciding to add a new hire to fill the gap in skills, the organization should consider providing the technology or training that might help an existing employee preform the needed skill. Another solution to the skill gap is to change job descriptions of current employees (Lavoie 2017). A survey of existing employee skills may find someone with the needed marketing ability. If the employee is not currently using this skill, their job can be changed so that they can contribute to achieving the marketing goals.

Steps in analysis
- List all employee creative skills whether or not currently utilized.
- Survey employees as to financial skills that they possess.
- Discuss past job experience in management and start-ups.
- Ascertain marketing abilities.
- Verify entrepreneurial interest and experience of employees.

Organizational culture assessment—you are what you believe

First, financial resources were analyzed to determine if there was money to implement the strategic marketing plan. Then human resources were analyzed to determine if there was a match between the employees' skills and what is needed for

the strategic plan to be implemented. However, success in implementing a strategic plan will depend on more than money and skills. Even when both are present, a plan can fail because it is not implemented due to a lack of employee support. Therefore, an examination of organizational culture should be conducted to ensure that the final strategic plan is supported by everyone in the organization. An assessment of the current organizational culture will determine whether it needs to be changed to encourage support of the strategic plan.

A strategic marketing plan is more than a written document; it is a plan for action. One of the major issues that must be addressed is to analyze the organization's culture as to whether the employees will either support or resist implementation. The existence of this organizational culture means that marketing's role in developing a marketing strategy cannot be done in isolation. Instead, marketing must work alongside the creative team as the work is being produced (Bilton 2007).

Culture is a way of living that is transmitted from generation to generation. Culture helps answer many questions about how to live and relate to others. Most people do not think about the culture in which they live or work as it is simply considered normal. However, if someone travels to another country or works in another organization they will immediately become aware of cultural differences, usually by framing other people's behavior as unusual. By experiencing other cultures, the differences become apparent.

Organizations and companies have cultures of which the employees may be unaware. These cultures may reinforce behavior that is risk-adverse, and therefore, the employees may resist change. Or there may be an organizational culture that encourages behavior to embrace change. Either organizational culture will impact the implementation of a strategic marketing plan.

Organizational culture can be thought of as consisting of inward and outward elements (Schein 1985). The elements of inward culture are values and beliefs. Every employee brings with them existing values and beliefs that are based on underlying assumptions on what is important in life. Because these values and beliefs are difficult to change, they should be

as important in making the hiring decision as the skills that are needed to perform the job. For example, the belief in the role that art plays in life and the value of the importance of creativity are already present in an employee. The outward elements are the physical signs or culture such as how employees dress and the design of office space. These outward elements reinforce the organization's values.

Organizational cultures can be divided into two basic types; they are either risk-adverse or adventurous. Risk-adverse organizations have employees whose first response to a new idea is dismissal. These organizations focus on avoiding problems rather than looking for opportunities. As a result, the marketing strategy will be based on what has always been done in the past. The employees of these organizations will resist the implementation of a new marketing strategy. While it might seem that this does not describe a creative or cultural organization, this is not the case. Because many of these organizations often face limited financial resources, the employees can become very fearful of the future and tend to want to follow the same strategy as in the past.

What is needed is for the organization to change its focus to an adventurous culture where new ideas are welcomed. This type of organizational culture causes the employees to seek out new opportunities. When presented with a new marketing strategy, they will see the possibilities of success. To change from a risk-adverse to adventurous culture requires that employees be motivated and rewarded for trying new ideas.

If it is believed that the organization culture needs to be changed in some way, then part of the implementation section of the organization plan should address this issue. For example, creativity may be a core value of the organization. If the analysis finds that employees no longer believe that the organization is creative, this value needs to be reinforced. This can be done by ensuring the facilities for the organization reflect this attitude through location, colors, and furnishings. If it is believed that employees will resist change and, therefore, not put forth the effort to implement the marketing strategy, events can be planned that build excitement and commitment. For example, a kick-off party for a new strategy can be held. If hard work is

going to be needed to get the company started, the managers of the company must demonstrate this behavior through their own hard work.

Steps in analysis

- Develop a list of needed cultural traits including values, beliefs, and assumptions.
- Ensure that the physical surroundings demonstrate the desired culture.
- Plan events to build enthusiasm for implementing the marketing strategy.

THINK-ACT-PLAN: Internal analysis

Think: Have you ever worked in an organization where the lack of people, time, or money to complete a project was a problem? What happened as a result?

Act: Interview someone at a creative organization to ask if they have sufficient resources. Then study their website and social media to see if there is evidence of these resources.

Plan: Write the internal analysis for your marketing plan. If you are creating a plan for a new organization, describe the level of resources and type of culture that you plan the organization to have.

RESEARCHING EXISTING INFORMATION

Social media sources of information

Existing information that is already available online or in print is referred to as secondary data. It is available from databases that include information provided by government sources, academic studies, or trade organization research. However, with the growth of

the use of social media there are now new sources of secondary information. This is such a new phenomenon that the method of analyzing this type of data is still being developed. However, in the meantime, insights can still be gained by examining these secondary sources. The list below provides some ideas.

Twitter: Data from person or organization tweeting and also followers of Tweets used for positive and negative comments on products.

Facebook: Data from posts, pictures, groups, persons, and events, used to find demographic information on the users.

YouTube channels: Data from video used to assess the usage of the product by studying videos of customers.

Instagram pictures: Data from comments, likes, and shares used for insights on consumer preference information not only from the content of the photos but from how often they are shared.

Pinterest boards: Data from pins, users, comments, re-pins used for new product insights by looking at boards to see how customers associate different ideas.

While not scientifically valid, such secondary research will provide answers to some research questions while providing ideas for primary research that needs to be conducted.

Beaulac 2019

QUESTION TO CONSIDER: What information about me could be inferred by looking at my use of social media?

The organization will first gather information on the internal environment including finances, human resources, and organizational culture. In addition, the organization must now scan the external environment, including customers, competitors, economic conditions, technological advancements, and socio-cultural changes. All of these issues will need to be researched before the organization is ready to start writing a strategic marketing plan. However, time can be saved because

some of these questions can be researched using data that already exists in secondary sources. This secondary research uses sources of information already collected by others. For example, academic journals will have the results of research studies on consumer preferences and purchase motivation. Government databases will have information on economic conditions. Already existing studies of socio-cultural issues, such as social media use, can be found online. In addition, specialized publications and websites can provide information on technological changes. In contrast, if the organization wants information about their already existing customers' motivations and future behavior, they will need to conduct their own primary research.

Issues to be researched—someone has already asked

The issues that need to be explored can be expressed in the form of research questions. These questions can be answered using census data, academic studies, business associations, trade journals, and general publications. Some of these secondary research questions will focus on the need for a better understanding of consumers in general. Other secondary research will be more specific such as a question on how many people purchase a product. There may be research questions that need to be answered about competitors, the current state of the economy, or about the current social concerns of community members. Factual questions will focus on issues such as who purchases and how much they purchase. While the organization might still wish to conduct their own research about the social media use of their customers, they may also wish to know about social media trends in the population. These types of questions can be answered by doing online research of already existing information.

Sample secondary research questions and sources

- *Census data*: How many people aged 18–28 live in our region?
- *Academic studies*: How many people are using different types of social media?
- *Business associations*: Who is our largest competitor?

- *Trade journals*: What are the current trends in our product category?
- *General publications*: What are the latest advancements in payment systems?

A process for researching data—to keep you on track

Conducting secondary research will be part of the process of scanning the external environment. The secondary data that has already been collected by other individuals and organizations can be used to answer questions on customers, competitors, the economy, technological advancements, and socio-cultural changes. If secondary data is available, there will be no need for the organization to conduct primary research saving both time and money. Most secondary data will be obtained through conducting online research.

Questions regarding demographics of customers, such as age, ethnicity, income, or education level, can be answered using government census data. Most governments collect this data for election and tax collection purposes. It will vary depending on whether the information is collected at the national, state, region, or community level. The public's access to the data will also vary depending on governmental policy, but most countries make basic census data available online. For example, a research question may be asked about the income level of the community to help determine the appropriate pricing of a product. This information should be easily obtainable in many countries.

In addition, to a census, other government or non-government organizations may collect data on the community. The local education system will have data on the number of children or adults enrolled in school. Such information will be useful when a research question is asked about the number of primary-aged children so as to ascertain if this segment is large enough to target with a new product. Business associations will have data on the types of businesses in the area. For example, if the research question involved the number of competitors, association data will be useful.

Other sources of information include trade and professional associations that target specific groups based on a shared

profession. As a service to their members, they may collect survey data on consumer product preferences. These association websites, trade journals, and professional magazines have articles on demographic data. However, their most common use is to learn about trends in both the industry and consumers.

Lifestyle magazines and websites are targeted at people who share a similar social or cultural interest. These can provide insights on what product benefits the targeted market segments prefer. In addition, the articles can also inspire new product ideas. Finally, keeping abreast of the general media including business news is part of the process of collecting data that can be used to answer research questions.

Secondary research analysis—locate, skim, and only then read

Secondary research that is part of scanning the external environment should be conducted on an ongoing basis. A simple means of retaining online information is to bookmark any useful information in a separate folder on the computer. The information will then be available for future reference. For example, an article on promotional pricing could catch the eye of the marketer. By saving the article, it is available when a research question is asked about whether consumers are motivated to purchase by limited-time discounts. If a longer session of secondary research is planned, it would be a good idea to have a system of locate, skim, and read. It is all too easy to get overwhelmed with information when searching online.

First, there is the need to locate sources of information. While most people might only think of conducting research with Google when doing a search for information, many of the needed information sources are not available for free. Therefore, databases of information found on academic or public library websites should also be used. These databases provide digital current and back copies of academic, trade, government, and general publications, each of which has its purposes.

Academic publications provide research data on trends, groups, and issues. While providing statistically proven data, they can be written in a style that is difficult for anyone but other academics to read. Trade publications are meant for

people who work in or are interested in a specific industry. They are generally easier to read and understand than academic publications. Governments collect data on any number of issues and provide quantitative reports that describe the economy and populations. Finally, general publications, including newspapers and magazines, carry articles of interest to the general population. While government publications are usually free the other publications have subscription fees, which is why the information cannot be simply googled.

Once access to the databases is located, keywords should be used to search for articles that will be of interest. The authors of the articles should also be reviewed to see if any of the names are familiar. If not, the authors' credentials should be examined to see if they have the expertise necessary to speak authoritatively on the subject. Once appropriate sources are located, relevant articles and reports should be read to see if they contain information of use. Only if they do should the article then be analyzed and the information added to the secondary research findings.

Using social media as secondary research—now you can listen in

Besides information from general online searches and publications in databases, social media provides secondary data that can be useful to develop a marketing plan. First, forum and blog comments can be read to gain insight into consumer trends. For example, people's attitudes toward specific brands will be commented upon. In addition, social movements, such as environmentalism, will be discussed. This information can be used when designing public relations campaigns so that the causes chosen will represent the concerns of potential customers. Product review sites can be excellent sources of information for product improvements or new product ideas. Even if the product being reviewed is that of a competitor, the information can still be useful. Of course, reviews for the organization's product should require reading.

Product reviewers don't provide only information on people's opinions of current products; they also provide information on products that they wish existed but currently do not. In

fact, there are companies that rely solely on these reviews for all their new product ideas (Feiter 2013). These companies have employees that specialize in product categories such as technology and continually scan online for product improvement ideas suggested by consumers. For example, a number of people are wondering why there is no speaker that can float in a swimming pool; the company hires a manufacturer to produce one and then sells the product online.

Blogs can also be a useful source of secondary research findings. Many blogs will analyze and explain research findings from academic and government sources in a manner that is easier to understand. Blogs will also discuss recent consumer trends using sources from general publications. If more information is needed, a link to the original source is usually included.

There are also sophisticated software tools that will conduct online secondary research for the organization. However, one of the easiest ways to do so is by using hashtags, which provide real time information on what is on people's minds. The hashtags can be related to product categories, such as handmade products, or specific products, such as scarfs. In addition, the hashtags may be related to holidays or events.

While primary research, such as surveys, focus groups, and interviews, may only be conducted infrequently because of the cost and time involved, secondary online research can be conducted on an ongoing basis. It should be someone's responsibility in the organization to regularly monitor social media for comments about the organization, product, competitors, and trends.

A research tool that should be used on a continual basis is social listening. This method involves using keyword search to find information on social media sites. It takes a structured approach to find meaning in the overwhelming number conversations that take place online. This is done by using tools that will search for mentions in conversations over many different social media platforms. The search may be by type of targeted consumers, product, or industry. The advantage of using social media sites such as Facebook, Twitter, and Instagram, is that the information is given in real time and

is unfiltered. The advantage of using social listening as part of the research process is that the comments are unfiltered (Barysevich 2018). When consumers are asked direct research questions about the product, the way the question is written will partly determine the answers that are received.

Social media listening is essential for discovering new trends as many are first started on the internet. Listening to consumer complaints about competing companies can assist with product improvements. The public preference of competitors can be analyzed. In addition, the strengths and weaknesses of competitors can be uncovered. Social listening can also help with decisions on which consumers to target, where to promote, and what price will be acceptable.

THINK-ACT-PLAN: Finding secondary sources

Think: When you are researching online for information on a place to visit, what type of sources do you use? Do you follow a process?

Act: Find five sources of already existing information that would be useful to your organization.

Plan: Write a short plan describing your process for finding needed secondary sources.

SCANNING FOR INFORMATION ON PEOPLE AND COMPETITORS

How social media can help small businesses scan the external environment

All organizations now understand they need to include social media in their marketing strategies. However many still do not understand that social media can be used to research customers, competitors, and trends. The information that is discovered can be useful in many ways.

Remain customer-centric: When social listening results in discovering customer complaints, the company can respond immediately by addressing the issue within the organization or improving the product.

Learn trends: Trends are continually changing so marketing strategy needs to continually evolve to take advantage of these changes.

Understand pain points: Listening to customer complaints about competing products can provide information for future improvements.

Develop marketing strategy: Simply finding out where consumers are having product discussions will let companies know on what social media sites they should have a presence.

Discover competitive advantage: The company may find from positive comments about their products a new advantage of which they were unaware.

Nair 2019

QUESTION TO CONSIDER: What kinds of information can social media provide on both your customers and competitors?

After the organization has an understanding of their internal resources, including their organizational culture, the external environment needs to analyzed or scanned using secondary research. This analysis should include customers, competitors, economic conditions, technological advancements, and socio-cultural changes. This would include an analysis of customers, whether they are current or potential. In addition, the organization's competitors, both direct and indirect, must be researched. No organization exists without competitors and their products and strategies must be taken into account when developing a strategic marketing plan. The external economic situation for the community will certainly affect pricing decisions. The technological environment needs to be analyzed as new technological advancements can be incorporated to

improve products. In addition, technological changes affect how products are promoted and distributed. Finally socio-cultural factors must be understood as they affect product preferences. All of the information obtained from external environmental scanning using secondary research will assist in finding opportunities of which the organization can take advantage.

Customers—the more you know the better

As part of conducting the environmental scan, the characteristics and preferences of both current and potential customers should be researched. Of course, the organization needs to know who is currently purchasing their product, but it should also research who is not buying but might be potential customers. The research should also focus on customers' motivation for purchase and on how customers use the product.

The first step is to review any sales data the organization has available to determine the number of current customers. Because of the technology used in making sales, there should be data both on final sales but also website analytics and shipping location. In fact technology can track every step on the consumer journey from first contact to final sale (Stubbs 2018). While there should be readily available data on total sales revenue, the information that is needed is how many different customers have purchased. In addition, it is useful if sales data can be used to determine whether there are repeat customers and how often these repeat customers purchase. If the organization sells online and ships a product it will have information on the geographic location of purchasers. If it does not use e-commerce, it can be assumed that most customers are local. While it might be impossible to ascertain demographic data from online sales, for sales made in person information on characteristics such as age, gender, and ethnicity may be available.

It would be advantageous if primary research, which will be discussed in the next chapter, using a survey could be conducted of current customers to learn more about why they purchase and how they use the product. If the organization has email addresses for customers, an easy method is to send out

an online survey to learn more about product preferences. If not, asking customers as they purchase will assist in providing some useful information.

Secondary research should be conducted to identify new groups of potential customers. This can be done by reading articles focused on the lifestyles that might find the product benefits of interest. In addition, social media can be reviewed to determine if there are groups of consumers who are unhappy with current product choices.

Twitter is a popular social media platform for discovering issues of concern to consumers (Ahmed 2019). Content analysis is done by analyzing the number of new hashtags being developed. If one of the most frequent hashtags is about either a global concern, such as a new virus, then the organization can address the issue in their marketing strategy. If the hashtag is in response to a local event, such as devastating fire or tornado, then the organization can let the community know what they are doing to help. Thematic analysis takes a deeper look at the responses collected under one of the hashtags. The organization can get insights into how they want an organization to respond by either changing a product or becoming more involved in solving a problem.

Steps in analysis

- Quantify the number of customers that have purchased along with relevant data.
- Describe as much as possible their demographic and geographic traits.
- Develop a primary research survey to ascertain the motivation for purchase.
- Use secondary sources to discover alternative groups of customers to target.

Competitors—they are our friends, not our enemies

No business exists in isolation as consumers will always compare one product with another. Businesses that target customers with similar products are rivals, but they are not enemies. They both understand their products must be unique

in some way. For two businesses to have the exact same product is counterproductive to both. This is particularly true now that product reviews can easily be found online.

Therefore, as part of the environmental scanning process, competitors should be researched. The first step is to determine what organizations and products are direct and indirect competitors. For many creative and cultural products, there will be no direct competitor because the creative talents of employees result in a unique product. However, as consumers may not understand the distinctiveness of the product, they may see similar products as competitors because they do not see the differences.

When analyzing competing products, the organization should consider factors such as price, customer service, and overall product quality, which are easy to compare. While an organization should certainly analyze these tangible factors, it is actually the intangibles such as product benefits, reputation, and company image that are often the deciding factors when purchasing a creative or cultural product. By researching these competing factors, the organization can then use this information to differentiate their product from its competition.

This secondary research can be conducted online by examining the websites of competitors. However, it is even better if primary research can be conducted by visiting competing organizations and speaking personally with competitors. One of the reasons for business networking events is to provide this opportunity to learn more about the current products of competitors. Most competing companies keep in contact with each other using networking events. While still competing, there is no reason why competitors cannot share knowledge that will be helpful to both.

Steps in analysis

- Determine what products customers see as competitors.
- Analyze the tangible features and intangible benefits of competing products.
- Examine competitors' websites.
- Network in person with competitors at events.

Assessing your own organization's culture: a how-to guide

Everyone is aware of the culture of an organization, but trying to describe it is challenging. Culture behaviors are so ingrained in our everyday life that they are difficult to see, let alone describe. Here is a process that starts with asking questions.

Attendance: Do people participate willingly in company functions outside of the office? If not, they may do their job but are not part of the larger organizational mission.

Doors: Which office doors are kept closed? A closed door can be a sign that input is not welcome.

Gossip: Is the office gossip invariably negative? Everyone needs to complain sometimes, but employees should also applaud the successes of others.

Retention: Do people stay at the company or is there high turnover? People may join a company for a job, but they stay to be part of a team.

Parting: When people do leave, do they do so with relationships intact? An organization should remain interested in the welfare of an employee even when they are leaving.

Offices: Who gets the biggest offices? Not all offices should be the same, but who gets the biggest tells you who the organization values.

Walls: What type of art or information is posted? Just like in our homes what we put on our walls expresses who we are.

Interactions: What type of interpersonal interactions do you see? You can observe if the organization encourages interaction or wants people to only stay focused on the job.

Perkins 2019

QUESTIONS TO CONSIDER: What would I find if I answered the above questions about my organization?

It may be obvious that an organization needs information on current and potential customers and also competitors. It may be less obvious that time must be spent on researching external forces that do not directly impact the company. However changes in what is happening in the external forces can affect if a person buys a product. Three of the main forces are economic, technological, and socio-cultural.

Economic—people have to have money to buy

While an individual may be able to ignore the economic news, a business person must understand the current economic situation as it will affect how much disposable income customers will have available to purchase creative and cultural products. While when the economy is in decline consumer spending decreases and when the economy is growing consumer spending increases, the relationship is more complicated (Glassman 2019). A slowing economy does not immediately affect spending. It will not do so until members of the public believe the decline will be long lasting and the same is true of economic expansion. The budget available for marketing is dependent on how the overall business is performing. If the economy is doing poorly, it might be necessary to adjust prices either temporarily through a discount or permanently by lowering the price but as consumers do not change spending patterns quickly the organization should wait for signs that sales are slowing before acting. In addition, external economic factors will affect the price of raw materials and the cost of renting or leasing premises.

An online search of a government database should provide information on the current rate of economic growth. However, while a single number alone, such as the rate of economic growth, is data, it does not provide information. For example the rate of economic growth in the region might be found to be 2.5 percent. This number can only be judged to be good or bad if the past percentages are known. For example, if growth had been at 4.2 percent the previous year, then 2.5 percent means that growth has slowed down significantly, and people may be concerned about retaining their jobs and, as a result, save money rather than spend. On the other hand, if economic growth has been at only 0.6 percent the previous year, the

same 2.5 percent growth may make people feel the economy is recovering, and they will be more likely to spend money.

Almost all individuals and businesses need to pay some type of taxes, either on a local or regional level. The amount of taxes will increase or decrease based on the political situation in the country but also the economic situation. When the economy is not doing well, the government may decrease personal taxes so that people will have more money to spend. This can increase spending on products and benefit business. To boost the economy the government may also decrease business taxes so that they will be encouraged to expand and hire more employees.

Another factor that will affect business decisions is the cost of renting or leasing space. These costs can be determined by looking at online listings of commercial realty companies. There is little point of building into the strategic plan the idea of a downtown office for a design firm if the cost is excessively high. Because real estate listings do not provide trend data, a visit to a realtor would be useful. A local realtor would have information on whether rental or lease prices are likely to increase or decline.

An economic analysis should also be conducted on the trends in prices of raw materials, operating supplies, or business services that are needed for the production of the creative product. When a creative entrepreneur produces a limited number of products that are sold personally, prices can be quickly adjusted to take into account any changes in these costs. However, as a creative organization grows, the prices of supplies, materials, and services become more critical. Prices cannot be quickly adjusted as the product price will already be on products in stores, listed online, and in promotional material. Some creative products such as jewelry use precious metals and stones whose prices can change dramatically. An analysis may discover an alternative material that could be used for which prices are stable. This might provide an idea for a new product that would open up the opportunity for a new segment of customers.

Even the price of services used needs to be analyzed. The cost of utilities to heat and cool an office, store, or studio can vary and needs to be taken into account when a decision on

premises is being made. The cost of gas and petrol for vehicles for traveling musicians is a cost that must be taken into consideration when a touring strategy is discussed. The more economic information that is obtained the better will be the resulting decisions.

It might seem counterintuitive but a strong economy can also present challenges. When the economy is strong more people are hired to produce products. This can present two problems. First, a low unemployment rate will make it more difficult to hire. This results in the second problem of higher wages that will need to be paid to attract and keep employees. With a limited pool of potential employees, companies will compete by offering higher wages, which will increase the cost of doing business.

Steps in analysis

- Find economic data for the region.
- Check business tax rates.
- Review prices for renting or leasing storefront or production space.
- Check the price trends for the materials that will be needed to produce the product.
- Determine the cost of utilities.

Technological—what's new that will affect you

Technological advancements can affect distribution and promotion. In addition, technological advancements affect how the product is produced. Creative products are rarely mass produced, and yet an external analysis may uncover that there may be cost savings from using a new type of technology in their creation. These cost savings can then be passed on to the customer by having a lower price. In addition, adding technology to a product may provide additional benefits desirable to the customer. For example, if one wedding photographer promotes online that they add special digital effects to wedding photos and edited video diaries of the special day, customers will be disappointed if other photographers do not do the same.

Technology also affects how the product is distributed and promoted. Digital products can now be distributed online with no need for the product to be picked up or be shipped. People

may prefer to research products online and then purchase in person. Or they may prefer to research products in person and then later purchase from the comfort of their home. They may even wish to order online while at a store. As a result, the organization may have to increase the methods they use for product distribution to include online. Finally technology affects how organizations are promoting their products to customers. The ability to maintain direct communication between the producer and the public has redefined promotion methods.

Technological changes can also have negative on business (Chrisos 2019). When an organization is dependent on technology for tasks and the technology fails, production and sales can stop. For example, if the electronic payment system for processing credit cards fails, the business cannot make sales. No one remembers how credit cards were processed with a paper system. Another problem that results from technology is that fewer employees no longer have the interpersonal social skills to conduct business. In addition business colleagues that only interact with each other using technology may not be able to work as well on team projects.

Steps in analysis

- Determine how technology has changed competing products.
- Analyze new forms of online or electronic distribution.
- Examine how purchase methods have changed.
- Research how promotion of competing products has been affected by social media.

Socio-cultural—people are complicated

Socio-cultural issues, including political beliefs, social concerns, and cultural identity, are critical to analyze as they affect people's product preferences. People are increasingly forming part of their identity around political and social issues that have meaning to them. These issues then form part of their cultural identity. This could be political issues such as party affiliation. The issue might also be more complicated as members of the public may desire to purchase or not purchase products made in certain countries because of a political situation. With social

media CEO's of companies are now known to the public, which expects them to take a stand on social and political issues (Doerr 2018). They are now considered leaders of their communities not just their companies and the public expects them to use their wealth and power to produce social change.

Purchase decisions and product preferences can also be based on social issues relevant to customers. These social issues might be a concern for environmental issues that result in consumers wishing to buy only products that do not harm the environment. Another social issue might be poverty, which might result in customers wishing to purchase products that assist in local economic development.

Socio-cultural issues can also include purchasing behaviors based on customers' ethnic origins, which affect their cultural identity. The roles of men and women, the importance of children, and the attitude toward the elderly will affect product choice. As the ethnicity of communities changes, organizations must adapt and offer the desired products. However, changes in the ethnic composition of a community can also cause the organization to re-evaluate how it both distributes and promotes products. For example, ethnic groups that wish to socialize as a family will not be interested in late night performances. Ethnic groups will also expect promotional material to represent them as potential customers.

Steps in analysis

- Research current political causes with which people are concerned.
- Examine changing preferences based on political and social issues.
- Analyze customers' cultural identity to determine if they result in specific product needs.

THINK-ACT-PLAN: External analysis

Think: What external environmental factors affect you personally? Does the state of the economy change your spending plans? Do you purchase products because of new

Analyzing resources and forces

technology? What social and cultural changes have you noticed in your neighborhood?

Act: Use census data to research the geographic area where your organization and its customers are located. Either search online or visit competitors to learn what they offer. Read the news to determine any cultural or technological changes that may affect your organization.

Plan: Write the external analysis section for your marketing plan. Some sections will have more detail as not all external factors will affect an organization equally.

Creating the strategic marketing plan

You are now ready to write the internal analysis of financial resources, human resources, and organizational culture. In addition, you are ready to write the external analysis of customers, competitors, economic conditions, technological advancements, and socio-cultural changes.

REFERENCES

Ahmed, Wasim. "Using Twitter as a Data Source: An Overview of Social Media Research Tools (2019)." *London School of Economics Blog.* June 18, 2019. https://blogs.lse.ac.uk/impactofsocialsciences/2019/06/18/using-twitter-as-a-data-source-an-overview-of-social-media-research-tools-2019/. Accessed March 9, 2020.

Barney, Jay. "Firm Resources and Sustained Competitive Advantage." *Journal of Management* 17.1 (1991): 99–120.

Barysevich, Aleh. "How to Create a Winning Social Listening Strategy for 2019." *Social Media Today.* October 30, 2018. https://www.socialmediatoday.com/news/how-to-create-a-winning-social-listening-strategy-for-2019/540862/. Accessed January 20, 2020.

Beaulac, Hugh. "How to Use Social Media for Market Research." *CXL Institute.* February 18, 2019. https://cxl.com/blog/social-media-market-research/. Accessed April 2, 2020.

Bilton, Chris. *Management and Creativity: From Creative Industries to Creative Management.* Malden, MA: Blackwell, 2007.

Butler, Adam. "Do Customers Really Care About Your Environmental Impact?" *Forbes.* November 21, 2018. https://www.forbes.com/sites/forbesnycouncil/2018/11/21/

do-customers-really-care-about-your-environmental-impact/#3a646ba4240d. Accessed November 11, 2019.

Chrisos, Marianne. "What is the Negative Impact of Mobile Technology on Business Communication." *Tech Funnel.* May 16, 2019. https://www.techfunnel.com/information-technology/what-is-the-negative-impact-of-mobile-tech-on-business-communications/. Accessed December 12, 2019.

Doerr, Patsy. "Four Ways Social Impact Will Affect Businesses in 2019." *Forbes.* January 14, 2018. https://www.forbes.com/sites/patsydoerr/2019/01/14/four-ways-social-impact-will-affect-businesses-in-2019/#57db06736e71. Accessed January 12, 2019.

Feiter, Jason. "The Amazon Whisperer." *Fast Company.* November 18, 2013. www.fast company.com/3021229/chaim-pikarski-the-amazon-whisperer. Accessed May 8, 2015.

Glassman, Jim. "Will Consumers Stop Spending?" *JP Morgan.* January 30, 2019. https://www.jpmorgan.com/commercial-banking/insights/will-consumers-stop-spending. Accessed March 14, 2020.

Lavoie, Andre. "3 Ways to Identify, and Fill, the Skills Gap in Your Workplace." *Entrepreneur.* March 26, 2017. https://www.entrepreneur.com/article/291098. Accessed November 12, 2019.

Nair, Ranjit. "Five Reasons Small Organizations Should Invest in Social Listening." *Entrepreneur.* April 15, 2019. https://www.entrepreneur.com/article/331791. Accessed January 17, 2019.

Perkins, Kathy Miller. "Assessing Organizational Culture Made Simple". *Forbes.* October 12, 2019. https://www.forbes.com/sites/kathymillerperkins/2019/10/12/assessing-organizational-culture-made-simple/#4304036634cc. Assessed April 13, 2020.

Schein, Edgar H. *Organizational Culture and Leadership.* San Francisco, CA: Jossey-Bass, 1985.

Stubbs, Anges Teh. "How to Use Retail Data Analysis to Boost Sales." *Software Advice.* April 24, 2018. https://www.softwareadvice.com/resources/retail-data-analysis-to-boost-sales/. Accessed January 12, 2020.

Researching current and potential customers

Chapter 4

This chapter will answer the following questions

- Why is writing an appropriate research **question** critical for obtaining the correct information?
- How should the research sample be determined and who should be asked to participate as research **participants?**
- What **quantitative descriptive** research methods are available to discover "what"?
- What **qualitative exploratory** research methods are available to provide insights as to "why"?

THE CHAPTER IN A FEW WORDS
- The organization must first understand the research process starting with formulating the question to analyzing the findings. The first step is writing a research **question** that will result in obtaining the needed information. Critical thinking skills will be needed so that the question is not based on assumptions.
- After writing the research question, the next issue will be what research **participants** should be used as subjects. Finding the participants for a statistically valid survey will

require probability sampling. Nonprobability sampling, including convenience, purposive, and snowball, will be used for exploratory research studies.

- If statistically valid results are required, **quantitative descriptive** methods, where every participant is presented with the same questions, will be used. A survey that can be distributed via email or posted on social media is challenging to write as the researcher will want to gather as much information as possible, but long surveys may not be completed by participants. Data mining and analytics can also be used to discover what behavior is engaged in by consumers while on social media or the organization's website.

- If the purpose of the research is to obtain insights as to why consumers act the way they do, **qualitative exploratory** methods such as interviews and focus groups can be used. While the findings from surveys will be numbers and percentages, the findings from interviews and surveys research will be recordings of conversations or written notes that are more challenging to analyze.

WRITING THE RESEARCH QUESTION

Social media research challenges and opportunities

One of the advantages of analyzing an organization's social media content is that it can provide answers to research questions that weren't asked. While online, current and potential customers are free to give any comments, opinions, or suggestions they feel inspired to provide. However, here are three challenges with using social media comments as the basis for research.

Not a representative sample: Most current and potential customers do not comment on social media. It is unknown whether those commenting represent the views of most customers.

Difficult to match with segments: It is difficult to attribute comments to particular customer segments. Therefore, the

organization does not know if their targeted group has a problem with the product.

Difficult to attribute to individuals: It is difficult to analyze trends using social media data. If negative comments are replaced by positive comments over a six-month period, it is impossible to know if customers have been made happier or if the positive comments are from a new group.

On the positive side, social media opens up new opportunities for research.

Find genuine product advocates: Organizations want to hear from people who are frequent users of their products so that feedback can be used for any needed improvements. Social media makes it easy to find and follow these individuals.

Get data from untapped markets: There may be groups using the product that would be unknown to the organization without social media. Once found these groups can be targeted with a promotional message.

Learn how people communicate: Social media allows the organization to hear what terms and language customers use when discussing the product. Messages can then use these same terms.

Poynter 2014 and Chahal 2017

QUESTION TO CONSIDER: How could we use social media sites to conduct research?

Because of a desire to find answers quickly it will be tempting for marketers to simply start asking questions without first understanding how writing the correct question, choosing the appropriate research method, and finding suitable research subjects will affect their ability to find the needed answers. This temptation should be resisted as the research will need to be redone if an inappropriate question is asked and the wrong method and subjects are chosen. Research methods can be divided into those that find factual information about consumers and their behavior and those that try to determine

why consumers engage in a behavior. Once the right question and method is chosen the right people to participate must be found. It is rarely the case where everyone of interest can be asked to participate in research. Instead a sample will be chosen from within a larger group based on factors such as age, gender, customer status, or geographic location. People are than chosen in such a way that the choice is random with no input from the researcher. This method is used when factual information is needed. When conducting research to determine why people engage in behavior another method is for the researcher to carefully select participants based on specific attributes such as interests, values, or lifestyle.

The research question—knowing what you need to know

While there will be many questions that can be researched, the marketers should keep in mind what has already been learned through conducting the internal and external environmental scan. For example, if the external environmental scan found the opportunity of a new customer segment to target, then the research question should focus on analyzing the preferences of these new potential customers. Likewise, if internal analysis revealed weakness of a lack of information on the pricing preference of current customers, then the research question will focus on learning the correct price level that will maximize purchases.

The first step to developing a research question is to determine what needs to be known that is not known now. The creative organization will probably be able to think of many information needs. If not, it is helpful to use the customer plus the marketing mix of product, price, distribution, and promotion as a guide. Starting with the customers, the organization may want to know what products they prefer and why they do so. They may want to know how consumers use the product once it is purchased. They may also want to know why some customers do not purchase the product. Instead of focusing on the customer, they may also write a research question that asks specific questions about the product, such as how consumers think it can be improved. Or, they may want to understand what price the consumer is willing to pay. The research question might also deal with distribution

by asking where and how consumers prefer to purchase the product. Finally, many research questions could be asked regarding the type of promotional message that should be used and the choice of communication method.

When deciding on the research question it is critical that it align with the goals of the organization (Smith 2020). It may be tempting to research an issue or problem simply because it is of interest to the researchers. This would be a waste of time and other resources. The findings that result from the study should be useful in reaching a business objective. If this is true, then it will be easier to get support for the research effort from other departments in the organization.

Writing the research question—not as easy as it seems

At first it may seem simple to write a research question. After all, there are many issues about which the organization will need information. However, a research question can be written that is so broad that the resulting data will be meaningless. For example, a research question might be written to ask if consumers buy jewelry. Because this question does not specify when they purchase, what type they purchase, and where they purchase, the results will only say yes or no to the question, which does not provide enough helpful information to develop a marketing strategy.

It is tempting to assume that the organization understands the most important information needed. Instead a process of critical thinking should be followed. Critical thinking can be thought of as a three-step process. The first step is identifying the pre-existing assumptions held by the organization regarding the cause of a problem. For example, a strategic planning process might have been undertaken because the organization's revenue has been declining. The organization might first make an assumption about the cause. They might assume that sales are down because the product price is too high. Therefore, a research question might be written to determine what price customers are willing to pay. However, a second step is to use internal research data to challenge whether these same assumptions are accurate and based on facts. For example, an analysis of sales data might reveal that higher priced items continue to sell well, but that the purchase of lower priced items

has declined. The third step before writing the research question is to explore new ideas for the actual source of the problem and its possible solution. For example, it might be hypothesized that lower priced items are not selling as well because they are perceived to have low quality. Using the information from the third step, an appropriate final research question can be written.

Sample research questions

- Why do people in our target market segment buy competing products?
- What benefits motivate young people to purchase our product?
- What media should be used to communicate our promotional message?
- What price would our customer find acceptable for our product?
- Do our customers prefer to purchase online or in person?

Technology and the research question—easy to ask but hard to get answered

Technology has provided researchers with an amazing ability to be in contact with consumers. Because people in most countries are now connecting with each other and organizations using mobile devices, research is both easier and harder to conduct (Shah 2018). Organizations now have the means of using email or social media sites to easily distribute their research questions. They can also use passive methods of research by mining all of the data collected on social media by consumers and analyzing how users are interacting with their websites.

All of this has made research easier. Less understood is how the ability to constantly be in contact has made it more difficult to get consumers to agree to engage in research. They may refuse to participate in research as they consider it an infringement of their privacy. A second reason for not participating in consumer research is that it is found to be too boring. People now expect to be entertained by all online content.

While organizations should use all the new methods of conducting research to get their questions answered, they must

also remember that for the above reasons it will be difficult to get the consumer to participate. As much time must be spent on considering the survey taking experience as writing the questions (Little 2018). Making the experience enjoyable, personable and meaningful can be done by having the survey format fit the personality of the organization. While the questions must be carefully worded, the introductory text and any visual elements should match the image and branding of the organizations.

THINK-ACT-PLAN: Research question

Think: Have you taken a survey recently? What research question do you believe was the reason for the survey?

Act: List five issues at your organization that could be the basis of a research question.

Plan: Write a research question that your organization needs answered.

CHOOSING PEOPLE TO PARTICIPATE IN RESEARCH

Hints for writing great research questions

When starting to write research questions it is best to follow a process. Using a stream of conscious approach will only result in more questions than can be asked.

First ask what: Defining what needs to be known will require prioritizing. Too many topics will be confusing to participants.

Then ask who: Only when the topic to research is deciding upon can you know who will need to be asked.

Now decide the method: The research method that will be used can only be chosen when the topic and the research subjects are known. The method must match the topic and encourage participation.

Time to write and test: Only now can the questions be written. Because of the earlier work, the questions should be easier to write. But be sure to test them on sample participants to ensure they are not confusing.

Lomas 2019

QUESTION TO CONSIDER: Why is it even more important to write questions clearly when distributing a survey online?

Once the research question has been written, the next step in the process is to determine who should be the research subjects. Depending on the question, the people asked to participate will need to be either current or potential customers. Creative or cultural organizations rarely do large-scale research studies of the general public. However, even a small survey can still be considered statistically valid if a sufficient number of people respond. To prove a fact without any doubt, everyone within the entire group must be surveyed. However, it is possible to prove a fact within a few percentage points of 100 percent certainty by surveying a sample of the total group. Fewer participants are involved in qualitative studies. Because the information obtained from each participant will greatly affect the findings, they must be carefully chosen using either convenience, purposive, or snowball methods.

Participants for surveys—you don't need as many as you might think

The first step in designing a statistically valid survey is to determine the population. In this usage the word population refers to the total number of people who are in the group being researched. Of course only a very large organization has the means to conduct a survey of the entire population, which is called a census, which will give an answer to a question with 100 percent certainty. Most organizations will settle for an answer that is 95 percent accurate, which means the true answer may vary 5 percent from the answer received. There are numerous websites that will provide this information. However, all that is necessary to understand is that the larger

the population the fewer the percent that needs to be researched to get a 95 percent accurate answer. For example, if the total population is 500, 200 participants need to respond to the survey. If the population is 1,000 the number of participants does not double but is 285. Only 350 participants are needed out of a total population of 3,000 for an answer with 95 percent accuracy.

The population may be current or potential customers but may also be defined by geographic limits, such as everyone in a certain region, city, or neighborhood. It can then be further defined by demographic considerations such as age, gender, ethnicity, education level, or family status. Another characteristic that might be useful to consider is psychographic, such as screening by values, attitude, or lifestyle.

If the researcher is not sure if the research subject falls into the population group, screening questions must be used. This screening will be conducted during the first questions asked on the survey, such as asking if the respondent is between the ages of 28 and 48 and has children living at home. If the participant responds negatively, the survey is ended; if they respond positively, the full survey is then conducted.

Probability sampling—everyone gets a chance to be asked

When a census of the population is conducted, everyone will be asked to participate. Because this can rarely be done, sampling is conducted. Sampling starts with deciding the population that should be considered as possible research participants. After all, asking people randomly to participate is a waste of time if what is needed is data from young males pursuing higher education. However, even the number of young males pursuing higher education may be too high to be able to survey them all. This difficulty in surveying everyone results from two reasons. First there is the problem of establishing contact with all the males. For privacy reasons, universities would probably not divulge this information. Even if the contact information could be obtained, if there are many universities in the area, there might be several thousand names on the list.

However, even if everyone could be reached, when populations are large, the organization may decide to limit the number of research participants to limit the costs of conducting the survey.

Sampling simply means that not everyone is asked. Of course, the issue then arises of how to choose whom to ask. The first decision is whether to use a probability or nonprobability method to choose the research participants. A probability sample is used so that there is the same probability of any single person in the population being chosen to participate. For example, the researchers might have a list of customers who have purchased in the past. A probability sample would be achieved by going down the list and including every other or, if the population is very large, every tenth name. If the organization wishes to conduct research where the answer can be stated to be proved within a certain percentage of certainty, probability sampling should be used with the needed number of responses obtained.

Probability sampling process

- Decide on the population to be surveyed.
- Determine the size of the population.
- Calculate the sample size.
- Choose the needed number of participants from the population using the random method.

Nonprobability sampling—you make the decision

Most research conducted by creative and cultural organizations will use nonprobability sampling, which means all members of the population do not have an equal chance of being chosen. This cannot be statistically valid. However, this does not mean that research participants are chosen without any consideration as to their ability to add value to the research findings. There are three main methods of nonprobability sampling, which are convenience, purposive, and snowball.

Convenience: Convenience sampling is a method where research subjects are chosen based on their willingness to participate. While using this method certainly makes the research process easier, it can also result in a biased sample that is not representative of the entire population. For example, if only customers who come into the store are surveyed about problems with the product, the results will be biased. People who have had negative experiences with the product are unlikely to return to the store.

However, there are situations when convenience sampling is an appropriate method. For example, if the population to be surveyed is parents who bring children to events at museums, attending a museum event and speaking with any parent who is willing to cooperate is acceptable. It is assumed that the responses from those not asked would be similar. Another example would be older people who attend gallery openings. Attending an opening should result in finding enough individuals who are there and are willing to participate. However, if there is no location where the needed type of research subject is found to congregate, using convenience sampling may not work.

Purposive: Another method of finding research participants is by purposive sampling. In this case, the first step is to develop a list of demographic and psychographic characteristics that potential research subjects should possess. After this list has been compiled, it is determined how these individuals can be found. For example, if the purposive sample identifies young people who are interested in animals, it could be that volunteers at the local animal shelter might be asked to be research subjects. If the sample requires people who are interested in literature, there might be a local book club that would have people who meet the profile. Once the organization has been identified, these individuals can be asked to participate.

Snowball: Sometimes it is difficult for the organization to find research participants because they are socially and economically very different from the researcher and other people in the organization. For example, a design firm might come up with a new accessory that would be of interest to people who ride high-powered motorcycles. The marketer could use the purposive method and approach a local motorcycle club but will probably not have much success. The researcher will be seen as someone from outside the group and, as a result, members of the group will have no motivation to participate. With the snowball method, one member of the group is approached and the reason for the research is explained. Perhaps additional motivation is supplied by stating those who participate in the research will be given free products. If the first person agrees, they will be asked to recruit someone else who will be interested. This second person will probably know one

more person who can be asked to participate. As a result the snowball will grow until there are enough research participants.

Nonprobability sampling methods

- *Convenience*: Find correct location, choose those most likely to participate.
- *Purposive*: Identify characteristics, find organization with subjects, and invite to participate.
- *Snowball*: Choose first based on profile, ask chosen participant to identify others.

Using technology to find research participants—find them online

Technology can be helpful in finding participants willing to provide information (Mastalerz 2017). The organization can use an existing customer database to find contact information on potential participants. Potential customers may have also provided contact information that was collected online when asking for information. The resulting list of current and potential customer email addresses can be used to send a link to a survey or a request to participate in an interview or focus group.

To request participation in a research study, an invitation can be posted using social media channels. An incentive for participation such as a gift or discount may be needed when a particular demographic or lifestyle group is needed for the research. An additional method is to use people on the organization's website or social media. To reach these participants a pop-up survey can be designed to ask short questions about the product while customers are online.

If these methods are insufficient, the organization may need to be more aggressive in finding participants (Sharon 2018). If it is known that the targeted potential customers congregate at a specific location, such as a coffee shop, college campus, or entertainment venue, the researcher can also go to these locations. Once onsite the researcher can engage individuals in conversation and then ask if they are willing to participate. This method works best if there is a product prototype to show or

demonstrate. Another idea for finding research participants is to host events for this purpose. Potential customers can be invited to a happy hour or other small gathering with entertainment, food, and drink. At this event they can be used as an informal focus group, interviewed individually, or given a survey. While this method takes money and time to hold the event, the organization is guaranteed participants who should be willing to participate.

THINK-ACT-PLAN: Research participants

Think: How do you choose whom you would ask for advice on what to do on a weekend? Do you need a statistically valid answer?

Act: Define the characteristics of those you choose when you need personal advice about a relationship. What sampling method would be appropriate?

Plan: Write a description of who will be included in your research and how they will be chosen.

USING QUANTITATIVE DESCRIPTIVE RESEARCH TO DISCOVER "WHAT"

Analysis of survey data is about more than just statistics

There are numerous sources of information on how to write survey questions. In fact many programs for developing online surveys will include tutorials on the subject. It is also easy to get statistics and percentages generated from an online survey platform. There is less information on how to analyze the data to determine what it means. Here is a process for successful analysis.

Put your preconceived ideas aside: It is very tempting to look for the answers you want, and by doing so, miss important facts.

Review the findings: Instead of immediately starting to generate overall total responses to questions, scroll through all the responses. This will give you a broader view of the range of results.

Look for future trends: After the overview, it is time to generate the totals. It is natural to look at the responses that ranked high, but keep an open mind, and eye, for the outlying responses. They can inform you of issues that could become more critical in the future.

Use statistical analysis: Your survey program can generate much more than just total number of responses and percentages. Learn how to use and understand cross tabulations as they can show relationships between answers.

Create visuals: Many people find it easier to understand numbers when they are in charts or graphs. They also provide a more dramatic effect if data is widely skewed in one direction.

Determine action: If all that is done with survey results is to analyze and report the findings, the survey has been a waste of time and money. Instead action based on the findings should be recommended.

Stillwagon 2017

QUESTION TO CONSIDER: What preconceived ideas might I bring when analyzing the data from a survey on why consumers purchase our product?

A survey is frequently used to answer factual questions. Because the questions will focus on a description of consumers and quantify their behavior it is often referred to as descriptive research. A survey asks factual questions that provide answers on who, what, where, and how. For example, a research question on who buys the product can be answered by writing survey questions that ask about age, gender, and income level. A research question on what they prefer to buy can be answered by writing survey questions that ask customers to rank different products that are available. In addition, where they buy can be

answered with a question that distinguishes between website purchases, craft fairs, or different store locations.

Survey method—the method everybody knows

When many people think of research, it is probably a survey that first comes to mind. A survey is a research method where all participants are asked the same questions with predetermined answers. While most survey questions will ask research subjects to choose from a list of possible answers, they can also include open-ended questions that allow respondents to answer in their own words.

While a survey can be conducted using paper forms distributed at retail stores or at an event, the increasing popularity of customer surveys is because they can be simple to administer online. All that is necessary are customer email addresses, which can be collected during purchase transactions. The research subjects then can be emailed a link that will take them directly to an online survey site.

The first step in writing a survey is to list any screening questions that might be necessary. Although research subjects will be chosen because they meet certain criteria such as a specific age group or past purchase history, there still might be individuals included who do not fit the profile criteria. Therefore, the first question should ask about demographic details such as age or gender. In addition, a screening question will confirm whether or not they have bought the product in the past during a specific period of time, such as a month, six months, or a year. The researchers may decide to exclude certain results based on the answers to the screening question. Or, they may decide to analyze the results separately.

For a survey to be successful, the right questions must be asked. In addition, the questions must be clearly written so that they are understood by the research participant without explanation. This might seem simple, but it is actually very challenging to write research questions so that all research participants will interpret them in the same way. The only way to confirm this is through testing the survey on people who are similar to the research participants who will be taking the survey.

In addition, to the survey questions, the suggested answers for multiple choice questions must be written. While it is quite easy for the researcher to write the question, such as asking why the participant does not buy a specific product, they may have no idea of the reasons they do not do so. For this reason it is best if a quantitative research survey is written only after a qualitative method, such as focus groups or interviews, has been used. This can give the researcher information on what possible answers to include. For example, the marketers' first possible answer might be that people do not purchase because of price. In reality, a focus group might have uncovered that people do not purchase because they are not aware of the product. If the wrong answers are included with the question, the time and effort spent in conducting the survey will be wasted.

Survey design—looks are important

The writers of a survey have two competing goals. One is to gather as much information as possible and the second is to get the participants to both start and complete the survey. Survey fatigue is a well-documented fact. As technology has made it easier to write and send out surveys, consumers may get one each time they share their email when making a purchase. As a result, consumers may not complete or even start survey forms.

While it is common to test survey questions with a few potential subjects to ensure they are understood correctly, usability testing of online surveys should also be conducted (Lauer, McLeod, and Blythe 2013). This testing will focus on how participants navigate their way through the survey noting when they tend to stop the process, thereby not completing the survey. Some of the factors that can affect completion include the most basic, such as the way the words look on the screen including font type, size, and color. The addition of visual components, such as images, can help to keep the participant engaged. Since the survey length is an issue, grouping the questions in sections that are clearly labeled can make a survey seem shorter. In addition, keeping any explanatory wording to a minimum can keep participants from stopping the process. While the technical aspects of writing an online survey are necessary to understand, just as important is the need to consider the visual details.

Distributing the survey—online or social media

If the research question focuses on current customers, then contacting research participants should be quite easy as the organization should have records of customers' email addresses or be able to connect with them on social media. This is one reason marketers should always try to collect contact information. If this contact information is tied into frequency of purchase, type of purchase, or both, the list of participants can be further refined. The survey can be distributed by sending a link to the form in an email asking for participation.

Surveys can also be distributed using social media. Short surveys can be posted directly on social networking sites, such as Facebook, using the poll function. This function will provide a template for writing the questions and answers. The survey will need to be short as 52 percent of users will not complete a survey that takes over three minutes to complete. It has been found that 80 percent of social media users have not completed a survey that they started (Messler 2019). To make the survey more appealing photos or images can be added. A survey sent out via Twitter has to be even shorter. Usually a single clearly written question is used. People on Twitter are not going to take the time to respond to any lengthy inquiries. Instagram can also be used for posting single questions. This method starts with an image to which a question is attached, such as for a color preference. The image must be able to catch the attention as viewers will be quickly scrolling through images.

Data mining—digging for gold

Data mining is the process of analyzing large amounts of online information to discover patterns in consumer behavior. The data already exists and can be examined for past behavior to predict future behavior. For example, an online merchant that ships thousands of packages to customers has information on what was purchased by each individual. In addition, the business will know when it was purchased. Examining this data using sophisticated software tools will allow the business to provide product and promotion information specifically tailored to each individual.

Data mining searches online behavior to provide information on people's attitudes and preferences. Data mining can provide information about consumer trends by searching databases for

patterns that may not be easily discernable while analytics is studying the public's use of the organization's social media to make product, pricing, and promotion decisions.

One issue of which the organization must be aware is that consumers are increasingly concerned about the collection of online information on their purchase history. While data mining and other techniques can be used to improve products, the organization must follow guidelines so that the consumer is comfortable with the process. First, the consumer should have the choice of having past purchases not used to result in suggested new purchases. If customers are willing to have their data used in this way, they should be provided with a benefit, such as a discount on purchases.

First, a general question, such as why purchases for products varies over time is asked. Then the data sources, such as the organization's product sales base, are searched. This data is then processed or cleaned so that the elements are similar. Once this is done, the data can then be searched using algorithms for relevant patterns. For example, data mining might find that sales increase on the three days following the release of promotional material. This lets the organization know that the promotion has been successful.

Analytics—what they do on your website

What is unique about insights from social media is that they can be used to define market segments based on behavior. In the past it was necessary to conduct research asking individual participants about what motivated purchase. Now, consumers provide this information freely online. The problem is how to organize and analyze the data. Analytics can involve using sophisticated and expensive software. However, if the organization only wishes to analyze its own media sites, Google analytics can be used to great advantage. For example, if the organization is selling products online, the e-commerce data can be analyzed for information on user conversion. It can measure where a consumer entered the site, the landing page, how long they stayed on other pages they looked at, and what they were on before they purchased.

Organizations that use their social media to build awareness and promote engagement can also use analytics, which is

also measured from data on behavior. When using analytics, organizations should first establish goals for what they wish to achieve on their social media site. If the site has e-commerce, then the goal would obviously be purchase of a product. However, it might also be smaller actions that demonstrate engagement such as signing up for an email update on new product releases or adding comments on product usage. These are steps that can eventually lead to purchase. Analytics can help the organization understand what information on the website caused the user to sign up or post. Through this understanding, the organization can then change the information in a way that encourages even more users to take these actions.

There is a simple formula to follow when using analytics. Simply noting what has happened online is not a good use of the information. Instead the information is meant to be used to make business decisions. Therefore, the organization must, first, analyze the analytic reports so that they can better understand their customers' online behavior. Second, the organization should then change the social media site so that more of the wanted behavior occurs. For example, it may be noticed that after watching video clips online, users then click on the link stating where the product can be purchased. It can be assumed that seeing the product demonstrated in the video increases interest to the point where the user wants to know if they can buy it conveniently. If the desired outcome of the social media site is to get more people into stores, it can be assumed that videos motivate this behavior. To test this assumption, more videos can be added and the analytics checked again to see if even more users are clicking on the purchase location link.

Google analytics has become very sophisticated in tracking attribution, which is what actions the user took before they completed the desired goal, such as purchase of a product. The organization needs to understand how all the marketing efforts worked together to prompt this action. For example, it might be site visitors, who create accounts, browse extensively, or read product reviews, who are more likely to eventually purchase the product. By understanding the cost to the organization of providing the information versus the likelihood that it will result in conversion helps to design cost-effective online marketing.

USING QUALITATIVE EXPLORATORY RESEARCH TO DISCOVER "WHY"

Online or in-person—which type of focus group is best?

Technology has affected the way we do research. As focus groups using online communities are conducted more frequently, they have gained legitimacy. Here are some of the reasons why researchers prefer using technology to obtain information using already existing online communities rather than bringing people together in the same room.

Easier to organize: They do not require a moderator or the travel of participants to a specific location. People can participate from the comfort of their home or local coffee shop.

Everyone gets a voice: In-person focus groups can be dominated by a strong personality. Even when this does not happen, some people are slower to respond and their voices might not be heard. This is less likely to happen online.

Real time data: The online community focus group participants don't need to recall data. Instead they can use their phones or tablets to see data in real time.

However, there are still advocates for the traditional in-person focus groups. They point out these strengths.

Going deep: A skilled moderator can keep the conversation focused on a single issue and by doing so can uncover deeper insights.

More than just words: A moderator can use visual and auditory cues to obtain information. People communicate much of their meaning in ways other than the literal words. Their tone of voice, loudness, eye contact, and sitting posture adds richness to the findings.

Selection of participants: While in-person focus groups are limited in the number of participants who can be involved, the participants can be screened and selected to provide the needed information.

Andreano 2019

QUESTION TO CONSIDER: What online community could I use as the basis for a focus group?

Qualitative exploratory research methods are used to determine answers to questions on attitudes and motivation that can't be answered simply with a yes or no response. For example, exploratory research may be used to better understand the motivation that causes consumers to purchase the organization's product. Such research questions are not easy to answer as the research subjects may need time to consider the reasons for their behavior. Although more difficult to administer, qualitative research can provide insights that will lead to product improvement, better promotion methods, and new product development.

While the most common research method for quantitative descriptive research is the survey, there are more qualitative exploratory research methods including interviews and focus groups. While descriptive research is easier to conduct, exploratory research is used more frequently by marketing departments in creative and cultural organizations.

Interviews—in person and personal

If the creative or cultural organization has little knowledge of what benefits people want in a future product or how people are using a current product, one exploratory research method of getting these answers is by conducting several in-depth interviews. Each interview will usually take 30 to 60 minutes, which allows the researcher to probe in-depth questions on issues such as consumer motivation. Interviews are best used when decisions that will require a large financial investment, such as introducing a new product, are being considered. The interview format allows follow-up questions to ensure that the reasons for giving an answer is understood. The process provides quality of information over quantity. Surveys are not always reliable as participants may not take time to consider their responses (Kenny 2019). A skilled interview will probe beyond this first response.

The interviewer will start the interview with a few prepared questions that will be asked of each participant. However, individualized follow-up questions will be asked to probe more deeply into the responses. As a result the findings from each interview will be unique. Part of the skill of the interviewer is to analyze the findings for overall themes and also unique ideas.

Because an interview will take a significant length of time to conduct, fewer participants will be involved than when conducting a survey. Because there are fewer participants, it is critical that each be chosen carefully so that the time devoted to the interview is not wasted. Interview participants should be chosen to reflect the demographic, geographic, and psychographic characteristics of the population being studied. Second, they should be chosen so that they have both the necessary knowledge and an interest in participating. Because an interview is rarely considered a fun activity by participants it may be necessary to use an incentive such as a sample product in order to obtain participation. While the incentive should be valuable enough to motivate participation, it should not be so valuable so that a research subject is participating only to receive the incentive. In this situation, they will probably not provide thoughtful answers.

Intercept interviews—quick and easy

Intercept interviews are conducted in person and consist of two or three short open-ended questions that are easily answered. Intercept interviews are best used when the researcher needs to confirm a fact but also wants an opportunity to ask a follow-up question, which cannot happen in a survey. Intercept interviews can be used informally with current customers simply by asking, in a conversational manner, why the customer came to the store and their opinion of the product. The reason why this is a research technique and not just a conversation, is that the answers are recorded along with any relevant demographic or other data.

Finding participants for intercept interviews starts with determining the location where they can be found. This could be at an event, in the organization's own store, or at another public location. Once the location is determined, easily identifiable demographic characteristics need to be determined such as age, gender, ethnicity, and family status. When choosing participants, these traits can be assumed based on physical evidence. If this is not possible the potential participant may be asked. It is more difficult to determine psychographic characteristics such as lifestyle or attitude. Therefore, to determine if the potential participant has a specific interest, such as extreme sports or environmentalism, a screening question can be asked at the beginning of the intercept interview.

Intercept interviews are useful in situations where the consumer may not respond to a survey form. The behavior, such as buying a product that they frequently purchase, will not be intensive enough to prompt them to respond to a survey form that they receive later. In addition, because the behavior is routine, they may not remember their earlier motivation.

Focus group—everyone together

Focus groups are useful in conducting exploratory research on consumers. Focus groups are particularly helpful in uncovering motivation or behavior of which the participants may not be aware without prompting. The research is conducted by a moderator with a group of people, usually eight to ten, who share specific characteristics. The research is designed not to

provide statistically valid answers to research questions but, rather, insights on how current and potential customers think and the motivation for their behavior. Focus group participants are chosen based on both their psychographic similarities and knowledge of the issue being researched.

When conducting survey research each participant responds to the same set of questions. Although focus groups may start with the same questions, the information that results from each group will be unique. This is because focus groups rely on group dynamics. While the moderator will prepare and ask specific questions, the follow-up questions will depend on the issues raised by the participants. This more loosely structured format should prompt both conversation and questioning between the participants. Participants are more likely to respond to each other than the moderator, particularly if they have psychographic traits in common.

As a result, the findings from focus groups cannot be projected on to the population as a whole. Focus groups are most useful in the beginning of the research process for generating and exploring ideas. However, an idea generated in a focus group can then be used as the basis of a survey to confirm if indeed the idea can be projected on to the entire research population.

With permission from the participants, the focus group moderator records the session. The transcribed notes are then analyzed both for repeated themes and also for outlier opinions. The findings from focus groups can be helpful not only in improving existing products but also with designing new products. It is the skill of the moderator conducting the focus group and the researcher analyzing what was said that can lead to creative insights that are impossible to obtain with any other research method.

Focus groups can also be conducted online as long as the participants are comfortable using technology to express their views. Online focus groups follow the same format as those held in person expect that two-way video communication is used. While voice only can be used, most people will feel more engaged if they can see their fellow participants. Conducting a focus group online saves participants the time and inconvenience of travelling to a central location. Instead

of a single focus group session, the researcher may create an online community for research purposes (Schram 2018). An online community is used to gather feedback on an ongoing basis rather than in a single focus group session. Such communities are useful in gathering ideas during the product development process.

Recruiting for both types of groups can be challenging. People may be reluctant because they are too busy to participate. They may also have privacy concerns as they will be videoed. To help recruit participants the purpose of the research should be explained so that they know how their comments and insights will be used by the organization. The potential participants should be treated as a future colleague and team member, rather than an anonymous research subject. Participants should also be informed that they will be provided with a summary of the research results. After all, there would be no research without their cooperation.

Analyzing the data from qualitative research—more art than science

Unlike survey results, exploratory techniques do not result in numbers that can be compared, contrasted, and turned into easily understood percentages. Instead the data will be in words, notes, and images. These require a different system for analysis. First, any interviews or focus group discussions should have been recorded. By doing so the person conducting the research is free to question and listen without the necessity of taking notes. Once the research is concluded there is no need to type a complete transcript of the recordings. Instead while listening to the recording, notes of the main points being communicated should be typed. These notes are then reviewed for common themes. For example, the notes from a focus group on why consumers do not buy a product may show many different responses. However, an analysis may find that three themes are common among all the participants. If all mention unfamiliarity with how the product can be used, cost of the product, and inconvenient purchase location, these issues should be addressed. However, if only one or two participants mention they are unhappy with the product design, this issue can be ignored.

Creating the strategic marketing plan

You are now ready to add a research plan to your marketing plan. This plan should include a research question, a description of the research subjects, and the method of conducting the research. While it is always best to conduct research at this stage in the process, you may need to finish writing the marketing plan before conducting the research due to time constraints.

REFERENCES

Andreano, Roberto. "Online Communities vs. Online Focus Groups." *Further.* May 20, 2019. https://info.go-further.co/furthermore/online-communities-vs-online-focus-groups. Accessed November 22, 2019.

Chahal, Mindi. "The Future of Social Insight." *Marketing Week.* February 22, 2017. https://www.marketingweek.com/future-social-insight/. Accessed December 8, 2019.

Kenny, Graham. "Customer Surveys are No Substitute for Actually Talking to Customers." *Harvard Business Review.* January 17, 2019. https://hbr.org/2019/01/customers-surveys-are-no-substitute-for-actually-talking-to-customers. Accessed January 2, 2020.

Lauer, Claire, Michael McLeod, and Stuart Blythe. "Online Survey Design and Development: A Janus-Faced Approach." *Written Communication* 30.3 (2013): 330–357.

Little, Ali. "Pollpass: Why We're Changing the Survey Taking Experience." *Global Web Index*. October 17, 2018. https://blog.globalwebindex.com/ thought-leadership/pollpass/. Accessed November 8, 2019.

Lomas, Fiona. "How to Write Great Research Questions." *Smart Insights*. October 28, 2019. https://www.smartinsights.com/marketplace-analysis/ customer-analysis/how-to-write-research-questions/. Accessed December 15, 2019.

Mastalerz, Ania. "DIY Recruiting: How to Find Participants for Your Research." *Medium.com*. November 21, 2017. https://medium.com/mixed-methods/diy-recruiting-how-to-find-participants-for-your-research-6f9a05dd1a33. Accessed August 13, 2019.

Messler, Meaghan. "How to Use Surveys on Social Media." *Business2Community*. April 4, 2019. https://www.business2community. com/social-media/how-to-use-surveys-on-social-media-02185694. Accessed December 2, 2019.

Poynter, Ray. "Why Has Social Media Analytics Met with Limited Success in Market Research?" *GreenBook RSS*. GreenBook. April 25, 2014. www. greenbookblog.org/ 2014/04/25/why-has-social-media-analytics-met-with-limited-success-in-market-research. Accessed April 8, 2015.

Schram, Maxim. "Market Research: Online Community vs. Focus Group." *CMNTY Blog*. June 16, 2018. https://www.cmnty.com/blog/ online-research-community-vs-focus-groups/.

Shah, Jasal. "The Impact of Technology on Market Research." *Entrepreneur*. September 26, 2018. https://www.entrepreneur.com/article/320708. Accessed October 8, 2019.

Sharon, Tomer. "43 Ways to Find Participants for Research." *Medium. com*. March 3, 2018. https://medium.com/@tsharon/43-ways-to-find-participants-for-research-ba4ddcc2255b. Accessed August 20, 2019.

Smith, Scott. "How to Define Your Research Question." *Qualtrics*. January 14, 2020. https://www.qualtrics.com/blog/research-problem/. Accessed March 10, 2020.

Stillwagon, Amanda. "How to Analyze and Interpret Survey Results." *Small Business Trends*. December 16, 2017. https://smallbiztrends. com/2014/11/how-to-interpret-survey-results.html. Accessed March 7, 2020.

Establishing strategic goals

Chapter 5

This chapter will answer the following questions

- What is the process of determining the organization's future marketing **strategic plan?**
- How is a **SWOT** analysis used to make sense of the organization's internal resources, external environmental factors, and consumer research findings?
- Why is determining the organization's **competitive advantage** critical to success?
- How are strategic actionable **goals and objectives** developed?

STRATEGIC PLANNING PROCESS

With strategic planning one size does not fit all

There are different processes that can be used by organizations to develop strategic plans. Too often organizations think that a complex process is needed which is not the case. The process chosen depends on the number of people involved and the contentiousness of the issues faced by the organization. Many cultural and creative organizations are small but because they are mission focused even a small issue can be contentious!

Few people/non-contentious issue: In a small organization with a non-contentious issue to resolve, the strategic decisions can be handled with what are commonly called hallway meetings. In other words, get-togethers can be held when and where people gather. There can be less formality because everyone already knows and trusts each other.

Few people/contentious issue: However, even in a small organization, if the issue to resolve is contentious, then a task force should be created. The members of the task force spend their time resolving the matter with others in the organization by negotiating one to one.

Many people/non-contentious issue: In this case a formal meeting including everyone should be held. Since the issue is non-contentious, there is no need for negotiating. A meeting where the issue and its resolution is explained is all that should be needed.

Many people/contentious issue: Strategic conversations are called for in this situation. Many small group meetings will need to be held to assure that everyone's voice is heard and that all remaining issues are resolved.

Strategic planning takes time and effort because it is necessary to get everyone on board with the new plan if it is to be successful.

Beinhocker and Kaplan 2002

QUESTION TO CONSIDER: Which of the tools listed above will need to be used in my organization?

Planning is a part of everyday life that often goes unnoticed. Few people would start a two-week holiday without a plan of where they wished to go and how to get there. If they did so, the chances of something going wrong are very great. The traveler might bring the wrong clothes and, as a result, either freeze or swelter, or they may not have the correct visa and, as a result, be denied entry into a country. A lack of financial planning may result in them running out of money. Of course, if one is young with no obligations, these occurrences might seem an adventure. However, if someone is responsible for the marketing

of an organization, not having a plan can mean that the organization ceases to exist. This is a risk that cannot be taken.

The increasing use of technology in marketing promotion has led some to believe that there is no need for planning. All that is needed is the next clever Instagram campaign. The opposite is true (McDuffee 2014). Social media and other communication technologies are tools, not strategies. Tools are what are used to accomplish a goal, not the goal itself. The basics of business—an exchange to something of value between a buyer and a seller—have not changed since commerce first started in Mesopotamia (Harford 2017).

Rationale for strategic marketing planning—it's not just "busy" work

There are several reasons why it is worthwhile to put time and effort into developing a strategic marketing plan. First, it allows the organization to take stock of its purpose by writing or reviewing its organizational mission, vision, and values. It might be that these statements no longer fit what the organization has become and need to be revised. Or it may be that the organization has veered from its true purpose and must again focus on its mission.

Second, marketing strategic planning provides the opportunity to consider if the people in the organization are being used to their best capacity. Creative and cultural organizations exist because of the talents of the people who create the product. If these individuals do not feel that their talents are being utilized, they may decide to take their talents elsewhere.

Third, it is a means of igniting the excitement with which the organization was originally launched. Over time, the organization may have become focused only on bringing in sufficient revenue by selling products. While this is necessary, there was most likely a larger mission, vision, and values that fueled the excitement of the initial start-up phase of the organization. This energy can be reignited by developing and implementing a new strategic plan.

It is estimated that by 2021 there will be 3.1 billion social network users along with each global user spending 136 minutes online (Prahalad and Ananthanarayanan 2020). It is therefore

understandable that more marketing effort and money is going into social media marketing. However social media marketing must be developed and implemented the same as all other marketing plan components.

Getting started with the process—the first step is the most critical

At this point in time, the marketer will know the mission, vision, and values of the organization. They will have conducted an internal analysis of their financial position, their available human resources, and organizational culture. They will have also conducted an external environmental scan of competitors, economic forces, technological developments, and socio-cultural changes. In addition, they will have data from conducting consumer research. All of this information needs to be analyzed to develop the new marketing strategy. When completed, a strategic plan will answer specific questions that will guide the future of the organization.

Guiding question

- *Mission*: Who are we and what are our values?
- *Internal analysis*: What resources do we have?
- *External analysis*: How will what is happening in the world affect us?
- *Goals*: What do we want to achieve?
- *Objectives*: How will we ensure the achievement?
- *Tasks*: What specific steps will need to be taken and by whom?

In the past, it was not uncommon for top management to write the strategic plan. Once it was done, it was then distributed to everyone in the organization. This process was followed because it was believed that only management had the ability to decide the current mission and future direction of the organization. The role of marketing was limited to providing ideas to management on how to promote and sell the product. Finance was only expected to provide financial records so they could assess available resources. The operations department of the organization that actually produced the product was also not

involved in the planning process. They were simply expected to achieve the strategic goals developed by management.

However, it is now understood that this process does not work. This is particularly true in a creative or cultural organization, where marketing's role expands from not only selling and promoting the creative product to customers but also selling and promoting the mission, vision, and values of the organization to the public. Therefore, it is appropriate that marketing takes a lead role in the strategic planning process. In addition, because every decision has a financial implication, people who handle the finances of the company should participate in developing the strategic goals. Finance people can also be creative in suggesting ways that various ideas can be funded. Especially in a creative and cultural organization, the creative workers are not at the bottom of the organizational chart. Rather, they are at the center of the organization and are the key to its mission and future success. As a result they must be closely involved in developing the strategic plan. Now when developing strategy, management no longer makes the decisions but rather manages the process whereby the decisions are made.

If all the employees of the organization are going to work together to determine strategic goals, then having them involved in the initial stages of gathering and analyzing data will help them feel more competent to do so. In addition, having all employees involved in the entire process will result in more willingness to implement the strategic plan as they have felt part of the process and will, therefore, have less reason to offer resistance.

If because of distance all employees cannot be involved in the initial strategic planning steps of conducting the internal analysis and external environmental scan, the information obtained needs to be organized and provided to everyone in the organization. After the information has been provided, the employees should be given time to digest the information before starting to determine strategic goals and the necessary objectives. This can be done by having a short planning session devoted to the strategic plan (Davis 2017). Employees can be divided into small teams and each given the opportunity to suggest a specific strategy goal. Using poster board, markers, and any other visual aid they prefer, they will

then present the goal and the objectives for its implementation to the other employees.

Four-step process—from thought to action

Once the basics of strategic planning are understood, it is useful to have a roadmap through the process. One method to do so is to think of the process in the four steps or phases of analyzing, strategizing, prioritizing, and implementing.

Analyzing. During the analysis stage, the organization's employees take a step back to consider their relationship to customers, competitors, and the community. Using the information obtained through scanning and research, the organization should brainstorm to determine the issues that the organization is currently facing. These will deal not only with the financial position of the firm but also with its relationships with other stakeholders such as their community, suppliers, retailers, and customers. Once brainstorming has been completed, the organization employees should analyze industry and marketing data that was obtained through secondary research. This analysis may well bring new issues to light that were not considered previously. Any customer feedback will be reviewed to determine any problems with the product. Employee input is also valuable as they will be able to provide insights based on their area of responsibility and expertise.

Strategizing. Once all the data on the organization's situation is gathered, the organization is ready to move to the next phase, which is to develop their strategy. As a first step the mission, vision, and value statements are reviewed. Based on the information from all sources gathered during the analysis stage and using a SWOT analysis, the organization's competitive advantage is determined. At this stage in the process, everyone should understand and agree with what makes their product unique, or its unique selling proposition or USP. It is a lack of understanding of why a consumer would buy the product versus a competitor's that is the reason that marketing plans fail (Talbot 2018). With this understanding the organization is now ready to write their strategic goals and objectives.

Prioritizing. As there may be numerous goals that could be pursued, it is essential that the organization set priorities. Trying to accomplish too much with limited resources of time, money,

and people will ensure that all the goals fail. Once the strategic goal is decided, the organization must use the objectives to set performance indicators. It is not enough to simply state that sales must be improved, new products developed, or customer satisfaction increased. A quantifiable indicator must be set so that the organization will know when it has been successful. For example, a performance indicator would be that sales will increase by 10 percent, one new product will be introduced each year, or customer complaints will be cut in half. A further task at this step in the process is to develop a budget. Achieving most goals will require additional resources, which will cost money. For example, if new product development is a goal, either a new employee will need to be hired to do so, or a current employee given the task. If a current employee is given the task, then someone else may need to be hired to perform their existing work responsibilities.

Implementing. Lastly, the strategic plan must be implemented. This will involve a rollout of the plan to employees to generate enthusiasm and acceptance. A calendar of goal, objective, and task completion must be developed so that everyone is kept on track. Quarterly progress on performance indicators should be monitored so as to ensure the plan's success. If the indicators are not being achieved, then adjustments to the plan should be made. Finally the plan should be reviewed each year to update the goals, objectives, and tasks where necessary.

THINK-ACT-PLAN: Making a goal

Think: How do you plan your day? Do you put conscious thought into what you hope to achieve? Do you assess at the end of the day what was accomplished? If you do not plan your day, how will you do so as part of your job?

Act: Write down a personal goal you would like to achieve. What information is needed to make this goal a reality? How could friends or family be involved to ensure that you achieve the goal?

Plan: Write a short paragraph on how the organization for which you are writing a marketing plan can involve employees in the process.

Establishing strategic goals

Strategy: everything is not new

The world is changing so fast it might seem that every aspect of running an organization must be reinvented. However this is not the case. While the technological and social environments are undergoing rapid innovation and change, they are simply the continuation of already existing trends. Because it is the responsibility of the marketing department to scan and analyze the external environment, they have a critical part to play in helping others in the organization understand what seems to be brand new has already happened in the past. Here are three ongoing trends that will affect the development of a strategic plan:

Technologically innovation: There has always been innovation. Tools have always been invented that helped the organization produce and market a product. The tool in the past was a physical tool and now it is digital. How it can be used in the organization to help it reach its goal is the same question.

Organizational virtualization: When business began, small businesses handled all aspects of production from finding raw materials to sales. As organizations grew they found that outsourcing aspects of production helped them to achieve their goals. Now we have moved to an organizational structure where competing businesses will sometimes collaborate on goals rather than compete.

Customer focus: When the selection of products was limited, the customer bought what was available. When more goods were available than could be purchased, marketing was used to inform consumers. Now the customer informs the company what they want to be produced.

Girzadas 2019

QUESTION TO CONSIDER: Which of these trends are affecting my organization?

To prepare a strategic marketing plan, the organization must first write their mission, vision, and value statements upon which all decisions will be guided. Second, they must determine their financial and human internal resources and also analyze their organizational culture. Third, they must examine the external environment including economic, technological, socio-cultural, and customer aspects. Finally, if needed, consumer research may be conducted. As a result, the organization will have a large amount of data to use.

Data, information, knowledge, wisdom—what's the difference

Data is a set of unorganized signals, words, facts, and numbers without any analysis, and, therefore, without meaning (Figueroa 2019). Information is created when data is analyzed, and its meaning for the specific organization is understood. The analysis involved asking questions such as what, when, and who to find patterns within the data. Knowledge is when a person can use this information to plan future action. Wisdom results when the organization has a deep understanding of the implications of their actions to both the organization and the public.

A SWOT analysis is a tool for organizing the data obtained through scanning and research into information that will then result in knowledge of what actions can be taken and the wisdom to make the right choice. For example, the fact that a new technology for processing payments has been developed is interesting but has no meaning. Information is needed on how this technology is being accepted by consumers. With this information, the organization then has the knowledge needed to decide whether to adopt the technology for use by its customers. Wisdom would be considering the question of what would happen if the new technology fails. If the process had stopped at having the data that the new system was introduced, the organization might purchase the system, which would be a waste of money if it is not desired by their customers and adversely affect profits if it fails.

From data to knowledge

- *Data*: Facts obtained by scanning and research.
- *Information:* Meaning of the facts to the organization.

- *Knowledge*: How the organization should use the information.
- *Wisdom*: Understanding the implications of the action.

Conducting the SWOT—making sense of it all

Some of the information for the SWOT analysis will have been obtained during the internal analysis. For example, there should now be a clear understanding of the amount of funds available for implementing a new strategy. The organization will also know the skills of its employees. In addition, it will have found if the organizational culture will need to change before any new strategy is implemented. Likewise, the information on the external forces, including economic, technological, and socio-cultural, will have been gathered. The economic information is needed as it will affect the pricing strategy. Technological changes in society will affect distribution and promotion, while the socio-cultural preferences will affect the benefits desired in products. In addition, the organization will have information on current and potential customers from conducting research. It is now time to analyze all the information so as to determine if they are internal strengths or weaknesses or external opportunities or threats.

When considering internal strengths and weaknesses, only those of the organization are analyzed when developing a strategic plan. However it can be useful when analyzing external opportunities and threats to also consider the strengths and weaknesses of competitors as these can be the source of a competitive advantage (Brandenburger 2019). For example small organizations can often use the strength of larger competitors against them. A small organization is able to focus on a personal relationship with customers. While large organizations can send out Tweets to thousands, small organizations can respond personally.

Strengths: Organizational strengths, such as people, money, skills, and unique products, are internal to the company. It might be tempting to state that all aspects of the organization are strengths. However, even if this fact was true, it would not be helpful. Some features of the organization will be stronger than others, and it is on these factors that the marketing strategy will be based. For example one strength might be the financial

position of the company, which would include not only current funds but also access to future funding. Of course, the talents of the creative employees would be an organizational strength. If members of the organization have specific skills in marketing or financial management, these are also strengths. The geographic location of the organization might be a strength if it is located where many potential customers live. Sometimes it is a strength if the organization is located in an area with low rents and taxes, even if the customers live elsewhere. Other organizational strengths would be access to suppliers for raw materials and access to distribution methods for the finished product. It can be difficult for those in the organization to see the strengths as they may be taken for granted. It could be useful to bring in someone who knows the organization, and yet is not intimately involved, to provide perspective.

Weaknesses: An organization's weakness may be the opposite of its strengths, for instance, a lack of creative staff or access to a means of distribution. However, there may be other factors whose absence may be a weakness. For example, a cultural analysis might have uncovered that members of the organization are reluctant to make changes even if necessary to ensure survival. While the organization's product may be a strength, a lack of any other products to diversify sales would be a weakness. A lack of knowledge, such as having no idea of what legal issues the organization may face in terms of liability or taxes, may be a weakness.

Opportunities: While strengths and weaknesses are internal to the company, opportunities and threats are uncovered in the external environmental scan. It may be difficult at first to determine if an opportunity is relevant to the organization. Therefore this should not be a consideration at this stage in the process. Instead, all opportunities that may in any way be relevant should be listed.

For example, a strong economy could be an opportunity as it means that potential customers have disposable income to spend. If the organization's product faces little competition in the market, this might also be an opportunity. A technological advancement of which the organization might or might not take advantage should still be listed as an opportunity at this stage. Many socio-cultural

changes, such as interest in new lifestyles and new social causes of which potential customers have become concerned, can be opportunities. For example, if living in smaller houses is becoming the norm, then there is an opportunity for products that fit confined spaces. If people are living in smaller urban spaces, performance-based companies may use this as an opportunity as it will mean that people are entertaining more outside the home. Demographic changes may also bring opportunities. If there are many older people in a community, there is an opportunity to target them as a new consumer segment.

Threats: Any of the positive changes mentioned above can also be a threat. For example, if the product produced by the organization is large scale and smaller homes are becoming the norm, this would be a threat. Expensive technology that cannot be afforded would also be a threat. An increase in the cost of raw materials would definitely be a threat as it would mean an increase in the cost of the product. Another threat that might be uncovered could be the entrance into the marketplace of a new competitor. New government regulations such as product licensing or taxes would both be threats as they would affect how the organization conducts its business and increase costs.

One method of dealing with a large volume of strengths, weaknesses, opportunities, and threats that result from conducting a SWOT analysis is to consider their effect on the organization. At this stage in the SWOT process it is necessary to determine which of the listings that while true, may not affect the organization. For example, the issue of increased use of online shopping may be listed as a threat to an organization that sells handcrafted jewelry. However, if it only sells at craft fairs, the online threat may be irrelevant. On the other hand, an opportunity that might be listed, such as the popularity of bright colors, might be seen as irrelevant as the company only produces prints in neutral colors. However, a creative insight might be that it is now time to introduce prints by artists who create in bright colors to take advantage of this trend.

Using this method of commenting on each of the listings of strengths, weaknesses, opportunities, and threats should help to determine their relevance to the organization. Using this method, the number of items listed should be cut. This will allow the

organization to prioritize when it comes to developing a single competitive advantage and marketing goal.

Matching strengths with opportunities—putting the internal together with the external

It is not enough to simply list and comment on strengths, weaknesses, opportunities, and threats. The purpose of the lists and comments is to provide a means to decide upon the organization's marketing strategy. To do so the organization must first examine its internal weaknesses and external threats to determine if they are relevant to the mission of the organization. If the product is costly because it depends on individual craftsmanship, this would not be a weakness if the environmental scan found that the economy is strong and that potential customers had disposable income to spend. The organization's strategy might then be to produce the best quality product possible, targeted at individuals with high incomes. External threats may also not be relevant if they do not affect how the organization produces its product or conducts business. For example, increased cost of rent for storefronts may simply confirm the organization's initial decision to distribute only online or at events.

However, looking at external opportunities to find ones that can be exploited by using the organization's internal strengths is crucial to the development of a new marketing strategy. For example, an opportunity that was listed might be the fact that many people are buying large flat screen televisions that they are hanging on the wall. If an organization's strength is that they produce digital art, there is a match, and a strategy might be developed to market digital art that can be displayed on the blank screens hanging on walls.

Problems with performing a SWOT—not the answer, just a tool to find the answer

The SWOT analysis is a popular business tool for decision-making as it is easy to understand and conduct. Rather than just relying on assumptions when making strategic decisions, it requires the organization to review the internal resources of the organization and forces in the external environment. However, there are two problems that can result when organizations use

the SWOT tool: relying only on the SWOT and having too much information to turn into actionable goals.

The SWOT is only a tool and not a predictor of success. The results of the SWOT analysis should be combined with creative insights from the employees of the organization. While tools are useful, it is these strategic insights that might be the reason for the success of a company. Using a SWOT analysis too rigidly is inappropriate. Instead, the SWOT analysis should be thought of as a way to guide the organization through a process of decision-making.

A second issue with the SWOT analysis is that the organization can develop an overly long list of strengths and weaknesses. As a result, they have difficulty determining their competitive advantage. They may also uncover so many weaknesses that they may believe the organization is doomed. A suggested way out of this difficulty is to determine the linkages between the listed strengths and also between the listed weaknesses. When doing so, it might be found that many have from the same basic cause (Coman and Ronen 2009). For example, three weaknesses might be declining customer numbers, limited products available for sale, and a lack of innovation. By looking for linkages, it might be determined that the main weakness is the lack of innovation. It is this weakness that causes the organization to not develop new products, resulting in a loss of customers.

THINK-ACT-PLAN: Conducting the SWOT

Think: How do I base my plans for my future on my personal strengths? When do I focus on my weaknesses? Can I give an example of how I took advantage of an external opportunity with one of my strengths?

Act: List five personal strengths and weaknesses. Now go online and look at job postings. Do you see any available jobs that are opportunities where you can use your strengths?

Plan: You are now ready to conduct a SWOT analysis for your organization. The success of the task depends on the quality of your analysis so take your time.

Everyone is creative, so everyone should be heard

Creative and cultural organizations are built on the talents of creative individuals. However, organizations can also be creative. In fact, organizational creativity is now seen as essential to being competitive. In organizations, collective creativity results in ideas that are not from a single individual but that involve input from many individuals from different departments. This is why it is imperative, when going through the strategic planning process, that everyone be involved.

While it is true that only the creative talent may be involved in the production of the product, everyone working in the organization may have ideas on how to create value for the consumer. Here are ways that organizations can encourage creativity among all employees:

Autonomy: First, they must give employees autonomy to accept or reject ideas. Sharing does not mean anything if management has the final say over what will be the organization's goals.

Closeness: Second, the organization must foster closeness. The physical layout of meetings and office space should encourage interaction. If the organization has operations that must be separated geographically, technology should be used to bring people together as frequently as possible.

Bridging: Finally, it should be someone's responsibility to ensure that all voices are heard on a regular basis. This individual must have the ability to seek out those who have the ideas and ensure that these ideas are heard throughout the organization.

The process of creativity in an organization involves generating new ideas that can be used to increase the value of the product to the consumer. The next step is the sharing of the idea throughout the organization. People will then

bring additional insights to the original idea. Third, the organization must apply the creative idea to the product or other aspects of the organization.

Parjanen 2012

QUESTION TO CONSIDER: How does my organization foster creativity in individuals?

Using the SWOT analysis helps the organization determine their specific competitive advantage as compared to competitors (Kareh 2019). Successful marketing strategy requires an analysis of both the organization's and competitors' strategies. If the product offers benefits that are similar to what is being offered by another company, it will be very difficult for the organization to survive. It is useful to think of the consumer asking one simple question, "Why should I buy your product instead of your competitor's?" The answer cannot be that the organization needs to sell products so that the creative people it employs have jobs. The fact that the company needs revenue to pay salaries is no concern to the consumer. The reason a for-profit company exists is because there is a demand from consumers for the product they produce. This unique offering is its competitive advantage. It is what it does differently or better than the competition.

Porter's generic strategy—everyone should know about Porter

Competitive advantages can be divided between those that are part of an overall organization and competitive advantages that are specific to a single product or a product line. One model of determining a companywide competitive advantage is to use Porter's generic strategy (Porter 1980). This theory states there are three ways to build a competitive advantage. It can be done through cost leadership, differentiation, or a focus strategy. Companies that can pursue a cost leadership strategy have access to funding that allows them to invest in efficient manufacturing and distribution. As a result, they are able to keep their product prices low. Companies that pursue a differentiation strategy also have to have funds that they invest in research to develop new products. However, the organization

must also have creative employees who can envision how research developments can be designed into new products.

The final strategy, which is to focus, is most relevant for creative and cultural organizations. With this strategy, the organization focuses on a small segment of the consumer marketplace. By doing so, they know their customers' needs and are able to provide products that meet them. As a result, their customers are loyal to the organization. The challenge when following this strategy is that the organization must be ready to change the product when the customers' needs and wants change. They also face the challenge of a larger organization that may produce a competing product more cheaply. In this case, promotion must be used to explain why the product produced is superior in value to a cheaper mass-produced product. Analyzing the organization using the Porter model provides a means of fresh insights on the organization's external threats. Many organizations are overconfident that their strengths will help them achieve their strategic goals without considering the challenges from their competitors (Tsipursky 2019). Using the Porter model can help reveal blind spots that might be otherwise ignored.

Value disciplines—a funny name, but an easily understood model

Another more recent model of competitive advantage that explains the strategic choices available to organizations is the value disciplines, which are operational excellence, product leadership, and customer intimacy (Treacy and Wiersema 1995). This model continues to be used to develop strategy for both large and small organizations. Most companies will demonstrate an advantage in one of the strategies, while a few companies will demonstrate advantages in two. It would be extremely difficult to demonstrate a competitive advantage in all three. It has been found that the organizational culture that makes it possible to succeed on one discipline is incompatible with the culture needed for another (Ordenes 2018). For example operational excellence requires employees focused on efficiency and measurement. Product leadership requires employees focused on risk and innovation. While customer intimacy requires employees who at all times put the desires of the customer first.

Operational excellence: Some companies focus on the production and distribution of their products or services in the most efficient way possible. By doing so they will keep their costs low, and therefore, they will be able to charge a lower price for their product. They can do so by reducing the cost of producing the product by using new manufacturing technology. Or manufacturing may be outsourced to another country to keep labor costs down. For services, rather than personally engaging with the customer, some aspects of the business may be conducted online using technology. For example, rather than handling phone calls when taking orders for customizable services, a website might be designed where customers can enter information on what service details they prefer.

In addition, operational excellence can be achieved through using efficient distribution channels such as getting products into retail outlets at a low cost through lightweight packaging or shorter truck routes. For example, producing products in a standard size so that they can all use the same packaging will reduce costs. Also, limiting the number of retail establishments that carry the product will simplify tracking sales and limit potential distribution problems.

As a result of following this approach, prices can be kept lower than the products of competitors. Few creative or cultural industries will pursue operational excellence as they rarely compete on price. Few of these organizations will be selling inexpensive, mass-produced products or online services without personal interaction. However, the issues of keeping operating costs low is still of importance for any organization as it will increase the profit of the company.

Product leadership: Companies that focus on operational excellence deliver a quality product at a low price. However, such companies rarely focus on product development as this would increase costs. Alternatively, companies that follow the product leadership competitive advantage, while concerned about costs, are willing to take the financial risk of developing new products. The most competitive companies that demonstrate product leadership will develop products that change the way people live. They will produce products that are so innovative that customers have not asked for them because they did not know they were possible. Because companies focusing on product leadership

must spend money on research and development and also bear the costs of product ideas that fail, prices for successful products will have to be high. However, customers will be willing to pay the price to get the benefits the product offers.

Some creative and cultural organizations can use product leadership as a competitive advantage strategy. Because of the talent of their employees, they are able to produce creative products that are groundbreaking. However, more than just creating the new product is necessary. Organizations must also create a brand image that will explain to the potential customer that, by purchasing this work, they will be trendsetters. Once this brand image is established, they will find it quite easy to introduce and sell additional creative products as they will be known for innovation.

Customer intimacy: A third competitive advantage a company can demonstrate is customer intimacy. With this advantage, the company does not focus on producing and delivering at low cost or on introducing the latest and greatest products. Instead, they focus on knowing and understanding their customers and, by doing so, providing them with the products and benefits they desire. Customer intimacy is often the only choice for a small company that cannot meet the low product prices of operational excellence competitors because they do not mass-produce products. In addition, they do not have the resources to create and market the newest product innovations. However, where they can excel is by having personal contact with their customers. While in the past this would have been done face-to-face, now it can also be done using social media.

Creative and cultural organizations that sell their product through their own studio or present a performance in their own venue will easily be able to get to know their customers as they will be in contact with them during the purchase and consumption process. However, much of this gaining of knowledge of customers can be done online using social media. While social media is certainly used to promote a product, one of its great benefits is learning from customers what they like or do not like about products. These desires can then be taken into consideration when developing a customer intimacy competitive advantage strategy.

THINK-ACT-PLAN: Competitive advantage

Think: Analyze your personal strengths. How would you describe your competitive advantage?

Act: Write a competitive advantage statement explaining how you demonstrate product leadership because you are the best student or employee. Now write one explaining how you are the most efficient. Finally write a competitive advantage statement explaining that you know what other people need and want. Which describes you best?

Plan: You are now ready to decide upon the competitive advantage for your organization. All other components of the plan will be based on this decision so consider carefully!

DECIDING STRATEGIC GOALS

Achieving customer intimacy isn't easy

Your company may already have an excellent product. However you are competing with larger companies who also are promoting that they have the best product. Focusing on a strategy of customer intimacy may give you the competitive edge you need but how do you do so? Here are some ideas.

Connect: Use as many communication channels as possible to keep in contact with customers.

Establish policies: Make sure all your customer service policies have customers in mind.

Post examples: Post online how customers are using the product.

Reward loyalty: Send gifts and discounts to repeat customers.

Host events: Invite your customers to your place for food, drink, and entertainment.

Offer training: Have free classes where the customers can learn more about your product.

Provide resources: Provide information on how to use, care, and repair the product.

Henshall 2020

QUESTION TO CONSIDER: Which of these ideas can we implement to achieve customer intimacy?

After the marketing department gathers and analyzes data, the next step is for everyone to participate in the process of deciding upon a specific strategic goal. This step is of critical importance as it will determine the actions of the organization over the next year or years. Therefore, everyone needs to be involved in goal formulation. One way to start this process is for the employees to discuss the worst failure that happened last year to the organization and the best success. The strategic goals should build on what the organization already does successfully and avoid what causes failures.

The marketing strategic plan will focus on the issues of customers, products, prices, distribution, and promotion. For an organization that is just starting in business, all of these issues might be part of the strategic goal or goals. For organizations already in existence, much of what they are currently doing may remain the same. However, some new goals will be need to be set or the organization will stay stagnant. To achieve these goals, some factors of the marketing mix will need to change. If the strategy involves targeting new customers, it is referred to as market development. On the other hand, if the strategy involves changes to the product, it is referred to as product development. Either way a first step is to write a broad goal statement that combines what the organization cares about, what it wants to do, and for whom it will be doing it and why.

Market development: If the goal involves market development, the goal will focus on a new group to target. For example, a goal statement might state that a theatre company with a mission of presenting challenging art now wants to expand community outreach. Its environmental scanning might have revealed that there are new corporate headquarters of technology firms

opening in the area. It also knows that employees in these jobs are required to be creative but are not motivated by the usual type of corporate training offered to increase creativity. The theatre company's new strategic goal might be to bring performances into these workplaces. The organization believes that by doing so, the company's employee creativity will be increased.

The goal statement will be based on the organizational strength of performers' talents to produce challenging work along with the external opportunity of employers trying to compete in a rapidly changing business environment. This strategic goal fits with the mission of the organization to expand the reach of their market.

Product development. However, the same organization's goal statement could be rewritten. Instead of looking for new audiences, the organization may choose to develop new products so that current customers would attend more frequently. Social listening, reading comments made by current and potential customers online, is an inexpensive and timely method of collecting information on which to base new product ideas (Blancard and Yip 2019). The theatre company's mission of presenting challenging work remains unchanged. However, the organization may decide to add a new product of workshops about its performances when online comments reveal that people want to learn more about the productions and actors so that they can better appreciate the performance. This new product might particularly appeal to a new segment of audience members. The external opportunity on which the goal is based might also be the desire of families to see performances that they can all enjoy. This goal gives the organization the opportunity to develop new strengths by adding educational workshops to help the families understand the programs.

Sample goal statements

- Adventurous Theatre will expand its outreach by presenting challenging drama in the workplace so as to increase employee creativity.
- Adventurous Theatre will expand by offering performance workshops to help audience members better appreciate the performance.

Objectives—more than one will be needed to achieve the goal

Of course, a goal statement is too broad to implement as it leaves out all the details of how the goal will be accomplished. Therefore, the next step is to determine what must be done for the goal to be achieved. These objectives should be specific even to the point of quantifying what will be accomplished and writing in detail the target of the goal. For instance, objectives for the theatre company might detail who will direct the new performance, what type of promotion will be needed, and how many performances will be held. The second goal statement would have objectives on developing quarterly workshops with an educational component for families with young children in the school-going age.

A large organization might have more than one marketing strategic goal, and objectives will need to be written for each. It is wise if smaller organizations focus on one goal at a time. After the goal has been successfully achieved, a second goal can be developed. Having too many goals at once can result in not having enough resources to achieve any (Levin 2018). A goal should be undertaken only if there is enough people, time, and money to achieve the goal.

The process of determining objectives that need to be accomplished in order to achieve the goal should involve everyone in the organization. For example, a strategic goal might be to open a gallery to display the works of local artists that will also serve as a community room for neighborhood organizations. This goal is based on the opportunity of a lack of meeting space in the area. Brainstorming by everyone in the organization to determine the objectives will quickly present several issues that need to be explored in order to implement the goal. First, space must be found for the gallery. It may be people in finance who will recognize the need for this objective as they will be concerned about rental costs and what rental fee community groups would be willing to pay. Second, someone in marketing might recognize that it must be determined how many community groups would use the space. Third, the creative artists might bring up the necessity of deciding what type of art should be displayed. Logistical issues that will arise with managing a commercial

space may be brought up by another employee. Finally, the gallery and community room will need to be promoted to the public, which will again be a concern of marketing.

Tasks—each with a name and date

Achieving each of these objectives will take a number of tasks. For example, finding a retail space will involve the tasks of contacting a realtor for possible sites, looking at commercial rental listings online, visiting possible sites, making a decision, and finally negotiating a contract. The second objective of determining interest will be achieved by finding a listing of all community organizations and then sending a letter that explains the idea. Contacting the community groups to determine if they are interested and what they would be willing to pay will be another task. Creating a proposed budget will involve determining the rent, staffing needs, and art prices. Logistical issues will include determining who will manage the space, insurance that will be needed, hours of operation, and the cost for janitorial services to clean up after. Finally, the objective of creating a promotion plan will need the tasks of preparing print material, creating a social media site, and performing personal sales calls. Achieving a single goal can be a longer and more complex process than it first appears.

Assigning responsibility and deadlines—who and when

The final step in the strategic planning process is to assign responsibility and deadlines. During the strategic planning process everyone may be very enthusiastic about moving forward. However, this enthusiasm may quickly diminish when the plan is implemented because of other, more pressing responsibilities. Therefore, each task should be assigned to someone in the group. Deadlines will also need to be created to ensure that the assignments are completed. This is critical as some tasks cannot be started before others are finished. For example, the promotional material cannot be prepared until the location and costs are established.

Goal-setting models—getting it right

Writing a goal that is both achievable and challenging can be difficult. There are a number of models that can be used when

writing goals (Lee 2015). The first is the SMART model, one of the most widely known. This model states that successful goals are specific, measurable, attainable, relevant, and time-bound. The goal must give specific information as to what is to be achieved. The goal should also include a quantifiable factor that can be measured. This quantifiable goal should be realistic so that it can be attained. The goal should also be relevant to the overall strategy of the organization. For example, if the strategy of the organization is to increase online sales, the goal should not be about opening a new retail location. Finally, for any goal to be successful, it must be given specific dates for achieving each step.

THINK-ACT-PLAN: Developing the goal

Think: What do you hope to achieve in the next year? Using this insight, write a goal of what you wish to achieve.

Act: Now list the steps that you will need to take to achieve the goal. How many objectives will be necessary to accomplish? Take the objectives and break them down into tasks. Now assign deadlines.

Plan: Now is when you will decide the organization's goal based on your competitive advantage. Breaking the goal into objectives and tasks is a process. Work on it a while, then put it away. Take another look, and you may think of additional objectives and tasks that will need to be completed.

Creating the strategic marketing plan

You are now ready to conduct a SWOT analysis to determine your competitive advantage. Summarize the information obtained for inclusion in your marketing plan. In addition, you can now write your goal, objectives, and tasks. All this information should also be included in your strategic marketing plan.

REFERENCES

Beinhocker, Eric, and Sarah Kaplan. "Tired of Strategic Planning?" *McKinsey & Company.* July 2002. www.mckinsey.com/insights/strategy/tired_of_strategic_planning. Accessed April 10, 2015.

Blancard, Vincent and Pedro Yip. "Social Listening is Revolutionizing New Product Development." *Sloan Management Review.* December 23, 2019. https://sloanreview.mit.edu/article/social-listening-is-revolutionizing-new-product-development/. Accessed January 19, 2020.

Brandenburger, Adam. "Are Your Company's Strengths Really Weaknesses?" *Harvard Business Review.* August 22, 2019. https://hbr.org/2019/08/are-your-companys-strengths-really-weaknesses. Accessed February 22, 2019.

Coman, Alex, and Boaz Ronen. "Focused SWOT: Diagnosing Critical Strengths and Weaknesses." *International Journal of Production Research* 47.20 (October 15, 2009): 5677–5689.

Davis, Alison. "Do Employees Understand Your Business Strategy? Use this Surprising Method to Engage Your Team." *Inc.* November 11, 2017. https://www.inc.com/alison-davis/do-employees-understand-your-business-strategy-use-this-surprising-method-to-engage-your-team.html. Accessed March 12, 2020.

Figueroa, Anthony. "Data Demystified – DIKW Model." *Toward Data Science.* May 24, 2019. https://towardsdatascience.com/rootstrap-dikw-model-32cef9ae6dfb. Accessed January 17, 2020.

Girzadas, Jason. "3 Enduring Trends Inform Strategic Planning Efforts." *Wall Street Journal.* May 14, 2019. https://deloitte.wsj.com/cmo/2019/05/14/3-enduring-trends-inform-strategic-planning-efforts/. Accessed February 18, 2020.

Harford, Tim. "How the World's First Accountants Counted on Cuneiform." *BBC News.* June 12, 2017. https://www.bbc.com/news/business-39870485. March 11, 2020.

Henshall, Adam. "8 Customer Intimacy Strategies for Companies of any Size." *Hubspot.* January 29, 2020. https://blog.hubspot.com/service/customer-intimacy. Accessed April 1, 2020.

Kareh, Ahmad. "Three Tips for a Better SWOT Analysis." *Forbes.* July 19, 2019. https://www.forbes.com/sites/forbesagencycouncil/2019/07/19/three-tips-for-a-better-swot-analysis/#7d8a83cc1356. Accessed February 11, 2020.

Lee, Kevan. "7 Goal-Setting Tips and Strategies for Social Media Marketers." *Buffer Social.* N.p., March 23, 2015. https://blog.bufferapp.com/goal-setting-strategies. Accessed May 12, 2015.

Levin, Marissa. "The One Aspect of Goal Setting You're Forgetting and Why it Matters." *Inc.* May 17, 2018. https://www.inc.com/marissa-levin/the-one-aspect-of-goal-setting-youre-forgetting-and-why-it-matters.html. Accessed January 12, 2020.

McDuffee, Bruce. "Go 'Back to the Future' with Strategic Marketing Plans." *Content Marketing Institute.* January 14, 2014. https://

contentmarketinginstitute.com/2014/01/back-to-future-strategic-marketing-plan/. Accessed February 12, 2020.

Ordenes, Pat. "Value Disciplines Model and Your Competitive Advantage." *Execute Strategy*. March 8, 2018. https://www.executestrategy.net/blog/value-disciplines. Accessed March 2, 2020.

Parjanen, Satu. "Experiencing Creativity in the Organization: From Individual Creativity to Collective Creativity." *Interdisciplinary Journal of Information, Knowledge, and Management* 7 (2012): 109–128.

Prahalad, Deepa and Ananthanarayanan V. "4 Questions to Boost Your Social Media Marketing." *Harvard Business Journal*. January 17, 2020. https://hbr.org/2020/01/4-questions-to-boost-your-social-media-marketing. Accessed March 10, 2020.

Porter, Michael E. *Competitive Strategy: Techniques for Analyzing Industries and Competitors.* New York, NY: Free, 1980.

Talbot, Paul. "The 1 Reason Why Marketing Plans Crash and Burn." *Forbes*. April 2, 2018. https://www.forbes.com/sites/paultalbot/2018/04/02/the-1-reason-why-marketing-plans-crash-and-burn/#2f1904366ac8. Accessed March 11, 2020.

Treacy, Michael, and Frederik D. Wiersema. *The Discipline of Market Leaders: Choose Your Customers, Narrow Your Focus, Dominate Your Market.* Reading, MA: Addison-Wesley, 1995.

Tsipursky, Gleb. "Your SWOT is Broken (Here's How You Can Fix It)." *Psychology Today*. November 21, 2019. https://www.psychologytoday.com/us/blog/intentional-insights/201911/your-swot-analysis-is-broken-here-s-how-you-can-fix-it. Accessed March 13, 2020.

Understanding consumer motivation and segmentation

Chapter 6

This chapter will answer the following questions

- How has the use of **social media** affected the segmentation of consumers?
- What are the factors that affect the **consumer purchase** decision process?
- What unique situations arise with the **business purchase** decision process?
- How are geographic, demographic, and psychographic **segmentation** used?
- Why do products need to be **positioned** against competitors' products?

SOCIAL MEDIA AND SEGMENTATION OF CONSUMERS

Brand relationships—it's complicated

The old goal in marketing theory was to build brand loyalty. First a consumer discovered through marketing messages a desired product. They then bought the product and if they

were satisfied would purchase again. This has changed. Consumers now want to build relationships with companies that produce a product they purchase. As a result companies must truly understand and connect with their customers. They can do so using customer relationship management. Here are some ways technology can be used to strengthen the relationship with customers so they purchase again.

Collecting data: You now have access to information on your customer's online behavior. From this you can design an online customer purchase experience with product suggestions based on their likes and dislikes.

Deeper analysis: Software can also take the collected data and find relationships that may not be apparent, such as seasonal purchase patterns. In addition artificial intelligence will be able to predict with accuracy future purchase behavior.

Social intelligence: Software can now analyze trends on social media, such as interest in a social issue that may be of interest to your customers. By understanding these trends, marketing messages can be adjusted to include the company's stand on the issue.

Kowalke 2017

QUESTION TO CONSIDER: How will I use technology to strengthen the relationship with my customers?

The creative or cultural organization is now on its way to developing their marketing strategy. First, the organization decided upon its mission, vision, and values. Another step in preparation for writing the marketing plan was to conduct the necessary analysis and research. The organization then examined their internal resources and their external environment and used a SWOT analysis to analyze the resulting information. From this SWOT analysis, they decided on their competitive advantage and developed a strategic goal, objectives, and tactics. The next step is to decide which consumer segment will have the most interest in purchasing the product.

Changes in segmentation theory—social media again changes everything

The segmentation of consumers into groups based on the belief that shared characteristics result in shared product needs and desires has been established marketing theory. However, the rise of social media has meant that marketers must be cautious in over-relying on segmentation. Segmentation was developed because sending out promotional messages uses the resources of time, talent, and money. As it is known that consumers differ as to the products they desire, it makes sense to save resources by sending promotional messages to only the group of consumers most likely to purchase.

However, today consumers depend less on promotional messages for product information and rely more on receiving information about products through their social networks. Interest in the product then spreads via social media. As a result the organization is in danger of ignoring groups of consumers that were not targeted, but rather found the product through word-of-mouth online. While it is still appropriate to segment and target groups of consumers most likely to purchase, organizations must always be analyzing their customer base to determine if interest is being evidenced by a new group that was not targeted. The organization can then make the choice if it is worthwhile to further develop this organically grown segment.

Social media is used by organizations to form a deep relationship with their current segment of consumers. This focus on knowing and understanding customers is not achieved by merely using social media. Instead the business knows that the consumer is now in control of the marketing process and is no longer a passive player merely to be segmented and targeted. This new way of understanding consumer groups results in a cultural change in how businesses approach the market.

Social media as a tool to aid segmentation—they segment themselves

The practice of segmenting consumers into homogenous groups has been a part of marketing theory and practice since the middle of the last century. Social media rather than ending the

practice can help in segmentation by both identifying a segment and positioning the product (Alton 2018). In fact social media can result in consumers forming their own segments through joining online communities focused on products and brands. Such communities can be found on social networking sites, such as Facebook, and professional networking sites, such as LinkedIn.

One of the challenges when segmenting is the first step, which is determining what characteristics are relevant in determining purchase behavior. Marketers have traditionally looked at geographic location and demographic characteristics such as age, income, and gender for clues for purchasing preference as these are all easy to determine. It is much more difficult to determine consumers' psychographic characteristics such as values, attitudes, and lifestyles that motivate the purchase of a product. However, rather than the organization trying to determine the psychographic characteristics that motivate purchase and then segmenting consumers, consumers now self-segment online. They do so by participating in online forums and commenting on particular websites based on their values, attitudes, and lifestyles. Marketers can then model their segments based on these characteristics. Rather than hypothesize on the psychographic characteristics of potential customers when describing a segment, this method starts with finding an already existing segment online that it then describes.

Engaged consumers—can do the promotion for you

While most people now use social media sites to research products before purchase, not all become actively engaged online with the organization. An organization can assume their target market segment is researching their product online to determine if it has the benefits they desire. Most potential consumers will view the organization's website, read reviews, and ask their Facebook friends for product advice. It makes sense for the organization to use their resources to post information online for these consumers.

However, a smaller segment of this group looking for information online goes a step further. This is the group of people who will not only research products, they will actively

engage online with the public about the product. The company can build a community around these engaged consumers (Williams 2019). They are the customers who routinely post questions and comments on the organization's website. They will even answer questions from the public about the product. In addition, they will also post reviews on product review sites. Finally they may mention the product in blog postings and in Tweets.

Such individuals can have an enormous impact on the purchasing decisions of others through comments, blogs, and uploading videos. The challenge for the organization is how to respond. To do so, all comments, both positive and negative, must be acknowledged.

The organization must either manually or using software search out social media sites where their product is mentioned. Any response should include a name and contact information so that the commenter can get in touch personally with the organization if the concern is not addressed. This is particularly true when handling complaints. Anyone who has taken the time to post negative comments will also readily post a comment on any lack of response from the organization. When doing so, the organization is not only responding to the commenter but also to the entire target market segment that are also online reading or watching reviews, blogs, and videos.

THINK-ACT-PLAN: Responding to a complaint

Think: How has social media affected the way you decide upon a product to purchase? When do you believe marketing messages? What social proof effects your purchase decision?

Act: Go online to a review site and find a comment that complains about the organization or product. How did the organization respond? Should the complaint have been handled differently?

Plan: Now write the response you would submit to a complaint that your product costs too much.

FACTORS AFFECTING THE CONSUMER PURCHASE DECISION

The customer and marketer relationship

Everyone knows the purchase decision varies depending on the cost of an item. The decision to pick up a chocolate bar near the store's checkout counter can be made on impulse. However, the more a product costs, the more consideration must go into the decision.

A handy model of considering this process combines the stage in the purchase process, the actions of the consumer that result, and the actions that the marketer should take in response. The relationship with the customer whether face-to-face or online must continue throughout the purchase process.

Consumer	Marketer
Awareness: Asks if you can solve their problem.	Broadcasts general message on availability.
Interest: Decides that perhaps you can.	Provides information on benefits.
Evaluation: Determines if you are for real.	Shows proof of benefits through testimonials.
Trial: Considers possible ownership.	Shares information on return policy.
Adoption: Finally makes a purchase.	Makes the purchase process easy.
Loyalty: Returns to buy again.	Thanks consumer and offers new purchase incentive.

Stanford 2018

QUESTION TO CONSIDER: Can you describe how we affect the customer at the six stages listed above?

Whether consumers start the purchase process with a specific need for a product or become aware of a product when looking for other information, what needs to be examined is why some decide to purchase while others do not. If this is understood, the marketer can then adjust the product benefits, the price of the product, where it is distributed, change the promotional message, or any combination of these marketing mix components to better encourage purchase. While each person is an individual and the reasons for purchasing or not purchasing are unique, there are three general forces, namely, the economic situation, social influences, and psychological factors, which will affect the purchase decision.

Economic influences—perception is reality

The economic influence that affects the purchase decision must be analyzed in greater depth than the simple issue of whether the consumer can afford the price. Often when consumers are asked the question of why they did not purchase products they will respond that they cannot afford to do so. They respond in this way because this is the simplest answer to give, even when they may purchase a competing product that costs more. In this case the issue is not price but perception of value.

When considering the price of a product the consumer will calculate the monetary cost against the benefits the product provides. They will also consider the product's effectiveness and dependability. Even if these two factors meet the purchase criteria, the convenience of making the purchase will play a role in the decision. While there are consumers who do not have the financial resources to purchase and simply must find a less expensive product, for other consumers the price is not worth the benefits the product offers and, therefore, the product does not have value.

Because the benefits provided by the product versus its cost will be one of the first purchase criteria, the marketing message must convey the value of the product. For example, having a landscape artist design a backyard will most likely be more costly than simply planting flowers. Therefore, what should be conveyed in the promotional message is the value of having a place to spend quality family time. Or, the message might

convey that the garden will impress friends when entertaining. The value of these benefits will offset the higher price in the minds of some consumers. In addition, other benefits that can be promoted to justify the higher price are the values of convenience and reliability. The promotional message can explain that not only will the garden provide esthetic benefits but it will do so in a manner that is easy to maintain, therefore, lowering future costs and increasing the value. It can also be reliable, in that the bushes and trees that are suggested will last for years.

Psychological influences—what we need, want, or both

The psychological factors that influence a decision can be described as what motivates an individual to purchase a product. In addition, the consumers' overall perception of a product is affected by psychological factors. For example, basic needs for food, clothing, shelter, and safety will motivate the purchase of a product. In contrast, perception of the product will determine which, among the competing products that meet the needs, will be chosen.

It is sometimes thought that marketers can use promotion to manipulate consumers into purchasing a product, but this is extremely difficult to do. Trying to tell consumers they need a product when they do not believe they do will be met by resistance that will harm the brand image of the organization. Consumers are more likely to trust their own instincts than a marketing message from an organization. Being told that the organization knows better about what they need will be seen as paternalistic at a time when people value autonomy.

Instead the organization needs to understand the consumer's psychological needs so that the promotional message can communicate the benefits provided. Few creative and cultural products will meet the basic human needs for food, clothing, and shelter at the lowest cost. A fashion designer may sell clothing but there will most certainly be lower cost clothing alternatives. An artist may sell paintings that decorate a wall, but so does the local discount store. While one product may be an original creation and the other mass-produced, both fill the need to decorate the wall.

Instead other psychological factors, such as a need for beauty, a symbol of achievement, or a desire for a better world, will more likely affect the purchase decision for creative or cultural products. There are consumers who are willing to pay more for a painting that brings beauty into their life. In addition, they may be psychologically motivated to purchase a high-priced painting because it is a visible symbol of the owner's success. Finally, a painting may be purchased because doing so supports a social cause in which the consumer is interested.

Social influences—family and friends play a role

There are numerous social factors that affect the decision to purchase a product. These factors can be grouped into cultural, family, and reference groups. It is understandable that the culture in which a person is raised will affect the purchase decision, particularly for creative and cultural products. Some cultures will emphasize the importance of expressing individuality and will praise creativity. The individuals from these cultures will be willing to purchase products that are original and express individual points of view. Other cultures will emphasize fitting into a norm. They will be more interested in creative and cultural products that represent traditional cultural values.

Family may support the values of the larger culture in which they exist or may differ from these values. Even when an individual makes the purchase decision, the social force of family and friends will strongly influence which product is chosen. While an individual's family is a given, they will select their own reference group. This is a group of people whose views the individual agrees with and, therefore, wants to emulate. The consumer may already belong to the group, but if not, their affinity for the group leads them to mimic their behavior. For example, someone who grows up in a culture and family that frowns on displays on personal expression may be discouraged from wearing fashionable clothing until they find a website that shows people wearing such clothes. The website may show these individuals in interesting locations and engaging in exciting activity. Finding such people online or in person, the consumer will also want to purchase and wear similar clothing.

Think: What was the last expensive product that you purchased? What psychological needs did it meet? Were there any family or reference group influences on your purchase?

Act: Find a creative product online and list three psychological benefits the product provides. Now list three social influences that could affect the targeted customer when they make the purchase decision.

Plan: Create a marketing message that explains the factors that influence the decision when consumers purchase your product.

FACTORS AFFECTING THE ORGANIZATION PURCHASE DECISION

Using social media marketing: the difference between B2C and B2B

Both businesses selling directly to consumers (B2C) and businesses selling to other businesses and organizations (B2B) use social media marketing. However the type of content posted, the channels used to communicate, and the metrics used to measure success differ.

Content: When marketing to consumers B2C social media marketing uses visual as video continues to gain in popularity as the way consumers prefer to learn about products. B2C businesses also need to produce posts that engage consumers and motivate them to share with others. When B2B businesses use social media marketing content needs to be professional. White papers, ebooks, and webinars rather than videos are the preferred methods for providing product information.

Channels: When B2C businesses use social media marketing a wide range of channels are available with

Facebook, Instagram, and YouTube being the most popular. The decision of which to use will depend on the channels the target market uses. When B2B businesses market to other businesses the choices narrow. These customers will be specifically looking for information using LinkedIn or going directly to the company's website.

Metrics: The measure for success in B2C marketing to consumers online is building awareness and engagement as the purchase journey is never straightforward and the consumer may need to view content from many sources before a decision is made. The measure for success in B2B marketing to businesses is sales lead generation. Once a potential purchaser has viewed content, the business will continue to follow up until a sale is made.

Green 2019

QUESTION TO CONSIDER: What are examples of how we use different marketing tactics when promoting to other businesses and organizations?

Type of organizations that purchase—there are more than you might think

Some companies are manufacturers of products. These businesses need to purchase raw materials from which they will produce their product. While they will also purchase supplies and services that are necessary to operate the business, most of their purchasing will be raw materials. It would be rare if a creative or cultural business sold raw materials to organizations to produce other products. However, other organizational purchasers are intermediaries that resell the product. This would include wholesalers that sell to retailers and retailers that sell to customers. In addition, government agencies and nonprofit organizations purchase products. Intermediaries and other types of businesses and organizations can be targeted by cultural and creative industries for the purchase of their products.

Wholesalers: Wholesalers specialize in a category of goods that they purchase in bulk and then resell to retailers, not to individual customers. Wholesalers are only interested in

purchases of large quantities of products, which they then break down into smaller units to be sold to retailers. Because of this method of operation it is unlikely that a small creative and cultural organization would be selling to wholesalers.

Retailers: Retailers purchase products to be resold to their customers. While large retailers with many stores will purchase from wholesalers, retailers who have only a single or few retail outlets may purchase directly from the producer of a product. The retail business model is to purchase a product that can be resold at a profit. Creative and cultural organizations that choose to sell directly to retailers will need to develop a promotional strategy that explains how the product will be of interest to the retailer's customers and also earn the store a profit.

Governments and nonprofits: Governments and nonprofits are also potential purchasers of products from creative and cultural industries. Rather than purchase products to be resold they will purchase products for use in their routine operations. In addition, they may purchase products to provide as gifts to clients or customers or products for their own use, such as décor in offices or public spaces. In addition, they may purchase performances for the purposes of entertainment of their employees or the clients that they serve. The basic purpose in governments and nonprofits purchasing products is to assist them in meeting their missions.

Specifications—just the facts

The purchase decision for organizational buyers will depend less on economic, psychological, and social influences and more on specifications, including quality, service, and price. Another difference from consumer purchasing is that organization-buying decisions are made by purchasing specialists rather than the individual who will be the end-user of the product. Therefore, research must be conducted to ascertain these specifications so that they will be addressed in promotional material.

People working in a government, or nonprofit organization do not have the freedom to purchase a product simply because of their personal preferences. Allowing them to do so could result in purchases that do not meet the organization's needs and that cost more than the organization budgeted. Therefore,

even before consideration of a purchase decision starts, the specifications for the product are defined. These can be categorized as price, quality, and additional services that may be needed for the use of the product. For products that are purchased routinely, this might simply be the part number, quantity needed, and the price the business is willing to pay.

Because creative and cultural products are rarely standardized the specifications will be more involved. For example, besides price and quantity it might specify that the product must be approved by a committee of employees. In fact if the purchase is for art that will be displayed at the business, it might be necessary to ensure the subject matter won't be offensive. If the product is to be used to meet a therapeutic mission, such as a performance for individuals with mental illness, the details for the performance must be specified.

The business or organization needing a product may release this information on specifications publicly and ask for bids. The creative organization must be prepared to provide detailed information on the product. Any online information aimed at a business purchaser, besides stating benefits, must include information on price, quality, and service. To make the business purchase process easier for products with more complicated specifications, online content that can answer many questions that previously required a personal meeting should be provided online (Goldberg 2017).

Purchasing specialists—they alone have the power to purchase

One of the challenges when selling to business customers is determining who has the authority to make the purchase decision. Large businesses, governments, and nonprofits will have purchasing or procurement departments. Only individuals in these departments have the authority to make the purchase decision. The reason these departments exist is to guard against fraud and to ensure product quality. Many of the contracts that are issued are for large amounts of money and are highly sought after. It might be tempting for an individual in a business to award such a contract to a friend or relative whether or not they are the best product provider. In addition, purchasing specialists are used as they are trained to negotiate the best price at the

required quality level. If a creative organization wishes to sell to such an organization they must determine the specification and also determine who has the authority to buy.

Social media and business buying—blurring the personal and business

The buying process for a business is a simple progression of awareness of a need, identification of possible solutions, evaluating criteria for purchase, and, finally, making the purchase decision. What has changed dramatically is that the information used for the identification of possible solutions is no longer only received directly from the company producing the product (Cohen 2015). Previously a business wanting to sell their product to another business would place information on their website and include a link to request additional information. However, many businesses searching for products on websites do not use such website links. Another method of marketing to business is with direct email messages. However, only a small percent of direct marketing emails are opened. Instead, some business purchasers are now finding out about products for their businesses, in the same way they do for themselves personally, by looking online. Business purchasers, rather than wait for a marketing message, are being proactive and using online sources of information to research products they may wish to purchase.

The criteria business purchases use when making purchases, which are quality, price, and service, have not changed. What has changed is how they find out about these criteria. As a result, the organization wishing to do business-to-business marketing must have more than a website. They must make sure they have their own content, including articles, images, and videos, shared online. In addition, they must encourage current customers to post testimonials.

THINK-ACT-PLAN: Business market message

Think: Think of where you work now or of your last job. What products needed to be purchased? Were you allowed to purchase or did someone else make the decision? Why?

Understanding motivation and segmentation

Act: Go online and find an organization or business that could purchase a creative or cultural product. List the specifications that you believe they might use to judge your product.

Plan: Decide upon a business market that you could target for your product. Write a promotional message that matches the benefits your product provides with what the business would need.

TYPES OF CONSUMER SEGMENTATION

Segmenting using online strategies

Knowing the segment of consumers you wish to target with your marketing message is not enough. You then need a strategy for how they can be reached. An easy answer is to simply place ads on social media websites and hope for results. The problem with this approach is that you don't know who will see the ads and therefore may waste money. To get better results you need a more targeted online promotion strategy. Here are three ways this can be done.

Expand reach with Google's in-market audiences: If you have a new product and need to build awareness this is a good approach. This method allows you to target consumers who are researching your product category.

Remarket with Google ads: What if a consumer looks at your website but then shops elsewhere? Google ads can place your ad where the visitor clicks next. It is like you can follow a customer that leaves your store into the next shop.

Use Facebook custom audiences: You can let Facebook find your targeted segment. If you know the content preferences of your consumers, Facebook will place your ads where they are most likely to visit.

Smith 2019

QUESTION TO CONSIDER: How can I use these social media strategies to reach my targeted customers?

When the creative organization starts to consider who they will target in the consumer market, the first step is to segment consumers and then target the segment most likely to purchase the product. Of course any member of the public will be welcome to purchase and no one who can pay will be turned away. However, treating everyone as a potential buyer is too costly as it would require an extremely large promotion budget. It is better to target marketing messages to those groups that already desire the product's benefits.

The traditional methods of segmentation were demographic and geographic. These were used as companies were able to obtain and track these variables. Using census data, companies could determine the age, gender, and income characteristics of a population. They could then devise marketing messages to target these groups. Using past sales data companies could easily determine where customers lived. While these methods of segmentation are still in use, it is now more common to segment based on psychographic characteristics such as values, attitudes, and lifestyles (Rogers 2019). In the past these internal variables were difficult to determine. Now, people form communities or tribes online based on these traits. Organizations can then analyze which of these groups would find messages about their product of interest.

Segmentation can be based on any characteristic such as height (used by clothing stores for tall people) to political beliefs (used when marketing to politicians). However, whatever basis is chosen the resulting group of individuals must be large enough to be worthwhile. For example, a segment of people over age 70 living in a small town who wish to learn to play the accordion will not provide enough revenue for the business to survive. The standard ways almost all organizations define segments are geographic, demographic, and psychographic, which are usually used in combination.

Geographic segmentation—where you live does matter

One of the decisions that an organization must make is on the geographic scope of their distribution and promotion efforts. Targeting too large a geographic area is challenging. Customers wish to purchase conveniently so distribution channels must be located throughout the geographic area. Even if the product

is sold online, additional promotion must be conducted across the geographic area to ensure that consumers are aware of the product. Of course, there are no geographic restrictions for social media marketing, but other traditional forms will need to be duplicated in each area.

For these reasons the geographic reach is the first base to be determined. Once the decision is made on the geographic area to target, the next step is to choose the descriptors. A geographic area may be based in a specific city or region but also an area known for a certain type of climate or lifestyle.

The decision to target a city or region must consider both the size of the geographic region and also the population density. If the urban population targeted is in a small geographic area, it is possible that there will still be enough potential customers. If the potential customers live in rural communities that have a more dispersed population, a larger geographic area is needed. Geographic segmentation does not mean that the organization is uninterested in selling products to people from other areas; it only means that promotion and distribution will be concentrated.

Demographic—just the facts

Of course using geographic location alone as a base for segmentation is insufficient. Many people with different product preferences will live in the same area. Therefore, the next step is to consider demographic segmentation. Some of the most common demographic descriptors that are used when segmenting are age, family life cycle, gender, and ethnic background. For example, age is used when considering who will be a potential customer as some products are specifically designed for a single age group such as toys aimed at children or canes for the frail elderly. However, even these generalities are often blurred as adults may collect toys and young people with disabilities may need canes.

Age: Age is used as a predictor of product preference because in a rapidly changing world, different age groups have had different life experiences. For example, young people who have grown up with technology will expect it to be integrated into as many product types as possible. Older people also use technology but may not consider it necessary and will need to be sold on why it improves the product.

Age cannot be used alone as a descriptor because with older people living longer healthier lives they may now purchase products that this age group may not have done in the past. In addition, with many young people putting off marriage and children it cannot be assumed that all people in their 20's are thinking of starting a family. Instead they may still be purchasing products and engaging in youthful activities into their 30's, 40's, or more.

Family life cycle: Perhaps a better method of demographic segmentation is to think of the family life cycle, which affects both spending potential and the products purchased. This cycle tends to occur for most people but will do so at varying ages. Young people typically are just starting out in careers and, therefore, have limited income. As a result they will be purchasing inexpensive products that meet everyday life needs. They then will have better-paying jobs but without a partner or children. At this stage they will have income to spend and be interested in socializing and other leisure activities. With a partner, children, or both they will be interested in furnishing a home and buying products needed by their children. Once this stage of life is finished they will again have money to spend on nonessentials.

Gender: Another demographic descriptor is gender. Some products are still used only by men or women. However many products can be used by both males and females but different benefits may appeal to each gender. In this case separate promotional messages may be developed. Rather than create separate promotional messages for each gender many companies are now using a message that will appeal to both men and women (O'Reilly 2019). Because of social changes purchasing categories, such as food by women and autos by men, that were formerly seen to be dominated by one gender are now purchased by both. The product's promotional message is being changed so that it features words and images meant to appeal to both genders. However, products that can be used by either gender may still require separate product features and promotional messages for each.

Ethnicity: Another descriptor of demographic segmentation is ethnicity. This can be challenging to use when segmenting

consumers as it can be seen as stereotyping. However, targeting is based on the fact that ethnic groups may share certain patterns of living. The consumption choices for types of entertainment, clothing, and food may result from their cultural backgrounds. This is true even when members of a minority group have integrated into the majority culture (Webber 2017). For example, certain holidays may be celebrated by an ethnic group. If this holiday involves gift-giving and the creative product can be used as a gift, then it is appropriate to target this group with a promotional message. The separate promotional message will need to be delivered using the media that is most commonly seen by members of the ethnic group.

Ethnic segmentation can also take into account other behavior patterns. Some ethnic groups stress the importance of the extended family group. If the product being promoted is entertainment, then the benefits provided by the performance targeted at this ethnic group would stress that it can be enjoyed by a wide range of ages. Ethnic pride can also be used as an appealing product attribute. The fact that the product is produced in a particular country or the performer shares an ethnic background can be used to target a specific ethnic group.

Psychographic—who they are inside

It is psychographic segmentation based on values, attitudes, and lifestyles that are probably the most useful for creative and cultural organizations. While there are products that involve food, clothing, and shelter that people need to survive, most product purchases are made to fill other desires. This is particularly true for creative and cultural products that may be purchased because of the consumers' values, attitudes, and lifestyles.

Psychographic descriptors can vary widely, such as those who participate in a leisure activity or who hold certain views of the environment. The only way the correct descriptors can be chosen is by the marketer who has already conducted research to understand potential customers. However now social media use can also provide information on a consumer's personality type (Graves and Matz 2018). By analyzing social media usage, such as what sites are visited and what topics are

liked, the organization can design messages tailored messages. Although using psychographic descriptors makes determining the potential size of the market more difficult, research using secondary sources can help find the answer. For example, if articles in art publications state that sales of expensive contemporary art is increasing, this is an indicator that there will be sufficient potential customers. However, this psychographic information must be combined with a geographic descriptor of the segment along with demographic characteristics.

Values: Values, which are deeply held beliefs of how life should be lived, are learned from the family as well as from outside organizations such as school, religion, and social clubs. They usually remain the same for a lifetime. Consumers may decide to purchase a product because they share the values of a company. For example, while consumers are able to purchase coffee beans at any grocery store, they may decide to buy the more expensive, hand-roasted coffee beans at a specialty store because doing so helps poor coffee bean farmers in an economically depressed country. Marketers must not only communicate the benefit of the product, a delicious cup of coffee, but also communicate the values of the company to this consumer segment.

Attitudes: While it would be difficult to change the values of a customer, their attitude, which is a preconceived idea about a product, can be changed. For example, consumers might have the attitude that buying contemporary art is only for wealthy individuals. This attitude might have been formed from seeing ads targeted at this group. Therefore, a promotional campaign would be needed to show visuals of young people on limited budgets interacting with the artists and purchasing their artwork. Of course, not all young people will become interested, but some attitudes will be changed.

Lifestyles: Lifestyle groups, people who associate voluntarily because they share an interest, affect how people will spend their time. Young people will often choose a group whose lifestyle will differentiate them from their parents and other family members. An example of a lifestyle group is one that follows a particular sports team. Other lifestyle groups may form around popular culture trends such as using the latest technology. However, culture and creative interests also support

lifestyle groups. A group may form on the basis of enjoying a particular cultural product, such as opera. They may also form around those who wish to participate in creativity even if their talent is limited, for example, a group that works in fiber arts. By promoting to such lifestyle groups, marketers can create a community that provides the members with access to information and proximity to the creator that the average consumer will not have. In return these community members will not only be loyal to the product, they will also market the product to others using personal contact and social media.

Creating the marketing mix—the final step

Once the target customer segment is determined, the final step is to design a marketing mix based on their preferences. Even if the product is not changed, it will need to be determined which product benefits will motivate purchase. A pricing decision must be made so that it is acceptable to the targeted segment. In addition, how the product will be distributed must be planned so that the product will be conveniently located for the target market segment. Finally a promotional message must be developed to communicate all of this information in a manner and with a method that will appeal to the segment targeted.

THINK-ACT-PLAN: Target market segment

Think: What product targets you as a customer? Is your geographic location one reason you are targeted? What demographic and psychographic characteristics make you a potential customer for the product?

Act: Use census data to research the location where you or your potential customers live. Decide upon a set of demographic characteristics and find the number of people in your segment. Go online and research lifestyle websites of interest to your potential customers.

Plan: Write a description of your targeted segment clearly stating the geographic area where they live, demographic characteristics, and psycho-graphic tendencies.

Brand positioning strategy

Because many companies sell similar products they must develop a unique brand position. Both the brand and the product can be positioned in relation to competitors, but the purpose and process differ. Product positioning focuses on the benefits of a single product and will answer the question of how it will solve the consumer's problem better than a competing product. Brand positioning informs the consumer how one company as a whole differs from another. A successful method of developing a brand positioning statement is to focus on values.

Identify the company's values: These should have been clearly stated in the mission statement.

Identify competitor's values: Read the mission statements of competitors to learn how their values differ.

Differentiate: Using the mission statement comparison, state how your different values have resulted in a better product.

Communicate: This differentiation communicated visually, and with a few words, should be on all the company's promotion material.

Sullivan 2019

QUESTION TO CONSIDER: What words and images best communicate how my organization differs from my competitors?

After going through the process of segmenting consumers into groups based on geographic, demographic, and psychographic characteristics, more than one possible segment will exist. The next step is to decide which of the possible customer segments the organization will target.

This will involve the decision as to whether to target a single segment or target more than one at the same time. After the organization has made these decisions, they must then position

the benefits of their product in the minds of their targeted customers against the benefits provided by competing products. This is as critical a decision for business success as deciding upon the product that will be sold. After all, there is no business until someone buys the product.

Segmentation strategy—don't target more than you can handle

The creative organization must not only decide what segments to target with promotional information but also how many segments to target. They must decide if they are going to have an undifferentiated strategy where they target everyone, a concentrated strategy where they target a single segment, or a multisegment strategy where they target more than one but not all segments.

Undifferentiated: Some marketers will treat all consumers in the marketplace as an undifferentiated mass of people who will all have the same product needs and desire similar product benefits. This may have worked in the past when there were very few products available so that consumers were happy to purchase any available product. For example, when Henry Ford started to manufacture automobiles at the beginning of the twentieth century, to keep the price low he produced only one standardized model in black. As he was famously quoted, the consumer could have any color automobile they chose as long as it was black. Because the automobile was new to the market and affordable, consumers purchased them in black.

Concentrated: Today there is little room in the marketplace for an undifferentiated product. Even with automobiles, as soon as other inventors developed different models of cars to attract more consumers, choice was provided. As a result Henry Ford also started to offer his cars in more colors than just black. The common marketing practice today is to segment the market into groups of consumers based on similar product needs and desires. The organization then targets a promotional message at the group who are most likely to desire the product. A concentrated strategy is one where a single group of consumers is targeted with a marketing mix of product, price, and distribution that meets their needs. This marketing mix is then promoted with a unique message to this group. For a small

creative and cultural organization, a concentrated strategy is often chosen because only one marketing mix needs to be developed. If the organization grows, they may then decide to target an additional segment.

Multisegment. A multisegment targeting strategy is used when more than one group of consumers are targeted. Even if the groups all want the product, the price, and distribution, may differ. Some groups may not be able to pay a high price so a lower-cost version of the product may be offered. Some groups may want the product but prefer to purchase online rather than in a studio so e-commerce ability may be added to the organization's website. As a result a unique marketing message must be created for each segment. Small companies will most likely have a concentrated targeting strategy as it takes resources to target more than one group. As an organization grows, it may target more segments. While targeting more than one segment requires additional time and money, it can also increase revenue by attracting new consumer segments.

Positioning the product—it's in the eye of the beholder

By now the marketer has determined the product benefits and described the target market segment based on geographic, demographic, and psychographic characteristics. In addition, they have decided to target either a single segment or more than one segment. Now that the organization knows to which segment of consumers the product's benefits will be communicated, it might seem that the process is finished. However, there is one more issue, product positioning, that needs to be considered.

No product is alone in the marketplace. Instead it is grouped in the consumer's mind with competing products, all of which are promoted as having similar competitive advantages. Positioning the product, the final step in the segmentation process, is when the marketer considers how to communicate to the consumer the difference between the organization's product benefits and those offered by competing products. The product can be positioned positively. For example, an organization might promote that buying an original piece of art supports the local economy in a way that buying a mass-produced print does not. The competing product can also be positioned negatively as when it states that

buying a mass-produced toy for a child may be dangerous as harmful chemicals may have been used in its production.

Product positioning can be based on a number of factors. The product can be positioned based on overall attributes such as price or quality. For example, the product might be positioned as being the lowest priced among competing products. If the product cannot compete with competitors on price, the marketer may position the product against the competition as having higher quality. Or the product may be positioned based on specific features that other products lack, such as being the only product that comes with its own carrying case.

In addition, positioning can also be based on the status of the product's brand image. For example, marketers may decide to position buying original student art as having a status that buying a print from a store does not. This is particularly true of services where product attributes can be difficult to compare. For example, attending the first night of a performance does not guarantee better performance. In fact, the opposite is true as there may yet be details to work out. Instead, attending the first-night performance is positioned as a status event. More people can attend a performance at a later date, but only a select few will be able to attend the first night.

Positioning may not stay stable over time. Sometimes the original positioning strategy must be changed to accommodate changing consumer trends. In this case it is said that the product is repositioned. An example might be a product that was originally positioned as low priced. However, if, over time, many other low priced competitors enter the marketplace, then the product may be repositioned as having a unique product feature along with the low price.

Competitive grid—a visual helps see relationships

One method of visualizing the position of the product versus competing products is a competitive grid. This grid consists of two lines intersecting to form four quadrants. Each line is labeled with one of the product's competitive advantages or features most critical to consumers when they make their purchase choice. For example, it might be price, from high to low, and the amount of gluten-free products available, from few

to many, at natural food stores. If there are ten stores in the area, they are all placed on the grid where they relate on price and product availability. It might be found that the quadrant that represents stores with high prices and numerous products include many store names. However, it might be seen that the quadrant with low prices and much availability is empty. Therefore, there is a market opportunity to position a natural food store as the low price alternative for gluten-free products, a quadrant with few stores listed.

THINK-ACT-PLAN: Competitive grid

Think: The last time you made a purchase how did you choose between competing products?

Act: List five products that are sold globally. Now go online to see if the products are changed based on local preferences.

Plan: Prepare a competitive grid of your product and its closest competitors. Do so using a large sheet of paper so that you clearly see the relationships.

Creating the strategic marketing plan

The next step in writing your marketing plan to is to describe your target market segment by their geographic location, their demographic description, and their psychographic characteristics. In addition, the positioning of your product against competitors needs to be defined.

REFERENCES

Alton, Larry. "7 Ways to Segment Your Social Media Audiences." *Social Media Week.* March 10, 2018. https://socialmediaweek.org/blog/2018/03/7-ways-to-segment-your-social-media-audiences/. Accessed January 13, 2020.

Cohen, Heidi. "How the 2015 B2B Purchase Decision Process Has Changed—Heidi Cohen." *Heidi Cohen Actionable Marketing Guide.* N.p.,

February 20, 2015. http://heidicohen.com/2015-b2b-purchase-decision-process. Accessed May 12, 2015.

Goldberg, Michael. "How to Integrate Content into the Marketing Organization." *Dun & Bradstreet.* September 6, 2017. https://www.dnb.com/ie/perspectives/marketing-sales/integrate-content-into-marketing.html. Accessed February 12, 2020.

Graves, Christoper and Sandra Matz. "What Marketers Should Know about Personality Based Marketing." *Harvard Business Review.* May 21, 2018. https://hbr.org/2018/05/what-marketers-should-know-about-personality-based-marketing. Accessed March 20, 2020.

Green, Ben. "3 Differences Bewteen B2C and B2B Social Media Marketing." *Oktopost.* April 10, 2019. https://www.oktopost.com/blog/differences-b2c-and-b2b-social-media-marketing/. Accessed January 31, 2020.

Kowalka, Peter. "Five CRM Trends that are Changing Customer Segmentation." *IT Blog.* August 30, 2017. https://it.toolbox.com/blogs/peterkowalke/five-crm-innovations-youll-see-in-2018-083017. Accessed January 30, 2020,

O'Reilly, Lara. "Some Marketers Moving Away from Dated Gender Targeting, Study Shows." *Wall Street Journal.* January 28, 2019. https://www.wsj.com/articles/some-marketers-moving-away-from-dated-gender-targeting-study-shows-11548673201. Accessed January 12, 2020.

Rogers, Charlotte. "Why Behavior Beats Demographics When It Comes to Segmentation." *Marketing Week.* April 16, 2019. https://www.marketingweek.com/behaviour-demographics-segmentation/. Accessed February 23, 2020.

Smith, Lisa. "8 Audience Targeting Strategies from Digital Marketing Experts." *WordStream.* September 30, 2019. https://www.wordstream.com/blog/ws/2019/04/15/audience-targeting. Accessed February 14, 2019.

Stanford, Kara. "The Six Sages of the Buying Process and How to Build Your Marketing Roadmap." *The Talented Ladies Club.* February 22, 2018. https://www.talentedladiesclub.com/articles/the-six-stages-of-the-buying-process-and-how-to-build-your-marketing-roadmap/. Accessed March 3, 2020.

Sullivan, Felicia C. "Let's Talk About Brand Positioning and Purpose." *Medium.* February 18, 2019. https://medium.com/s/how-to-build-a-brand/lets-talk-about-brand-positioning-and-purpose-b74a51da9896. Accessed February 19, 2020.

Webber, Richard. "Why it's not Racist for Marketers to Treat Ethnic Groups Differently." *Global Market Alliance.* July 5, 2017. https://www.the-gma.com/marketers-ethnic-groups. Accessed January 3, 2020.

Williams, Blair. "How a Community Can Contribute to Building Your Online Brand." *Forbes.* December 3, 2019. https://www.forbes.com/sites/theyec/2019/12/03/how-a-community-can-contribute-to-building-your-online-brand/#720231b5669a. Accessed March 24, 2020.

Discovering product benefits

Chapter 7

This chapter will answer the following questions

- How do consumers and organizations move through the product purchase **process?**
- Why is the **definition** of products so complex and, therefore, difficult to promote?
- How are product **attributes** analyzed?
- What is the process of product **development** for the marketplace?

PRODUCT PURCHASE PROCESS

Consumer relationship with social media is changing

Social media has changed both the way people purchase products and the way products are promoted. In fact it has had such a profound impact that it has changed the way we live, not just buy products. While the use of social media is widespread globally, there are some problems that have resulted. Marketers need to be aware of these issues.

Privacy issues: While people want to use social media to find information online, they do not want social media to collect information on them. Studies have found that a

majority of users are not willing to share information even if it means a more personalized experience.

Mental health concerns: People are becoming more aware that comparing themselves to the idealized life found on social media can lead to dissatisfaction with their own life. They are also more aware that they may be spending more time on social media then they should.

Commercialization: People are unhappy with companies using social media content as a marketing tool. While people are not interested in traditional promotional messages, they also resent marketing messages that are concealed in entertainment.

Siu 2019

QUESTION TO CONSIDER: How will my organization address the public's concern for online privacy?

The initial stages of a strategic marketing plan have been conducted resulting in a strategic goal supported by objectives and tactics. In addition, a segment of potential customers has been targeted. Now it is time to focus on developing the marketing mix of the product, price, distribution, and promotion. It might be tempting for someone in charge of marketing to immediately start considering how to price, distribute, and promote the product. However, to do so without first establishing how the product might need to be enhanced to meet the needs of consumers would be foolish.

The first consideration is how the organization can encourage the consumer to move through the purchase process. The purchase of a product starts with the recognition of the need and ends when the product is in the home of the customer. This process can be disrupted at any point, resulting in the consumer not making a purchase. The first issue to understand is that there are different types of decision-making based on the complexity and cost of the product. Usually the more complex and costly the product, the more time will be taken in making the purchase decision. However social media has now changed this assumption (Hellenkemper 2017). Seeing expensive products on sites such as Instagram or YouTube can lead to an emotional

response that an ordinary ad might not elicit. Recommendations from people that are admired and followed on Twitter can also lead to immediate purchase. The emotions that can be triggered by visuals and also recommendations include love, envy, and pride. Rather than spend time on doing research on other product alternatives, the consumer may purchase immediately.

Types of consumer decision-making—more money, more care

Consumers may not always consider the process they go through when deciding why or how to purchase a product. However, marketers must understand this so that the correct promotional message can be provided at the appropriate time in the product purchase process. Products can be categorized by three methods used when buying or purchasing. The promotional message and how it is communicated will differ depending on whether the product purchase process is routine or involves limited or extensive research.

Routine: Some products are purchased routinely without much thought. These are products, such as soap, that are inexpensive and widely available. Because of these facts, if a wrong purchase decision is made, the consequences are not serious. A wrong choice of soap can be discarded, and the product purchased again. What has changed is that even a routine product can now be marketed as a category that needs to be researched (Watamanuk 2018). Soap can now be sold as a luxury product, a health product, or a status product. This trend has been reinforced by Instagram sites and influencer recommendations. Social media can now be used by organizations to show that a formerly routine product is now specialized by using handcrafted techniques or natural ingredients to reach a segment of consumers that are willing to pay more.

Limited: Products that are more expensive and complex require limited involvement resulting in the consumer spending more time making the purchase decision. To help them do so, the organization must provide information to consumers on the product's features and benefits. With this type of product purchase, the consumer has familiarity with the product category but not with all the brands that are available. To

encourage purchase, the organization must explain their product's competitive advantage. For example, if consumers are shopping for an original print for their home, they already know that there are many different artists from which they can purchase. They need to know that they will find the information online or in the gallery on how the artists differ and why the purchase price is appropriate. Because the price is higher than that of a mass-produced print, they do not want to make a wrong decision as they may not be able to return the purchase. This decision can be heavily influenced by recommendations by other consumers. Since marketing communications are not trusted, the organization must ensure that potential consumers see recommendations by linking them to their own social media and website.

Extensive: Purchases that require extensive involvement are high priced and complex. If a consumer is considering a purchase of an expensive piece of digital art or garden sculpture, they will want information provided on the process of creating the product and also information on the creator. Because the risk of making a wrong decision will be costly and also very visible, more than one consultation may be necessary before the purchase decision is finally made. The marketer must not only provide information but use sales techniques to help the consumer through the purchase process. Again, technology has changed this process. Instead of taking the time to make a call or visit a store, the consumer will expect to be able to use technology such as a chatbot to get immediate responses to requests for information. They may also tweet their questions. Getting information with these methods allows even products requiring extensive research, such as works of art, to be bought online. While at first resistant, the art world now understands that consumer purchasing behavior has changed and some traditional galleries are being closed with sales moving online (Beard 2017). Consumers now rely on online research for almost all types of products, even those that are expensive and complex.

Consumer buying process—shortened by social media

The traditional purchase process for consumers consists of need recognition, search for information, evaluation of alternatives, purchase, and postpurchase assessment. While this model is

still useful for many products, creative and cultural products are often promoted via social media. In addition, even if they may not be purchased online, they will be researched online. As a result, a new purchase process model has been developed consisting of three steps of awareness, consideration, and purchase. It is not always a linear journey. A consumer may see a product on Instagram they decide to purchase, but first take the time to do research.

Awareness: In a traditional marketing model, the first step is the consumer seeking out information to meet a need or solve a problem. As a result, traditional print promotion started with advertising to communicate the fact that a product existed to fill the need or solve the problem. However, now it is more likely that a consumer will come across a product through casual online browsing or through the use of social media. As a result, they will first discover the product and then realize it can improve their life in some way. Therefore, the marketer must use not only their own website but also social media, including blog posts, and posting photos and videos on other sites to build awareness of their product.

Consideration: Once the consumer is aware of the product, the consideration stage involves the consumer searching for more information. Marketers must understand that that there is an abundance of easily assessable, already existing information about products online. However, marketers can still influence consideration by using promotion to direct consumers to their own website where customer reviews, photos, videos, and detailed information can be provided. It is essential that the organization also have their voice heard during the consideration process. If they are silent the consumer will believe any negative comments they find online are true. Therefore, the organization must ensure that their positive message is communicated using as many social media sites as possible.

Purchase: The final step in the process is purchase of the product. Consumers want the purchase process to be as convenient as possible. They may take considerable time during the consideration process reading reviews, examining the company's website, and talking with others. However, when

they finally decide to purchase, they want to do so immediately. How they prefer to purchase will vary. Even if they spend most of the consideration process researching a product online, when the time comes to purchase, they may decide to do so in a store. If so, they demand quick customer service. In contrast, they may do their product research in a store but then decide to purchase online so the product is shipped to their home. They may even purchase online, while they are still in the store. The organization needs to ensure that the consumer can purchase with the method they prefer. If there is any inconvenience in the process, the purchase may not take place and a competing product may be purchased.

Business buying process—focus on factual needs

Rather than sell a product to individuals, the organization may decide to market their product to other businesses, governments, educational institutions, or nonprofits. Even though the selling and purchasing organizations are both nonprofits, this is still referred to as business-to-business marketing. The reason for selling a product to a business is the same as the reason for selling to a consumer: the sale provides revenue to the company. However, it is often advantageous to sell to a business as they may buy in more quantity than a single consumer. A creative or cultural organization may decide to sell their product to a business, such as local corporate headquarters, or a nonprofit, such as a museum or a school. In addition, they may also decide to sell to a reseller, such as a retail store, who will then sell the product to the ultimate consumer.

When selling a product to a business, it must be understood that as the buying process is different, a separate promotion strategy must be designed. The promotion strategy used to communicate with the consumer target market segment will not necessarily be effective when promoting the same product to a business. Therefore, if the organization is selling to businesses, a different promotional strategy will need to be developed. If the creative or cultural organization is selling to retailers, the organization will need to design two promotional strategies. The first will communicate a promotional message to the retailer. A second promotional strategy will be aimed at consumers to build

demand for the product and also to create awareness that the product is available at a retail location.

In the past, business purchasers have had an entirely different motivation for purchase than do individual consumers, so they used different evaluative criteria. While individual consumers may purchase for emotional reasons based on the organization's brand image, business customers' most important criteria when making a purchase decision have been quality, service, and price. However due to the demands of consumers for organizations to live up to social and ethical standards, a fourth criterion of reputation enhancement has been added (Almquist, Cleghorn, and Shere 2018).

Quality: The first issue is product quality, which refers to more than having the product with the best features and benefits. In business purchasing, the word quality is used more broadly and refers to the product's ability to meet the required specifications. For example, a government agency may be buying art for display in a building. Because money from taxpayers is being used there may be certain requirements that must be met to ensure that the art will not offend. In fact, it may not be an individual decision but rather a purchase decision based on a checklist of specifications the product must meet. Nonprofit organizations that are purchasing may also have a need for the product to meet specifications. For example, a performing company may be hired for a specific group such as autistic children. Of course, the performance should be of high quality, but it may also need to meet certain specifications on action and noise. When retailers purchase to resell they will also be concerned that the purchase be attractive to their existing market segment of consumers. If it is not, no matter how high the quality, they will not be interested in purchasing.

Service: The second criterion that a business purchasing a product will consider is service. The organization making the purchase will want to ensure that any problem with the product will be addressed immediately. An individual will be unhappy if there is a problem with a product they purchase as they will have to face the inconvenience of returning it to the producer. However, a business does not have the time for this type of inconvenience as they may have purchased a large quantity of

the product. To ensure this does not happen, a business that is making a large purchase may want the creator of the product to be present at a meeting to explain the process of production. In addition, they may wish to see a sample of the product. A retailer who is purchasing products may want to see the financial records of the producing company so that they can be reassured that the creator of the product is financially secure. They want to be assured that the company will continue to be in business so that they will be able to fill any future orders in the required time frame.

Price: The final criterion for a business to purchase a product is price. Individual consumers may be convinced through the sales process to purchase even if initially reluctant to do so because of the price. However, organizational purchasers may be inflexible on price as the cost must fit within their budget. While promotional material or a good sales technique may convince an individual to spend more than originally contemplated, this will rarely work with institutional purchasers.

Selling to a business is often a multistep process. First, the purchase decision may not be made by the individual who does the purchasing. Instead, the purchasing may be handled through a separate department that has procedures it must follow. This is done in order to ensure that more than what is budgeted is not spent. In addition, because the purchase might involve a large amount of money, the business wants to ensure that the decision is not swayed by any personal relationships. The purchase decision may need to be approved by both the individual or department that wants the product and the purchasing department. As a result, the marketer must research who would be the best person to approach with the initial idea. In addition, the marketer must understand the criteria of the purchasing department. If both the individual and the purchasing department approve, the idea may then be referred to a committee to get budget approval.

Reputation: Consumers are increasingly concerned with how companies source raw materials, including safety and sustainability. They are also concerned with where and how component parts are manufactured. For this reason, a business buyer may ask the producing company the source of the raw

materials they use to see if they might cause any harm. Even if science has proven there is no risk, the business must still take into account the public's safety concerns. In addition there may be political concerns over where component parts are manufactured that need to be addressed. Creative and cultural organizations should promote their products to businesses with these issues in mind (Esposito, Tse, and Soufani 2016). Businesses that purchase products for resell know that they must maintain their reputation with the public.

THINK-ACT-PLAN: Purchase process

Think: What was the last product you purchased? Was it easy to understand or complex, expensive or low cost? Now describe the process you went through when you purchased the product.

Act: Find an expensive and complex creative product on a website. Analyze how the information provided about the company and product will help the consumer move through the buying process toward product purchase.

Plan: Write a description of the buying process that a consumer and business might go through when they purchase your product.

DEFINITION OF PRODUCTS

Even social media sites have a product life cycle

All products have a life cycle of introduction, growth, maturity, and decline. New social media sites are constantly introduced by tech-savvy entrepreneurs. Understanding the product life cycle of these sites can help answer the question of which sites your organization should use.

Introduction: When you become aware of a new site that you think might be a useful marketing tool, try it out personally. You can then experience the site as your

customers will do so. Ask yourself if the features it offers will be of interest to your target market segment. Most social media sites will die at this stage.

Growth: If the site becomes popular, it is in the growth stage. Many new features may be introduced while some will be removed depending on the preferences of users. Because you are already familiar with the site, you will be well placed to take advantage of its commercial applications.

Maturity: At maturity, everyone has heard of the site. At this stage, certain groups of consumers may expect organizations to have a presence. If you do not, you will be considered to be irrelevant. It is difficult to be heard if you are not already on the site.

Decline: Decline happens when the site has been replaced by a new site that better meets the needs of users. This can be because it has additional features, or it simply can be because of a trend. Having a presence on a site in decline can make consumers feel that you are not current with trends.

Keeping up with social media is a constant issue that must be part of the marketing plan.

Morgan 2018

QUESTION TO CONSIDER: How will I know it is time to change the social media sites I am using?

At first, the idea of a product seems simple to grasp. It is something that is exchanged for money to meet a consumer need. In reality, the idea of a product is more complex. First, in a technologically advanced world the nature of products is blurring. Now, the distinction between a physical product and an intangible service is no longer clear or even relevant. In addition, products do not remain static but go through a life cycle. Finally, interest in products moves through portions of the population in a predictable process called diffusion.

Defining the product—there is more to a product than what it does

The definition of a product is more complicated than it might first appear. The first concept to consider is the difference between a

tangible product and an intangible service. While the distinction might first seem obvious, it is not as clear as it appears, particularly in the creative and cultural industries. There are some products, such as a can of soup, that are simply tangible products. A consumer buys the can of soup and as a result will eat lunch. No service is provided and consumers must open the can and heat the soup themselves. There are also some services that are simply services. When getting a car wash, there is no other product involved than washing the car.

However, in the creative and cultural industries, the line between a product and service is often blurred. A tangible good such as a sculpture is a different type of product than a can of soup. If the sculpture is large the purchaser may also want the service of delivery and installation. If the sculpture is meant to be placed outdoors, they may want a service warranty against winter damage. If the sculpture is expensive, the purchaser may expect to not only buy the product but also be provided with the service of interacting with the artist so that he or she can explain the motivation for the creation of the work. No one is interested in interacting with the factory worker who produced their can of soup.

An intangible service, such as a performance, also may include tangible products such as programs, recordings, or T-shirts. These may be included along with the price of the product to motivate purchase. If sold separately, these tangible products may produce a significant percentage of the overall revenue.

Product life cycle—life and death are a certainty even for products

No product will sell forever. All products have a life cycle because the environment in which they exist is continually undergoing change. The product life cycle consists of introduction, growth, maturity, and decline. When most new products are introduced into the marketplace, they need to be priced attractively and promoted heavily so that awareness is built. At this stage, distribution may need to be adjusted based on where the best sales are taking place. Money must be spent during this stage of product introduction even though revenue

will be low, resulting in little or no profit. If the product is not desired by a sufficient number of consumers, the company will eventually run out of money to pay the bills, the product will fail, and the money spent will be lost. Social media is very useful during this introductory stage as it is a cost-effective means of reaching potential customers. It is also useful as it provides immediate feedback from consumers during the introductory stage (Nambiar 2017). If there is a problem with the product design or a desire for an additional benefit to be added consumers will post this information on review sites.

However, if the product does gain acceptance and sufficient purchases are made, it will move to the next stage, which is market growth. At this stage, sales, along with profits, increase. It might seem that this state of affairs might continue forever with ever increasing revenue as more and more people purchase the product. This does not happen, as one of two situations will lead to product maturity. First, the product may reach all consumers in the target market so sales will level off. Second, competing organizations seeing the consumer demand will enter the market with their own product and take sales from the first product that was introduced. As a result, sales will no longer grow.

Finally, the product will go into decline. At this stage, the public no longer sees a need for the product because competing products are superior, and the original product will be withdrawn.

Marketing mix changes: With each phase in the product life cycle, the marketing mix must change. While promotion in the introductory stage will be used to build awareness of the product, during the growth stage, less promotion will be needed. During the introductory stage, lower pricing may be used to motivate sales, but this can be stopped in the growth stage. When sales growth starts to decline, the product has entered the maturity stage. Promotion at this stage will switch to comparing and contrasting the product with others in the marketplace. In addition, promotion will use sales incentives to try to keep consumers loyal to the brand.

When a product is in decline, promotion efforts are made to retain customers. However, at this stage promotional messages

will only be aimed at those who are already purchasing the product. Prices will not be reduced in an effort to increase sales as there is little chance that new consumers can be enticed to try the product. At some point, sales will decline to the point where the product must either be revamped and reintroduced to the marketplace or withdrawn.

Diffusion of innovation—why some people buy first

Another issue that is imperative to understand when dealing with creative products is how their adoption by consumers spreads through the population. The diffusion of innovation model describes five groups of consumers who sequentially purchase a new product (Rogers 1995). While this theory has been used for years to describe how different groups react to the introduction of new products, how the groups find information about products has been changed by the use of social media (Assenova 2018). Social media has shortened the time a product needs to go from innovators and early adopters to the mass market of early majority. The early majority wants to avoid the risk of a purchasing mistake, and as a result, they want recommendations on the product. In the past, they would have needed to wait until someone they knew personally purchased the product. Now social media makes recommendations, both verbal and video, immediately available once a product is launched. As a result, both the success and the failure of a product become a reality more quickly than in the past. The first group, innovators, is only 2.5 percent of the population but has the resources and willingness to try new products. They may not be willing to try all new products. Instead, there is a product category, whether technology, art, or sneakers, whose trends they follow and whose new products they purchase as soon as they are available. Much of this information now comes through following trends on social media. Innovators will then post photos of themselves with the product on sites such as Instagram, Facebook, and YouTube.

Early adopters make up 13.5 percent of the population. They will purchase the products that the innovators are already buying. Social media plays a key role in this process as early adopters will seek out websites and blogs that communicate

the latest trends that innovators have embraced. Once the innovators and early adopters have purchased the product, it has reached a tipping point. The next step is that products move into the mass market of early and late majority. Early adopters look for validation on their choice by following social media. The more complex or fashion forward the innovation, the more validation through postings will be needed.

The early majority, 34 percent, will purchase the product once it is confirmed as useful and acceptable by the innovators and early adopters. They will find this information through online recommendations. At this stage it is said that the product has reached the mass market. There will be general consumer awareness of the product and consumers will not need to search out information.

Of course, at this point in the product's diffusion through the population, the innovators will have stopped purchasing and will be searching for the next new product. The late majority of 34 percent will purchase when they see that others in the mass market have purchased and like the product. They want personal assurance from their neighbors and do not rely on promotional messages. The last group, laggards, is 16 percent of the population. They are reluctant to adopt any new product and are, therefore, not the focus of promotional messages.

THINK-ACT-PLAN: Product qualities

Think: What product have you purchased that was both physical and also provided additional services? Think of yourself as a product. What stage of the product life cycle are you in? If you were a product, which group of consumers in the diffusion model would you attract?

Act: Look around the room where you are located and name the stage of the product life cycle for three products that you see.

Plan: Describe how what you create can be considered both a product and a service.

Social network? Customer experiences network!

While most businesses continue to think of social media as a marketing tool its best use might be as a customer service tool. Rather than think of it as a way to sell a product, social media can be used as a means of managing the entire customer experiences from awareness to post purchase. Four behaviors that can help the organization manage this process are listed below.

Prompt response: When contacting organizations via social media, consumers have become accustomed to a prompt response. This is true whether the problem is critical or simply annoying to the customer.

Always follow up: It isn't enough just to solve the problem, managing the customer experience also using social media to follow up to see if the problem is solved.

Personalize feedback: No one should get a canned response back to a complaint. The response needs to be personalized by using the consumer's name, referencing the problem and, if the problem can't be solved immediately, giving a timeframe for getting back in touch.

Pay attention: Don't just solve the problem, use the information received to improve the product. Consumer expectations are constantly changing and any communication can provide useful data.

Newman 2016

QUESTION TO CONSIDER: What social media methods do we use to manage the customer experience?

As discussed earlier, every product has a competitive advantage, which positions it as different from competing products. This competitive advantage is often the core benefit that the product provides to the consumers. However, some competing products have the same core benefits, which

present a challenge to marketers as they must find some way to differentiate their product against those of the competitors. If the core benefit offered is the same, the product may be positioned as being different based on actual product attributes, which include features such as design, quality, or price. In addition, the product may be differentiated based on the augmented product characteristics such as brand image and additional service. Very frequently with creative and cultural products, the augmented benefits include the values of the organization and are a means of differentiating the product to consumers.

Differentiating the product
- *Core:* Reason the product exists
- *Actual:* Product attributes
- *Augmented:* Intangibles of image, service quality, values

Core—without a core, there is no reason to exist
The core benefit of a product is the main reason for purchasing the product. If the product does not provide such a benefit, there is no reason for the product to exist. For example, no one buys laundry detergent to merely have it sit on a shelf no matter how attractive the package. Instead, it is bought to get clothes clean. Clean clothes are the core benefit without which no one would purchase a detergent. The issue when promoting a creative or cultural product is that the consumer may not understand the core benefit the product provides. Therefore, the purpose of the promotional information is to inform them of the benefits they will receive.

Another challenge for marketing creative and cultural products is that even when the core benefit for the product is understood, the consumer may not be able to distinguish between competing products. For example the consumer may understand the beauty that a photograph provides but still see all photographers as similar. As a result they may make their purchase decision based solely on price. If the marketer cannot differentiate on core benefits, they need to differentiate based on actual, or augmented benefits.

Actual—you get more than just the core

If the core benefits for competing products are the same, the competitive advantage is based on the additional benefits the product attributes provide. For photographs, the actual benefits might be something that appeals to the senses such as the vivid colors or the subject matter such as ocean views. Another example of an actual benefit might be convenience. In this case such beautiful handcrafted dishes would also be promoted as dishwasher safe. For creative and cultural products that are live performances, the marketer might promote an actual benefit such as the opportunity to socialize with friends.

Augmented—some products even give more

More product differentiation can take place by focusing on augmented benefits the product may offer. For example, consumers can be motivated to choose a product over its competitor based on the brand image of the company. This brand image may resonate with consumers because they aspire to be what the product represents. For photographs, the photographer might have a brand image as being current with new trends. As a result, purchasing a photograph would communicate that the purchaser is a trendy young urbanite. In addition, a creative product might provide the augmented benefit of personalized services. For example, the photographer may agree to visit the purchaser's home to help with the decision on the framing and the placement of the photograph.

Augmented benefits can also incorporate the mission, vision, and most importantly, the values of the organization. Many consumers believe that the business' stand on social concerns is just as important a criterion in making the purchase decision as core benefits (Vranica 2018). Most creative and cultural organizations are motivated to be in business for more reasons than just selling a product. It is probable that this mission includes making the community or the world better in some way. For example, a consumer might purchase a product because of the benefit of being associated with the environmental policy of the company. By doing so they feel they are also part of this mission or movement.

THINK-ACT-PLAN: Product analysis

Think: If you were a product, what is your core reason for existence? Do you provide any actual and augmented benefits? Does your personal mission in life add to your value as a product?

Act: Find an expensive and complex creative product on a website. Analyze if the information provided about the company and product will help the consumer move through the buying process toward product purchase.

Plan: Write a description of your product. Now draw the product. List on the sheet next to the product the core, actual, and augmented benefits of the product.

DEVELOPING NEW PRODUCTS

Creative ideas for test marketing a new product

If your organization has an idea for a new product, before production starts you will want to test the market to see if consumers are interested in purchasing. Of course you can do traditional survey and focus group research. But this can be costly and take time. There are several other ways that testing the market with a new product idea can be done early in the product development process.

Talk to people: Go to where potential customers already congregate and show them your product. Then ask for feedback. This way any improvements of changes in the product can be made before production starts.

Test 'ugly': If your product is expensive and time consuming to produce you may not want to wait until you show it to potential customers. You can share the idea early in the development process and then finish when you know exactly what benefits are desired.

Start a website: Even if you are not ready to go to market, you can launch a website to gauge consumer interest. Talk about the upcoming product and then ask for contact

information. Not only will you be able to tell if people are interested, you will then be able to provide them with more information once the product is available.

Detweiler 2019

QUESTION TO CONSIDER: What process does my organization use to test new product ideas?

While the creative and cultural organization may have been started to produce and market a specific product, as time goes by, creative people will come up with new ideas of what they would like to produce. Sometimes, these ideas will arise spontaneously, but at other times, it will be part of a deliberate process. In fact, an understanding of the product development process can be a spur, and not a hindrance, to creativity.

Sources of new product ideas—look around and they are everywhere

Traditionally, new product ideas have arisen from three sources, which include trends, gaps in the marketplace, and unsolved problems. First, trends in the external environment can be a catalyst for developing new products. For example, if everyone is using their cellphones to take pictures, then any product, such as a telescoping attachment or a case with revolving lenses that make this process easier, will probably find a market.

The second source of new product ideas is gaps in the marketplace. If it is seen that toddlers love to play with their parents' cellphone, which their parents do not love, then a realistic looking cellphone toy for toddlers should find customers. Lastly, unsolved problems can be a source of new product ideas. Parents who live in an area where it only snows once or twice a year may be unhappy that each year they must pay for an expensive snowsuit for the rare occasions when their child wants to play in the snow. Therefore, a snowsuit that is adjustable and will be wearable for more than one year should be able to find customers.

Crowdsourcing—many heads are better than one

Organizations should take advantage of the innovative ideas already available online. Social media can provide an unending

source of information on trends and ideas. It is the least expensive and easiest form of research into what type of product innovations are on the minds of consumers. For example, simply browsing through sites that allow consumers to post images will show how people are decorating their homes. Fashion sites can show how people are choosing to dress. While most people use these sources to find ideas to improve their lives, marketers can find ideas to improve their organization's product portfolio.

Crowdsourcing is a term that simply means getting ideas or resources from a group. Probably, its best known use is to raise funds by promising an incentive or offering the chance to support a cause. There are also crowdsourcing sites that are specifically devoted to product design where both amateurs and professionals can post ideas and ask for feedback. In addition, digital products can now be beta-tested using social media sites.

Crowdsourcing can also be used by organizations in ways other than just finding inspiration for new products. It can also be used to name current products, improve current products, and approve new product ideas (Bunskoek 2014). First, an organization can use crowdsourcing to have a contest for naming a new product. While the organization can certainly develop a name on its own, it can only appreciate the product from its own viewpoint, not the customers'. A Twitter or microblogging campaign can be developed to solicit name ideas. Not only will the organization receive insights, it usually does not have access to without conducting research, the contest will also build excitement for the product launch.

Social media can also be used to get consumer involvement for other types of product decisions. If the organization has several ideas for new products, they can use social media to ask for inputs into which idea should be developed. An organization can create a brand community site to present the competing ideas and allow for voting. These brand communities allow the most interested users of the product to contribute their ideas (Balkhi 2019). To incentivize participation, a discount can be offered for the new product that is chosen.

Some organizations may not have the resources to launch a new product. In this case, a blog entry can be posted asking

for suggestions for variations or improvements on a current product. Since consumers will use products in ways not imagined by the organization, the comments should provide new insights. Finally, a website page can be devoted to asking for entirely new product ideas. This can provide inspiration for the organization even if no new viable products can be developed. It will still be useful as a means for the organization's customers to share among themselves.

There are two problems businesses can have with using online comments, blog posts, and other consumer data to provide information on new product ideas (Shaw 2015). First, there is no way to know anything about who made the comment. Second, the sample of people who comment online is only a small percentage of people who use the product. The first problem of not knowing anything about the demographic or psychographic profile of the commenter can be reduced by research using specific product review websites rather than the entire online world. A profile of the users of these websites can be developed. The second problem can be addressed by understanding that even though the number of commenters is small compared to the entire population of users, it can still a higher percentage than other methods of traditional research.

Product development process—don't just rely on luck

A large company may have an organized product development process. In fact, they may even have an entire department devoted to the research and development of new products. Small to mid-sized creative and cultural industries are not likely to do so. However, all marketers should consider that current products may become less profitable as they move through the product life cycle and need to be replaced. Before this happens, new products should be introduced so that revenue does not decrease. The product development process is normally described in five steps of idea generation, screening, evaluation, development, and commercialization. In the usual process, ideas for new products are generated from current customers, competitors, and marketing research. The ideas are then screened for those that are most likely to be successful. The next step would be to develop a sample product and test the market to

determine if it will be successful. Finally, the product would be sold commercially.

Idea generation: This step of the development process is different for creative and cultural products. The ideas for products do not come from a separate department or from employees specifically designated to develop new products by looking at consumer needs. Instead, it is the creative talent that is inspired to produce new products, and it is marketing's role to find the potential consumers to whom to promote. The creative idea may have arisen from internal inspiration or from having seen or experienced something in the outside world. Some organizations are using internal crowdsourcing as they realize that their creative employees may have ideas of which potential consumers may not have thought. This type of crowdsourcing is particularly useful in organizations where employees are geographically distant as they don't have the usual opportunities to casually interact and share ideas (Williams 2019). With this type of product development, the idea for a new product probably did not arise from a consumer need. Therefore, it is marketing's role to take the product idea and determine if it does fit with a consumer trend, gap in the marketplace, or solve a consumer problem.

Idea screening: Idea screening is the stage in the process when only those ideas with market potential would be further developed. New product ideas would be screened to ensure that they fit with the mission of the organization. In addition, the new product must fit with the already existing objectives of the company such as a decision on which consumer market segment to target. It would also be the marketing department's job to analyze if there will be a sufficient return on the investment required to develop the new product.

However, in creative and cultural organizations, this process is changed. Since the creative abilities of the employees are the focus of the organization, fitting in with the mission should not be a problem. However, when the creative talent is inspired to produce a product, it may be that the objectives of the company will change. Marketing may need to consider whether a new market segment or distribution strategy will be needed for the successful promotion of the product.

It is most likely that the creative talent has not spent a great deal of time thinking about the revenue potential of their product. Therefore, marketing must work with the creative talent to ensure that either the cost of production is kept low enough to ensure a profit or that a higher price will be acceptable to current customers if promotion is used to explain the product's value. However, it may be that marketing will need to find a new group of consumers willing to pay the price.

Idea evaluation: Marketing will play a critical role in the idea evaluation stage. When considering the introduction of new products, research should be conducted on the reactions of consumers. This research will provide consumer feedback not only on issues such as style but also on more fundamental issues such as design. Marketing will play the liaison role to determine how much the creative talent is willing to change the product based on this feedback. For features that will not be changed, it will be marketing's responsibility to use the research to determine the best promotional communication to explain the product's features and benefits to the targeted consumer segment.

Test marketing: The fifth step in new product development is concerned with test marketing the product. This will include developing a tentative marketing mix of price, distribution, and promotion strategies. This is a critical step for mass-produced goods where millions of dollars may have been spent on getting the product to this stage. Going forward with mass production and distribution of a product that ultimately fails would mean even greater losses.

This process can also be seen with expensive creative and cultural products such as a Broadway show, where out-of-town trials are run before the show is booked into larger, more expensive theatres. However, the process can be simpler for less expensive creative and cultural products. Simply displaying a few of the new products in a retail outlet or holding a show or open house where customer feedback is received should provide enough information on whether it is a good idea to increase production.

It is in the nature of creative talent to want to develop new ideas, and the marketing department's job to make this process

Discovering product benefits

easier. However, it is also part of marketing's responsibility to remove products from the portfolio. This decision may be reached because the product is no longer producing any revenue. However, sometimes this decision is reached simply because there are too many products to produce and distribute efficiently. In this case, a discussion needs to be held with the creative talent. It may be that there are products that artists want to produce to meet their emotional needs even if they do not sell well.

THINK-ACT-PLAN: New product development plan

Think: What problem do you encounter on a daily basis that annoys you. Can you think of a new product that would solve the problem? Describe the product.

Act: Go online and search for a new product in a specific category with which you are familiar. Analyze why you believe the product will succeed or fail.

Plan: If you will need to develop a new product for your company, how will you go through the development process? Provide a development plan with both a timeline and task assignments.

Creating the strategic marketing plan

The next step in your marketing plan is to describe your product. List the core, actual, and augmented attributes of the product. Now define which of the benefits will be the focus of promotion to the target market segment.

REFERENCES

Almquist, Eric, Jamie Cleghorn, and Lori Shere. "The B2B Elements of Value." *Harvard Business Review.* March to April 2018. https://hbr.org/2018/03/the-b2b-elements-of-value. Accessed January 7, 2020.

Assenova, Valentina. "How Social Networks Contribute to the Spread of Unproven Innovations." *Knowledge@Wharton.* May 14, 2018. https://

knowledge.wharton.upenn.edu/article/can-innovation-spread-faster-through-social-networks/. Accessed March 12, 2020.

Balkhi, Syed. "Why You Should Create an Online Brand Community (and How to Start One)." *AdAge.* November 11, 2019. https://adage.com/article/industry-insights/why-you-should-create-online-brand-community-and-how-start-one/2217586. Accessed February 22, 2020.

Beard, Garret. "How Artsy Finally Convinced Galleries to Sell Fine Art Online." *The Verge.* July 18, 2017. https://www.theverge.com/2017/7/18/15983712/artsy-fine-art-galleries-online-auction-sales. Accessed March 17, 2020.

Bunskoek, Krista. "4 Ways to Crowdsource Product Ideas Using Social Media Contests." *Social Media Examiner RSS.* March 30, 2014. www.socialmediaexaminer.com/4-ways-crowdsource-product-ideas-using-social-media-contests. Accessed May 13, 2015.

Detweiler, Gerri. "5 Creative Ways to Test-Market a New Product." *Forbes.* September 29, 2019. https://www.forbes.com/sites/allbusiness/2019/09/29/test-market-new-product-tips/#23dbf2a7ce26. Accessed March 17, 2020.

Esposito, Mark, Terrence Tse, and Khaled Soufani. "Companies Are Working with Consumers to Reduce Waste." *Harvard Business Review.* June 7, 2016. https://hbr.org/2016/06/companies-are-working-with-consumers-to-reduce-waste. Accessed March 3, 2020.

Hellenkemper, Mona. "Emotional vs. Rationale: How Social Media Triggers Consumers' Buying Decisions." *Influencer.* June 14, 2017. https://influencerdb.com/blog/emotional-vs-rational-purchases/. Accessed January 6, 2020.

Morgan, Carol. *Social Media Marketing for Business.* Washington, DC: Builder Books, 2018.

Nambiar, P.K.D. "Digital Marketing: Breaking the Span of Product Life Cycle." *Insight Innovations.* April 16, 2017. https://www.insightssuccess.com/digital-marketing-breaking-the-span-of-product-life-cycle/. Accessed January 22, 2020.

Newman, Daniel. "Social Media is No Longer a Marketing Channel, It's a Customer Experience Channel." *Forbes.* January 12, 2016. https://www.forbes.com/sites/danielnewman/2016/01/12/social-media-is-no-longer-a-marketing-channel-its-a-customer-experience-channel/#66d9465e63a5. Accessed March 3, 2020.

Rogers, Everett M. *Diffusion of Innovations.* 4th ed. New York: Free, 1995.

Shaw, Richard. "The New Innovation." *Marketing Insights* 27.1 (2015): 36–40.

Siu, Eric. "The Changing Position of Social Media Change in 2020: What Does it Mean for Marketers." *Impact Brand.* November 25, 2019. https://www.impactbnd.com/blog/changing-position-of-social-media-in-2018-marketers. Accessed January 9, 2020.

Vranica, Suzanne. "Consumers Believe Brands Can Help Solve Societal Ills." *Wall Street Journal.* October 2, 2018. https://www.wsj.com/articles/consumers-believe-brands-can-help-solve-societal-ills-1538478000. Accessed March 24, 2020.

Watamanuk, Tyler. "When Did Soap, Once Simple, Become Complicated?" *New York Time.* July 11, 2018. https://www.nytimes.com/2018/07/11/style/whats-the-best-soap.html. Accessed February 14, 2020.

Williams, Henry. "Companies Turn to Internal Crowdsourcing to Pick Best New Ideas." *Wall Street Journal.* June 10, 2019. https://www.wsj.com/articles/companies-turn-to-internal-crowdsourcing-to-pick-best-new-ideas-11560219060. Accessed March 1, 2020.

Determining the product price

Chapter 8

This chapter will answer the following questions

- Why is it necessary to understand how price represents the **exchange** of money for value?
- What effect does the difference between fixed and variable **costs** have on the pricing decision?
- What are some pricing **methods** that can help determine the product price?
- How do other unique **challenges** affect the decision of how to price products?
- What pricing **strategies** are available to increase sales?

EXCHANGE OF MONEY FOR VALUE

Pricing per hour can cost you money

The easiest way to price a product is a set price for every product you sell. Because you produce different products, this would result in some priced too high while others were priced too low. A bit more complicated is to charge by the hours that you spend on a project. One problem inherent in pricing by the hour is that as you become more efficient at producing a product, it will take less time. Therefore, your price will decline. There are two advantages of value-based

pricing where the price is determined by the value received by the customer rather than by the hour.

Increased revenue: If you set a price based on the hours it takes to produce, as you become more efficient in producing the product, the price will decline meaning less revenue per product. With value-based pricing, revenue for the same period of time will increase as you make more products in the same amount of time.

Sell value: This method forces you to learn how to market the value of your product. After all the consumer doesn't care how long the product took to produce. They want to know what it will do for them.

Miliates 2020

QUESTION TO CONSIDER: What argument could be made for a high price for your company's product?

Today so many purchase transactions are electronic that the origin and purpose of money might be forgotten. However, considering the development and uses of money will help when thinking through pricing issues. Before the advent of money as a separate physical commodity, any transaction between people that was not a one-way gift was conducted as barter, or exchanges of one good or service for another. The only way for a person to obtain a product they needed was to exchange something they already had. The use of physical money, which is said to have intrinsic value, is an improvement over the barter system as money is convenient to carry, is divisible into smaller amounts, and can be used to purchase anything, unlike exchanging a chicken for a pair of boots.

Money allowed for the development of markets for goods. Markets are defined as a place, either physical or virtual, where money is exchanged for goods and services. Markets create wealth, which is a bit of economic theory that is useful to understand. When someone agrees to pay an amount of money for a creative good, they are saying that the product is more valuable to them than the amount of money. Therefore, after the purchase they have increased their wealth. They are happier with the product than they were before the sale when

they only had the money. Likewise, to the seller the money is more valuable than the creative good as the money will allow the creator to buy something else they may need. As a result the seller also has more wealth with the money, than they had before the sale.

Demand, supply, and prices—a delicate economic balance

Too often, companies think that if the product is of good quality and is heavily promoted, customers will pay any price that is asked. However, this is a misconception of how the marketplace for products works. In the end, only the consumer can decide if the price is correct. Pricing is further complicated by the availability of information on price aggregator sites where the prices for many similar products are compared (Heda, Mewborn, and Caine 2017). A business might promote itself as a low-cost provider of a product. Or it may develop a brand image of exclusivity in the hope that price will not be relevant to the purchase decision. Either way the consumer will research the price to determine what competitors are charging. If a consumer is focused on price, both promotional strategies will be ignored and the product with the cheapest online price will be purchased. These consumers will purchase based on prices they found online while ignoring promotional messages.

Trying to have the lowest price does not guarantee business success because profit does not depend on the number of items sold. In fact the organization may make more profit selling fewer products at a higher price than selling more products at a lower price. Therefore, one of the first issues to grasp is the economic theory of supply and demand. Demand, or the amount purchased, will fluctuate based on the price of a product. The company wants to supply enough products to meet demand. However, if too many products are supplied, it will drive down prices as those who would pay a higher price would have already purchased, and the remaining consumers will only purchase when the price is lower. The point where enough product is produced to meet demand, without overproduction that would drive down prices, is called price equilibrium.

Different consumers will be willing to pay either more or less for the product based on their level of desire. This could be because of internal needs or external situations. For example, if a consumer loves to purchase and wear unique personally designed jewelry as a means of self-expression, they will be willing to pay more than someone who sees no difference between handcrafted and mass-produced jewelry. External conditions also affect price. For example, people are willing to pay more for a cold beverage on a hot day. Likewise, the excitement of being at an art event may result in consumers purchasing products they might have not bought online from their home.

Looking at consumers as a whole, it can be said that as the price goes up the demand will go down because fewer people will be willing to pay the price. Of course, under this theory the lower the price, the more people will buy. As a result an organization might believe that selling at a low price will result in business success. However, there are two critical facts that result in this not being the case. First, any product must be sold at a price that is high enough to cover the costs of production. If not, the organization will lose money no matter how many products are sold. In fact, the more products that are sold, the more money that will be lost. A second argument against low prices as a means of generating revenue is that there is no reason to price the product lower than is necessary. If this happens, the money that people would have been willing to pay, but were not asked to do so, is lost.

Price inelasticity—demand doesn't shrink

Price inelasticity refers to the fact that the price of some products can rise and yet demand will remain almost the same. If the product is fuel for the car, the consumer has little choice except to keep buying gas even if the price goes up if they need the car to get to work. If a customer is unable to buy a substitute product that provides the same benefit, they will continue to buy even if the price is increased. In addition, if the product has a unique brand image, customers will continue to purchase even if the price is raised. However, if the price is raised for products that are seen as similar to others, have no unique benefits, and

do not have a strong brand image, the demand is said to be elastic in that as prices go up, the consumer will purchase a different product for a lower cost. This is the reason that, if there are competing products, marketing must spend time and effort on understanding and communicating the unique benefits and the brand image of the product.

There are product attributes that creative and cultural organizations should consider emphasizing as they affect price inelasticity and can result in people purchasing even if the price is increased. Stressing the product's competitive advantage can help consumers understand that other products, while priced lower, will not provide the same benefits. As a result consumers will be less likely to switch to lower-priced products. Marketers of creative and cultural products should avoid the opposite strategy of trying to keep prices low to meet competitor's prices so as not to lose customers. This is a strategy that will not work as mass-produced products can always be sold more cheaply.

However, there are two factors that can increase price inelasticity, where people will continue to buy even if the price is higher. First, if the product has more than one use, consumers may be willing to continue to purchase even if the price is higher than competitors. They will justify the higher price because of the utility the product produces. Second, if the product can be shown to have better quality, a higher price can be charged.

THINK-ACT-PLAN: Pricing research

Think: Are there products you buy without checking the price? What product would you not buy if the price went up 10 percent? How about 25 percent?

Act: First, think of a creative product that is purchased by your target market. Now go online and find the cheapest and the most expensive example of this product. How do the benefits differ?

Plan: You must now start to consider the pricing of your product. Develop a short survey that you could use to determine if your targeted consumers are price sensitive.

Determining the product price

DIFFERENCES IN TYPES OF COSTS

Buying tweets is cheaper than you think

Social norming refers to the internal thought process that says if something is popular with everyone else it must be good and I should like it also. Therefore having fans, retweets, and YouTube views are valuable to a company as they drive sales. As a result there are now companies that will set up fake accounts that will then follow you on Twitter, like you on Facebook, and watch your YouTube video. How much does it cost? Not as much as one might think. You can buy high-quality Twitter followers for 2 US cents each.

The practice is so widespread that it is estimated that 15 percent of Twitter accounts are fake and Facebook has 60 million fake accounts. Who does this the most? The answer is governments, actors, musicians, and politicians. How can you tell the fake from the real?

- The date of the fake accounts is recent.
- Fake followers and fans will have all joined within a short period of time.
- There are numerous profiles without photos.
- The accounts never comment or retweet.

While the monetary cost of cheating is cheap, the cost to a company's reputation when it is discovered that they are creating fake profiles will be very high as it will take a long time to rebuild trust in their brand and product.

Confessore et al. 2018

QUESTION TO CONSIDER: Have we become obsessed with the number of our social media followers rather than the quality of their participation?

Once the connection between price, supply, and demand is grasped, and the theory of price inelasticity is understood, the process of determining the correct price for the product can be tackled. It is easy to comprehend that a product must be

sold for more than it costs to produce. However, the difficulty is determining the difference between the two types of costs, variable and fixed. Only after the difference between these two types of costs is understood can the product be correctly priced.

Variable costs—the more products produced, the higher the costs

Even though price is the only component of the marketing mix that brings in revenue, the temptation for most creative and cultural organizations is to price the product too low. The problem is that once a price for a product is established, it is difficult to change as consumers will resist purchasing a product if the price is raised. If the product is already priced too low and the organization needs revenue, its only choice will be to lower costs by using cheaper materials and producing the product more quickly which can lower quality. Therefore, getting the price of the product correct when it is first introduced is critical. To do so an understanding of fixed versus variable costs is necessary.

Variable costs are what it takes to produce each individual product. They are called variable because the total amount of costs will vary depending on how many products are produced. The cost of raw materials that go into producing a tangible product will increase depending on how many are produced. For example the cost of labor will also vary as employees are needed to produce a product. However employees should not be seen only as an expense, either variable or fixed (Georgescu 2020). Creative and cultural employees who produce the product are essential. Spending on employees should be seen as an investment. Loyal employees who stay with the company are more knowledgeable and productive. While making employees redundant when sales are low will save on expenses in the short term, it will cost in the future in hiring and training costs for new employees when sales increase.

It is not enough to simply know the total amount that was spent on services such as raw materials needed to produce the product. The information that is needed for pricing is how much each individual product costs to produce. Many creative and cultural organizations produce more than one product some of which may be tangible goods and other intangible services.

Each of these products will need to be priced to reflect the cost of their production.

While social media sites may be free, there is a variable cost to social media. The first cost to consider is the cost of content creation. The staff time it takes to write and post comments, whether written or video, is a variable cost. The more content that is created, the more money needs to be budgeted for staff. The cost of this time will need to be recovered by an increased price for the product. If professional quality graphics, photos, or videos need to be purchased, these would also be variable costs. In addition there is the cost charged by companies such as Facebook, Instagram, and Twitter when an ad is clicked. These costs will vary based on such factors as the type of industry, the day of the week, the time of the day, the quality of the ad, and the number of users targeted (Mullin 2018). To help determine variable costs, now ads can be purchased where money is owed only when the consumer makes a purchase rather than just looks at an ad. If the organization is conducting e-commerce, another variable cost will exist, which would include the fees that are charged by a bank or other financial entity for processing each payment. The more products are sold, the higher the fee payment will be.

It can be difficult for a small business to account for variable costs per product. Fixed expenses that will be paid each month are easy to anticipate. The amount of money needed to cover variable expenses can be much more difficult to estimate. It can be helpful to budget some variable expenses monthly at the same amount (Hecht 2018). This can be done by averaging the cost spent annually and then using a monthly figure to calculate variable expenses.

Fixed costs—they just don't change

Fixed costs are those that would need to be paid whether or not any product is produced. Common terms for such costs are overhead or operating expenses. Fixed costs would include any rental or lease payments that must be paid for an office or studio. If the company owns a building the mortgage would be a fixed cost. In addition, utility costs, taxes, and payments are inescapable. Some organizations, if they cannot do the tasks themselves, may also have fixed costs such as accounting and

janitorial services that are used on a regular basis. Vehicles and equipment used in production would also be fixed costs.

Because fixed costs must be paid even if fewer products are produced it is critical for the organization's survival that these costs are kept as low as possible. High fixed expenses such as a mortgage on a building put added pressure on a company's budget. If a space is rented and the expense becomes too high, the company can move to lower-cost premises.

It can be confusing whether the hours worked by employees are considered variable costs or should be included in fixed costs. Employees who are hired for special projects, such as directing a play, are considered variable costs as they will no longer be paid after the project is completed. The higher the fee paid to the director, the higher the ticket price that will need to be to cover the variable costs. The salaries of managers of the business and fulltime employees are usually considered fixed costs as they are needed to produce the product and operate the business. While no business wants to lay off people, if fixed costs are too high this may need to happen. There are alternatives to making employees redundant (Sucher and Gupta 2018). First, to avoid this situation companies should hire carefully so as to not overstaff. If employee expenses do become too high there are alternatives to layoffs. Rather than make employees redundant, the company can ask if any employee would be willing to quit for a one time payout. If this does not work a short term cut in hours could be used.

Certain social media costs are also considered fixed expenses. For example, the cost of a domain name is usually small but still fixed. Hosting and backup for a site is an expense that is usually fixed. The cost of maintaining the bandwidth connection would also be fixed. Finally website and social media site development costs are usually a one-time fixed expense plus a monthly fee. While it might seem that social media expenses would always be categorized as marketing, this is not true (Gingiss 2019). Social media is also used as a fixed expense category in other departments of a company such as customer service. For example, if the company uses a chatbot to answer customer queries this would be a fixed and not variable expense.

THINK-ACT-PLAN: Calculating costs

Think: Everyone has a budget even if they don't keep track. What are your fixed monthly expenses that you cannot change? What variable expenses could you cut if you had less money to spend each month?

Act: Do some research to find the cost of the raw materials that go into your product. If you do not know, go online to determine rents and other expenses in your area. Determine what you consider an acceptable hourly wage.

Plan: Calculate to the best of your ability the variable costs of producing your product and the fixed costs of operating your business.

METHODS USED TO DETERMINE A PRODUCT PRICE

When the price isn't right

Pricing a product correctly is one of the most difficult decisions a business can make. It is also one of the most important. All of the time and effort that went into product development and marketing will be wasted if the price is incorrect. Even if the product is eagerly bought by consumers, if the price doesn't cover costs, the business will not be in business long. Here are four questions to ask as you consider price.

How do you compare? The price for the competing product may be low because they have lower production costs. It might be high because they have a well-developed brand reputation that you do not have.

Are you selling? Don't assume you are not selling because your price is too high. It might be that you need to improve your marketing so that people understand the value they are receiving.

What are customers saying? If you continually receive feedback that customers love your product but can't afford to purchase you need to change your prices or your customers.

Are you making a profit? Even if you are, you might still be pricing below what customers are willing to pay and you could have asked for more.

Erdly 2019

QUESTION TO CONSIDER: What other pricing mistakes can happen when pricing decisions are made?

After an overall strategy has been determined, there are three primary methods to set a price. First, the price can be based on variable and fixed costs. If this is not possible, prices can be based on what competitors charge. Finally the price can be based on the customer's perceived value of the product. It will be up to the organization to make the decision on which to use.

Cost-based pricing—pricing to cover costs

As discussed earlier, an organization must calculate the variable cost of producing each product along with the fixed cost of running the organization. For each product that is sold, the variable cost must be subtracted from the sales price. The remaining amount must then be used to cover the fixed costs. Only after all the fixed costs are covered for a specific period of time, will the company be making a profit. Using this information a product price can be calculated to cover all variable and fixed costs resulting in no loss of money but also no profit. This price is considered the breakeven price.

The way to calculate this breakeven number is by dividing fixed costs by the price less the variable costs. The breakeven point is the number of products that must be sold or the organization will be losing money.

$$\frac{\text{Fixed Costs}}{(\text{Price-Variable Cost})} = \text{Breakeven Point}$$

This simple calculation can also be used to determine price. If the organization knows the number of products it will probably sell, it can then calculate the price at which the organization will breakeven. To do so the dollar amount of the total fixed costs is divided by the number of products that will be produced. This provides the amount of fixed costs that must be covered by the

Determining the product price

price. If the variable costs are added this gives the price that needs to be charged to cover both fixed and variable costs. Of course to make a profit, the price will need to be higher.

$$\frac{Fixed\,Costs}{(Number\,of\,Products\,Produced)} + Variable\,Cost = Breakeven\,Price$$

An example of how this pricing method can be used is to consider an organization that produces videos. The organization knows the overhead or fixed costs that must be covered each month should be kept low. The organization does so by not owning expensive equipment or employing numerous skilled employees on a full-time basis. However, when they do produce a video they have variable expenses as they must rent equipment and hire people with specialized skills. They also have their fixed costs of running the business. If they start with their preferred price, they can use the first formula to calculate how many videos must be produced to breakeven each month. If they can estimate the number of videos they will be producing, they can use the second formula to estimate the breakeven price. Of course an additional amount must be added for profit which will either be set aside as savings for months when sales are low or reinvested in the organization.

Cost-based pricing is useful for small businesses as it is easy to understand. Once costs are understood the business only needs to calculate what percentage of profit will be needed. Unless there is an unforeseen rise in costs, prices stay stable. Customers appreciate the transparency of the pricing method as they do not like the feeling that they may be gouged by random price increases (Dholakia 2018).

Competition pricing—the same as what others charge

A second method of determining the product price starts with setting the price based on what is charged for competing products. This method is used when the product faces significant competition in the marketplace as it is natural that consumers will compare product prices. Consumers may conclude that when one product, which to them seems similar to others, is priced higher, it is too expensive. Therefore, the

marketer must research the prices of similar products to determine the price level that consumers find acceptable. If this price is not as high as the organization needs to charge to breakeven, it will then be necessary to lower costs.

The organization may not be willing to lower variable costs as using cheaper raw materials will lower the product's quality. Often lowering fixed costs, such as lease and vehicle payments, can be done without affecting sales as consumers do not gain any value from these expenses.

Value-based pricing—what it is worth to the customer

The third pricing method is value-based. The word value is often used to describe a good deal or an inexpensive product, such as in saying a product was a great value. However, when the word is used to discuss price it means that the consumer considers it consistent with the quality received whether the price of the product is high or low. Some consumers will pay a high price for a product because it has a competitive advantage that other products do not. In addition, the product may have a brand image that confers status onto the owner. In these cases, consumers will pay a high price and still consider the product a good value. In fact, if there is no evidence to the contrary, the high price may be considered a sign that the product is of high quality.

An organization may have most products competitively priced and have a few that use value pricing. These might be works of art that are signed by the artist or performances with special guest artists. Consumers are willing to pay more not just because of the value of possession or attendance but also for the status of being one of only a few consumers who were able to attain the product.

Another way to think about value-based pricing is to consider the value rather than the price of the best alternative available to the customer (Singh 2017). The creative or cultural product may be promoted as better than a mass-produced alternative because it is an original rather than a copy. While this may be true, the purchaser will consider whether this fact produces a value to them that justifies the higher price. The producer must explain to the consumer why the higher value is worth the cost and not depend on the consumer understanding the difference.

Social media's effect on pricing—now everyone knows

Social media has affected how companies share information on pricing. The public now expects to have available information on pricing with no hidden fees or costs (Hyken 2019). This is a challenge for creative and cultural organizations as they sell products whose cost of production is not always easy to understand. However, discussion of pricing issues does not discourage potential consumers from seeking additional information. One of the first questions consumers want answered is price, and with social media they expect a complete answer. Businesses are sometimes reluctant to post prices online (Sheridan 2017). They believe they will lose a potential sale if a customer sees a high price. But clarity on prices doesn't lose customers. It is not knowing a price that will cause customers to move on to another website.

All prices should be easily accessible. If the product is customized to individual needs, a price range should be provided. If prices differ widely between products an explanation should be given as to why this is so. The organization may explain that the prices vary based on the quality of the materials and the time it takes to create. If the product is priced based on competition, the competing prices should be given. After all, potential customers are going to search out the information on competing prices anyway. Finally if the product is value-based, the reasons for the high price should be explicitly stated.

THINK-ACT-PLAN: Choosing a pricing method

Think: What high priced item have you purchased recently? Why did you think it was worth the cost?

Act: Think of an inexpensive creative product. Now go online and compare prices from five different companies. How much do the prices differ? Why do you think they do so?

Plan: Will you price your product based on cost, competition, or value? Now is the time to decide on the price of your product.

UNIQUE CHALLENGES THAT AFFECT A PRODUCT PRICE

How to increase the value of your creative product

Whether a price is correct is always determined by the person who purchases the product. Only he or she can decide how much they value the product and, therefore, what they are willing to pay. When doing so, your customer will take into consideration the benefits the product provides along with the reputation of the creator. Here are proven ways to increase your product's value in the mind of the potential purchaser.

Give it your name: Use the same signature on all your work. It is part of your brand and lets people know what they are getting.

Give it a title: A title helps potential purchasers to converse about the work. If the title has an emotional meaning or a connection to a place or event it can even add value.

Give it a date: After you have produced a body of work, people may want to collect your earlier pieces and be willing to pay more to do so.

Give it a number: Scarcity adds value so give a number to your work even if you are only producing a small number of prints because it is all you think you can sell.

Give it a story: Provide the purchaser with some information as to why and how you created the work on YouTube or share works in progress on Instagram.

Huff 2015

QUESTION TO CONSIDER: How can I use the above ideas to increase the value and price of the products my organization sells?

As selling a product is the company's only source of revenue the issue needs careful consideration. Rather than price the product based on a guess at what the targeted consumer will be willing to pay, it is better to consider choosing the appropriate product

price as a process. Of course the goal is to make a profit by charging more than the product's variable plus fixed costs.

Pricing new products—to penetrate or skim, that is the question

A unique challenge is deciding how to price a product new to the marketplace. The two methods for pricing a new product are penetration pricing and price skimming. Some new products being introduced will have many competitors that people are already purchasing. In this case the challenge will be to get consumers to change their purchase behavior. They will need to be motivated to try the new product even though they may be happy with the product they are currently purchasing. One way to do so is to use penetration pricing, in which the market is penetrated through the use of a low introductory price. Even if this low price minimizes the profit that is made, it may be necessary to tempt consumers to try the product.

After a predetermined period of time the price is raised so more profit can be made. While price-sensitive consumers will stop purchasing, it is hoped that most consumers will be happy with the new product and will continue to buy even after the price is raised. Of course the penetration price should not be lower than the cost of producing the product or the organization will lose money. It should only be lower than the price that will be ultimately be charged to get the required profit.

Price skimming, which is the opposite of penetration pricing, is introducing the product to the marketplace at a high price that will later be lowered. The two reasons for using price skimming are because the organization can and because it must. First, the new product can be priced high if the product will be highly desired by a particular segment of consumers and also has no competitors in the marketplace. If it is anticipated that there will be a strong demand for the product, consumers, particularly those who are early adopters and innovators and who use products to create their identity, will be willing to pay the higher price. The price can then be lowered to attract additional consumers who were unwilling to pay the initial high price.

A second reason for price skimming is because the organization must quickly recoup research and development

costs by charging a high price. Innovative new products will have had considerable costs during their development. This is easy to understand when pricing groundbreaking new technological products. However, it also holds true with creative products as there may have been a long process of experimentation before the final product is produced.

Pricing and the product life cycle—each stage helps to determine the price

Another issue to be considered when developing an overall pricing strategy is the product's stage in the product life cycle. If the product is in the introductory stage the decision must be made whether to engage in price skimming or penetration pricing. During the growth stage, products that used price skimming will need to lower their price while those using penetration pricing will need to raise theirs. During the maturity stage all products face increased competition. As a result of this competition it is difficult to raise prices as new competitors may practice penetration pricing. During the decline stage, prices will need to continue to decrease until there is no longer any market for the product. At this stage the organization will stop producing the product as it can no longer charge enough to cover the cost of production and still make a profit.

Markup pricing—costs plus profit

Besides needing to price the creative product that it produces, a creative or cultural organization will also need to price products it purchases for resale, such as programs, food, or souvenir items. These items can be priced using markup, the most commonly used method by retailers. To get a sales price, the profit desired is added on to the cost of purchasing the product. However, rather than just adding a dollar amount, it is better to think in terms of percentages. For example, inexpensively produced T-shirts may be priced at 100 percent of the cost of purchase or by doubling the price paid by the organization. This is acceptable as people may be willing to pay the price for a product that is branded with the organization's name. For some products, such as programs that are expensive to produce, doubling the price may result in a final sales price that people are unwilling to pay.

Unethical pricing strategies—not all prices are fair, or even legal

Businesses cannot survive selling a product at an artificially high price as competitors will offer the product for less to attract customers. It is a competition between businesses that keeps prices fair for customers. There are some pricing strategies that organizations should not use as they are considered unethical, and may even be illegal in some countries, because they destroy this system of competition. Bait pricing is an unethical pricing practice where a low price is advertised to get the attention of shoppers but not in reality available. Price fixing, which is often illegal, is an agreement among competing companies to sell their products at the same higher than the normal price. If the consumer compares prices they will find they are all the same. When engaging in price-fixing the businesses no longer need to compete for customers based on price. They can make inflated profits based on fixed high prices. As there is no longer any reason for a company to offer a price as low as possible to attract customers, price-fixing undermines the competition that is healthy for the consumer. Predatory pricing is setting an artificially low price until competition is driven from the market and then prices are raised. Even business people who consider themselves ethical can find themselves following these practices (Lorenzo 2019). Being ethical is like any other skill. It must be continually practiced so no lapses occur.

THINK-ACT-PLAN: Pricing new products

Think: Have you ever purchased a product at a low introductory price? Did you continue to purchase after the price increased?

Act: If your business will be reselling products, go online and find the product's wholesale cost. What percent markup will you add?

Plan: Determine if you will use price skimming or penetration pricing. If your product is not new, how will its stage in the product life cycle affect its price?

Good reasons for giving discounts

Simply giving a discount on price because sales are low is not a good idea, as consumers may begin to believe that the product was not worth the original price. Even if they do, why pay full price if you know that discounts are frequently given? However, there are times when discounts are useful such as the following.

Unhappy customers: When a customer is unhappy with a previous purchase or has a negative experience with the company, offering a discount on their next purchase can help restore trust.

Old inventory: If the company has out of season inventory or products that are no longer produced, they should be marked down to provide space for new products. In this case consumers understand why the discount is being offered.

New markets: When the company is trying to attract a new customer segment, it is appropriate to offer a limited-time discount. After a period of time the price can be raised. Hopefully consumers will be happy with the product and continue to purchase it.

Appreciation: The company may offer discounts to specific groups such as seniors, military members, or students. As these groups, on average, have less to spend, the discounts should motivate purchases. In addition, such discounts signal to the public that the company understands and appreciates all customers.

Chadinha 2014

QUESTION TO CONSIDER: When and why should we be offering price discounts on our products?

Besides the overall pricing strategy, special pricing tactics can be used to increase demand when sales are slow. The advantage of using a pricing tactic rather than reducing the product price is that a tactic is only offered for a short period of time and can be ended when sales increase.

Tactics aimed at consumers—more pricing decisions to make

Organizations should consider using a pricing tactic with products that do not sell well at particular times of the year. This may be because demand is seasonal for these products, such as baskets to be used for summer picnics or warm wool scarfs for winter weather. Because demand for these products will be limited in the off-season, at the end of the season prices may be reduced to sell as many products as possible. Even though this will result in less revenue, the organization will then not have the expense of storing the product until the next sales season.

Besides end of season sales, seasonal pricing can also be used by keeping the price discounted during the off-season. This is to encourage consumers to buy the product even when it will not be used immediately. For example, people who are frugal will buy the product and put it away until it can be used. Using this approach provides some revenue to the organization even when sales are low. A rebate is another type of temporary price reduction that can be used to increase sales. With a rebate the purchaser is offered the return of a certain percentage of the purchase price. This may be too complicated a price tactic for a small creative or cultural organization to implement. A simpler method is to offer a coupon that is good for a discount on another product purchased during a specific time period.

Some other specialized pricing tactics that creative and cultural organizations can use include single pricing where all products are offered at a single or at the most two or three prices. The reason for using single pricing, even though some products will produce less profit than others, is that it makes price shopping easy for the consumer. Another reason for doing so is that having such a pricing tactic makes it difficult for the consumer to compare prices on individual products.

Leader pricing is offering a single product at, or even below, the cost of production. The reason for doing so, even though little or no profit will be made, is that the low price will attract customers to the store or studio. Once there, it is hoped that they will then purchase additional regularly priced products.

This should not be confused with bait pricing, which is enticing consumers into the store with false or misleading pricing. When bait pricing is used, the consumer arrives to purchase only to be told the product has just been sold out and they are pressured to purchase a much more expensive product.

Price bundling involves increasing revenue by selling more than one product at a time. However, it is different from quantity pricing as dissimilar products are sold together. For example, a consumer looking at jewelry that is being sold at full price may have a handcrafted box added to the sale for a reduced purchase price.

Tactics aimed at businesses—they are all about saving money

Other pricing tactics are used to encourage sales to businesses and other intermediaries. The most common is offering a quantity discount. In fact this is so common that a business purchasing a large quantity of a product will expect a discounted price. This discount will be offered even though the variable cost of producing the product has not changed. The organization is willing to offer the discount because it will be saved the marketing expense of finding additional customers.

Another pricing tactic offered to businesses is a promotional discount that is given to a retailer who performs marketing for the organization. This discount is usually agreed upon at the time of purchase of the product. A retailer might agree to feature the product in ads or place the product in a prominent window display. Because this will cost the retailer money, they will want to be compensated by purchasing the product at a lower price. The organization is willing to do so because the marketing undertaken by the purchaser will increase sales.

Professional service pricing—time or task-based

Not all products sold by creative and cultural organizations are tangible products or tickets to performances. Professional services, such as design consulting, can be priced using two methods. First, a flat hourly fee can be charged for services. This fee may be high as it does not just represent compensation for the time being spent servicing a client.

It also includes compensation for the years of education, experience, and talent that are uniquely possessed by the service provider, such as a musician who has trained for years at a conservatory. However, the service provider must still use competition pricing so that their prices compare with those offered by competitors.

A second method of pricing services is to price based on completion of a specific project. With this pricing method, rather than charge by the hour, one price is given for the completion of the project no matter how long it will take. Determining the price for this method will mean the service provider must estimate how long on average the service being sold takes to complete. Because the actual job may take longer or shorter, the amount of profit on each job will vary.

Finally, flexible pricing, or negotiating, can be used when selling services, such as brand image consulting. For service providers this tactic is most often used with high-priced services for which there is no easy price comparison with other products. If a consumer seems interested but is reluctant to purchase, the provider may offer a lower price in order to close the sale. The theory is that a lower profit margin is better than not selling the service at all. The problem with this approach is that if consumers become aware that the service can be purchased cheaper, they may all want a discount. Some services are priced slightly higher in the expectation that a discount will need to be offered at the time of sale.

THINK-ACT-PLAN: Choosing pricing tactics

Think: What product have you bought because the price was discounted? Would you be willing to pay full price next time?

Act: Go online and find examples of products that are being offered with special pricing. What percentage is the discount? Is the offer time-limited?

Plan: Determine what pricing tactics you will offer to your customers.

Creating the strategic marketing plan

You are now ready to add to your marketing plan the price or prices for your products. In addition, you need to explain the method used to determine the price. Also describe any special pricing tactics you will use.

REFERENCES

Chadinha, Russ. "7 Discounting Tactics That Don't Put Your Pricing Strategy at Risk." *Pros.com/blog. PROS.* December 18, 2014. www.pros.com/blog/pricing/2014/12/7-discounting-tactics-dont-put-your-pricing-strategy-risk1. Accessed May 14, 2015.

Confessore, Nicholas, Gabriel Dance, Richard Harris, and Mark Hansen. "The Follower Factory." *New York Times.* January 1, 2018. https://www.nytimes.com/interactive/2018/01/27/technology/social-media-bots.html. Accessed January 14, 2020.

Dholakia, Utpal M. "When Cost Plus Pricing is a Good Idea." *Harvard Business Review.* July 12, 2018. https://hbr.org/2018/07/when-cost-plus-pricing-is-a-good-idea. Accessed March 14, 2020.

Erdly, Catherine. "Are you Pricing your Products Correctly?" *Cultural Enterprise.* August 5, 2019. https://culturalenterprises.org.uk/blog/academy/are-you-pricing-your-products-correctly/. February 23, 2020.

Georgescu, Peter. "Cut Costs the Hard Way: Putting People Before Short-Term Profits." *Forbes.* January 2, 2020. https://www.forbes.com/sites/petergeorgescu/2020/01/02/cut-costs-the-hard-way-put-people-before-short-term-profit/#77b42b563c3e. Accessed January 30, 2020.

Gingiss, Dan. "How to Measure the Cost Benefit of Social Media Customer Service." *Forbes.* January 8, 2019. https://www.forbes.com/sites/dangingiss/2019/01/08/how-to-measure-the-cost-benefit-of-social-media-customer-service/#39067a6d50ee. Accessed February 14, 2020.

Hecht, Jared. "7 Ways to Make Sure Your Variable Expenses Don't Sink Your Budget." *Entrepreneur.* December 10, 2018. https://www.entrepreneur.com/article/323573. Accessed January 13, 2020.

Heda, Sandeep, Stephen Mewborn, and Stephan Caine. "How Customers Perceive a Price is as Important as the Price Its." *Harvard Business Review.* January 3, 2017. https://hbr.org/2017/01/how-customers-perceive-a-price-is-as-important-as-the-price-itself. Accessed March 3, 2020.

Huff, Cory. "How to Make Your Art Worth More Money—The Abundant Artist." *The Abundant Artist.* February 23, 2015. http://theabundantartist.com/make-art-worth-money. Accessed April 15, 2015.

Hyken, Shep. "Unethical Marketing Destroys Customer Experience and Brand Reputation." *Forbes*. August 11, 2019. https://www.forbes.com/sites/shephyken/2019/08/11/unethical-marketing-destroys-customer-experience-and-brand-reputation/#2acc547a724a. Accessed March 9, 2020.

Lorenzo, Lori. "Cautionary Tale Reveals Risk of Personal Lapse in Ethics." *Wall Street Journal*. June 12, 2019. https://deloitte.wsj.com/riskandcompliance/2019/06/12/cautionary-tale-reveals-risk-of-personal-lapse-in-ethics/. Accessed February 13, 2020.

Miliates, Greg. "You Should Never Charge an Hourly Rate." *LifeHack*. January 21, 2020. https://www.lifehack.org/articles/money/you-should-never-charge-hourly-rate.html. Accessed January 24, 2020.

Mullin, Benjamin. "Brands Now Spend Nearly Two Thirds of Digital Advertising on Mobile, IAB Says." *Wall Street Journal*. November 13, 2018. https://www.wsj.com/articles/brands-now-spend-nearly-two-thirds-of-digital-advertising-on-mobile-iab-says-1542124801. Accessed February 2, 2020.

Sucher, Sandra J., and Shalene Gupta. "Layoffs that Don't Break Your Company." *Harvard Business Review*. May to June 2018. https://hbr.org/2018/05/layoffs-that-dont-break-your-company. Accessed April 2, 2020.

Sheridan, Marcus. "Why Price Transparency is the Key to Trust." *Brand Quarterly*. November 6, 2017. https://www.brandquarterly.com/price-transparency-key-trust. Accessed February 13, 2020.

Singh, Jagpreet. "Value-based Pricing: Two Easy Steps to Implement and Two Common Pitfalls to Avoid." *Forbes*. July 27, 2017. https://www.forbes.com/sites/forbesbusinessdevelopmentcouncil/2017/07/27/value-based-pricing-two-easy-steps-to-implement-and-two-common-pitfalls-to-avoid/#4e843cad6413. Accessed March 22, 2020.

Distributing the product to the consumer
Chapter 9

This chapter will answer the following questions

- Why are **intermediaries** fundamental to the distribution process?
- What is the **channel** selection process, and why is it critical to business success?
- How should the organization **choose** a retail intermediary?
- How does the organization **negotiate** a retail distribution arrangement?
- When are **online marketplaces** an appropriate choice for distribution?

USING INTERMEDIARIES FOR DISTRIBUTION

Distributing digital products: advantages and challenges

Many of the products that we buy are now digital. Some examples are music, art, eBooks, project templates, memberships, and videos. Of course, they are sold online because the only way they can be experienced is on a screen. The distribution of digital products results in both advantages and challenges:

Advantages: The same product can be sold to many customers.

Low distribution overhead as no inventory must be maintained.

Easy immediate delivery with no shipping cost.

Challenges: Your product is competing for customers with free content.

Possibility of theft or piracy from someone downloading and reselling.

Online marketplaces that don't allow digital products.

Fortunately there are now digital apps and platforms that help creators with the distribution and sales process of digital products.

Kumar 2019

QUESTION TO CONSIDER: How can we overcome the challenges in marketing and distributing digital products?

Most people will instinctively understand that marketing involves a product, a price, and promotion. What they do not instinctively think of is the distribution of a product. Yet, distribution is the key to the success of a strategic marketing plan as it is how a product gets into the hands of the consumer.

Direct versus indirect distribution—one or both, the choice is yours

Direct distribution, the easiest method, is where the product is sold straight from the producer to the consumer. This may be face-to-face such as when the creator sells the product in their studio. It can also be when the creator sells at events and fairs. Even distribution from the creator's website is considered direct even though there is no personal contact. It is fairly simple to integrate direct distribution methods so that the producer may use e-commerce on their website, maintain a studio, and also sell at events. However, using direct distribution limits the number of purchases as there are only so many consumers the producer can reach personally. In addition, it is a problem for the consumer as they must seek out the producer of the product in order to purchase. If the organization decides that it will distribute directly using e-commerce, it may need to find a

logistics partner such as a shipping company. This company will not only deliver packages but can also advise on the packaging and the paperwork required on international shipments. In addition, they will provide monthly documentation on how many and where packages have been shipped.

Indirect distribution uses channel intermediaries, or other people and organizations, to sell the product to consumers. This can greatly increase the number of consumers who have the opportunity to conveniently purchase the product. However, the intermediary will also need to make a profit on the sale of the product. Either the producer must sell the product more cheaply to the intermediary so that once it is marked up the price will still be the same as it was originally, or the final retail price will be higher. To use an intermediary, the producer must understand the process involved in selling the product to retailers.

Formerly the organization had to decide if they should distribute through stores or online. Now, the question is no longer relevant as the bricks and mortar and online worlds have merged. Retail stores that formerly had a separate ecommerce and physical store marketing division have now merged them into one. Shoppers make no distinction between buying online and onsite. They will use both based on convenience (LaFleche 2019). A consumer may use a company's website that shows photos of the product and describes the product details for research. They may then purchase in a store. Or, they do the opposite, researching in a store but then buying online.

Distribution challenges—not as easy as you would think

The problem that distribution addresses is that the product may exist in one place while the consumer lives somewhere else. Intermediaries are the people and organizations that solve this problem. While this is easy to understand for tangible products, the issue is also the same for service products such as performances. In these cases, an agent is often used as an intermediary. The agent will book the venues where the entertainment takes place for either a flat fee or a percentage of

the money earned by the entertainer. The reason an agent may be needed is that the agent has an established reputation with venues who do not want to make a mistake by booking talent that will not appeal to their customers.

Digital products, such as digital art and video productions, also need to be distributed. The producer can post them online on a personal website in the hope that it will be found by consumers. However, the producer can also use an intermediary such as a video posting site or an online gallery. Consumers are more likely to look for entertainment on these websites or online galleries because they will have a brand image for a type of entertainment that the consumer finds enjoyable. They will become accustomed to using this intermediary when looking for content they will enjoy.

Tangible products may go through a distribution process using more than one intermediary. The product may first be sold to a wholesaler that buys in bulk and then resells to more than one retailer. Because the wholesaler is only interested in purchasing in large quantities, this option is rarely used for creative and cultural products. Most of these types of products are either distributed directly or are sold to a retail intermediary for resale to the ultimate consumer. Distributing products in emerging economies can be a challenge even when they are sold online rather than through a store (Basu and Robles 2019). The challenge will depend on where the customer is located. It may be easy to distribute through a government mail service or a commercial delivery service in an urban location. The difficulty increases if the customer lives in a rural location. The rural customer in an emerging economy may be connected to the internet and can easily order and pay for the product online. The problem is that there may be a high cost and low reliability of delivery to the rural address.

E-commerce—consumers love convenience

One distribution choice is to sell a product online. This might be, in addition, to selling the product through retail stores, the organization's own studio, or at events. It is rare that a creative or cultural product is sold only online as there is no reason why other distribution channels should not be used at the same time.

However, many organizations may decide to distribute using traditional channels and not distribute online because of two issues. The first is that an e-commerce site must be developed and added to the website. In addition, the website must be promoted. Because all these actions take time, the organization might decide to use an established online marketplace instead. Finally, the products must be packaged and shipped. However, the organization must still monitor the site for orders that must then be packaged and shipped.

The advantage of having an e-commerce site, in addition to traditional channels of distribution, is that consumers may want to physically see a product but then, because of convenience, go back and order online once the final decision is made. New technology allows online shoppers to do more than just see a photo or video of the products. Virtual reality, 3D imaging, and artificial intelligence allow shoppers on e-commerce sites to try on products such as clothing on their bodies or art on their walls (Enfroy 2020). An e-commerce site also acts as a review site. Consumers use online reviews from recent purchasers to help them decide if the product has the attributes desired.

Customers who are interacting personally with the organization should be informed that they can also purchase online. In this way, if customers are not ready to make an immediate decision, the sale will not be lost. Of course, having an online site means that customers who cannot be reached through other channels will also have the opportunity to purchase.

Social media and e-commerce—blending and blurring

Previously e-commerce was conducted using webpages on computers. Now these same webpages can be accessed and used via tablets and smartphones. In addition, social media sites can also be used to conduct e-commerce. Photo sharing sites such as Pinterest and Instagram and even YouTube are being successfully adapted to become a combination of social media and e-commerce (Wertz 2019). Consumers using thee social media sites are becoming less interested in static content. Instead they gravitate toward video and interactive content.

Once attracted to a product seen on such a site, whether social networking or photo/video sharing, they now expect to be able to purchase from the same platform.

These social media sites differ from traditional e-commerce websites as they allow for the curating of products. A traditional e-commerce site will have products listed with photos, descriptions, specifications, and prices. When shown on a social media site designed for sharing images, products need to be displayed differently. The product should be shown in use in its natural setting. The purpose of the site is to help people find ideas, not just purchase products. For example, if the product is a framed print, the shared image needs to provide ideas for how the prints can be displayed as part of a room's décor. This way the viewer receives value from the image even if they do not purchase the print. The product can have a description but pricing and detailed specification information will only be provided on the businesses' e-commerce site. To purchase the product the consumer simply has to click on the image to be taken directly to the e-commerce website. This might be the organization's own website or an online marketplace.

THINK-ACT-PLAN: Distribution methods

Think: Do you purchase products online, at events, at fairs, or in stores? Describe the number of different distribution methods you use when buying products.

Act: Look around the room and choose a product. Now look at the label to determine its country of origin. Research how the product may have gotten from the manufacturer through the intermediary to you.

Plan: Decide whether you will use the direct distribution methods of selling in your own store, at events, or using e-commerce or the indirect method of using an intermediary. Write a statement on what distribution methods you will use.

CHANNEL SELECTION PROCESS

> ### Technology has changed retail
>
> Everyone talks about how technology has made the retail store obsolete. In fact technology is changing how, when, and why we purchase. Here are a few ways.
>
> **Artificial intelligence:** AI will allow more targeted promotions for customers no matter where or how they shop. Watching lots of videos of a musical group? A message of an upcoming concert will be delivered in the format – email, texting, print – that you prefer.
>
> **The internet of things:** Having everything connected will mean that devices will know what and how to order without human intervention. The refrigerator will know when you are out of the gourmet yogurt you prefer and place the order for you.
>
> **Digital assistants:** Shopping will be done by using your digital assistants. Just tell Alexa or Google what you need. The assistant will place the order, charge your account and the product will be at your door.
>
> *Hall 2018*
>
> **QUESTION TO CONSIDER:** How can we use these new technologies to sell and distribute products?

There are many decisions involved when designing the distribution process of getting the product from the producer to the customer. Because most of this process is not evident in the purchase process, it tends to be overlooked when developing a strategy. However, it is critical as even the best product cannot be purchased if it is not made available. The three steps that are involved in this process are selection, intensity, and integration.

Channel selection—what is best for the customer

The decision of what channel to use for distribution will be based on both the location of the purchaser of the product and the location where the product is produced. It would seem to make sense that products should always be produced close

to where the potential consumers live. However, this may not be the case. For manufactured products, production may take place at a distant location, even a different country, based on the availability of raw materials and the cost of labor. Creative and cultural industries are unique in that the creation of the product rarely takes place at a separate location from where the organization is located as personal involvement is required for its creation. Because consumers may wish to interact with the creative talent, distribution may take place at the same location where the product is produced.

The location of competition also plays a role in deciding upon channel selection. It might seem counter-intuitive, but having the product close to competitors can increase rather than decrease sales. Having more than one brand of product available in close proximity is attractive to consumers as it is convenient when making choices. They can easily compare by simply going from one store to another. In addition, the ability to shop at more than one store may convince them to go shopping rather than research and purchase online. Getting customers into the store may be critical as it may take personal communication to close the sale.

It is easy to appreciate that the product should be sold at a convenient location for the consumer. However, now organizations are challenged by the fact that the consumer may wish to have the product distributed by more than one method. This allows the consumer to have the convenience of making the purchase at the time and location of their choosing. For example, a consumer may see the product for purchase at an event but decide not to purchase at that time. They will then expect to find the product available either at a retail location or online.

Because technology allows the product to be sold directly to the consumer, it is easier now to sell the product without using an intermediary. Finding and using an intermediary to distribute the product does not guarantee financial success for an organization. When a distributor such as a retailer is used, the organization is now dependent on their sales success. In other words, if the retailer is not successful in persuading customers to buy the product, then the products will not be sold.

Another model for selling and distributing a creative product is drop shipping (Barker 2018). In this business model the seller is not producing the product. Instead they take over the marketing and sales portion of the transaction for the creator. In drop shipping, the entrepreneur markets the product online. When a sale is made the address for shipping along with the revenue received less a profit for the entrepreneur is sent to the creator of the product, who then ships directly to the purchaser.

Channel intensity—choose the right level

After selecting between direct and indirect distribution, the next decision is whether channel intensity will be intensive, selective, or exclusive. Some products have significant competition, little differentiation, and no strong brand identity. Because of these factors, consumers will base their decision on the cost of the product; so prices must be kept low. Because only a small profit is made from each item sold, the company must sell in volume. Therefore, the product must be distributed intensively with a strategy to have it available everywhere the consumer may wish to purchase.

The company that produces an intensively distributed product relies on selling a large volume of it in order to generate sufficient revenue to make a profit. Creative and cultural products rarely need to be distributed intensively as their products are unique and can be differentiated from their competition. In addition, it would be beyond the capabilities of a small organization to handle the logistical issues involved in getting products delivered to many distributors.

Selective distribution uses a limited number of channels to distribute the product to the consumer. This might involve distributing through a retailer that has more than one location. Selective distribution might not only involve selling through a single retail outlet but also distributing the products at events such as art fairs. Such a combination of selective distribution is a common practice with creative products. Exclusive distribution is used when the product is made available to only one retail or studio outlet. Such products have unique differentiation and brand identity that results in consumers willing to search them out. In fact, the exclusive distribution adds to the status of owning the product.

Channel integration—more ways are better than one

The final issue that must be addressed is channel integration. This involves the decision of how much of the channel will be controlled by the organization. Some companies will own the entire channel. They will manufacture the product in their own facilities and then sell the product in their own retail stores. This approach is true of large international companies. In fact, it is also true of small creative and cultural organizations that produce a tangible product that they sell in their own store or present a performance in their own venue. The issue for small organizations is that it limits their distribution to only channels they control. Most organizations will use some channel they control such as their website along with channels controlled by others such as a retail store.

If an organization is selling its product online but, it is also distributing through a retailer, there are a few issues that must be negotiated. Their retail distributor may request that the items in the store should not be sold directly through the organization's website as the retailer may want people to only purchase through them so they make the revenue. However, the organization may still be free to sell other products online. The organization may negotiate to sell lower priced items through their retailer and sell more expensive products through their website. In this way, when a product does sell online, it is worth the producer's time to handle the order, and it does not threaten sales in the store. The goal is not to try to be on every possible site and in every possible store used by potential consumers (Dennis 2019). The goal is to ensure that all distribution methods used work in harmony with each other to make the purchase process from awareness to sale easy for the consumer.

Logistical issues—got to get it there

While the organization makes the choice to distribute the product using direct or indirect distribution, the issue remains of how the product will move through the channel. In a large manufacturing corporation, this will involve many steps, which together are referred to as logistics. A corporation located in its home country may have a production facility in another country, which in turn receives raw materials from a third country. The product may then be sold in a fourth or more countries.

Getting the raw material to the factory in time for production and getting the product to the retail location in time for sale to the final customer are logistical issues. Since creative and cultural industries rarely are involved in mass production, there is no factory. In addition, since the quality of the raw materials used in production is critical, creative and cultural producers are usually personally involved in the choice of suppliers. However, getting the product into the hands of the consumer remains a logistical issue that must be addressed. Many small companies will use an existing shipping company such as FedEx or DHL to handle their shipments. Besides package delivery these companies can also provide assistance with warehousing, insurance, customs documentation, security, and tracking.

THINK-ACT-PLAN: Distribution intensity

Think: What products do you buy that are distributed intensively or selectively? Have you purchased a product that is distributed exclusively?

Act: Visit a retailer that sells products that are distributed exclusively. How does the ambience differ from a retailer that sells intensively distributed products?

Plan: Decide the level of distribution intensity for your product. Describe the logistical issues you will face in getting your product to a retailer, to the consumer, or both.

DISTRIBUTING THROUGH RETAILERS

Should you be your own retailer?

You may decide that, rather than sell to a retailer, you are ready to sell your product to the public either at craft, art, or trade shows or in your own retail store. When making the decision on whether to sell directly to the public rather than have your product distributed and sold online or through another store you should ask yourself the following questions:

Distributing the product

- Do you enjoy interacting with the public?
- Are you able to educate people on your creative process?
- Can you defend your prices without getting defensive?
- Do your handle stress well when things get hectic?
- Do you have the stamina to remain positive all day even when business is bad?
- Can you handle complaints and negative comments on your products?

Only if these questions are answered positively should you consider being your own retailer.

Radeschi n.d.

QUESTIONS TO CONSIDER: How would we answer the above questions?

A producer of a creative product can sell directly to consumers in person or online. They can also sell using an established online marketplace such as Amazon or Etsy. Another distribution approach is to sell to retail stores. This can be difficult as retail stores are approached by many entrepreneurs who also want to get their products on the store's shelves. Lastly the product can be sold to a distributor who then sells the product to a retailer. The more levels of distribution, the less profit for the original producer of the product but the more opportunity to reach additional potential customers.

Once the decision to approach a retailer directly is made, the type of retailer is the next choice. Retailers vary based on the type of product carried, the prices of the products, and the level of services offered. Even if the producer of the product wants to use a retailer, they must convince the store to carry the product. There are advantages and disadvantages to indirect distribution through a retailer.

Advantages of not using a retailer—keep control and money

There are advantages to selling directly to the consumer without using a retail distributor. These include the ability of

the producer to communicate the promotional message directly to the consumer, which also allows them to learn more about consumer preferences. Another advantage is that they do not need to share part of the revenue from the sale with the retail store.

If a product's benefits are not easily appreciated by the consumer, the product's creator is in the best position to explain. This is particularly true if one of the product's benefits is the mission of the organization. Unless this information is presented convincingly, the consumer may purchase a substitute product at a lower price. Another reason why direct distribution may be preferred is if the product is too complicated for many consumers to understand such as a digital artwork that can be used as home décor. Simply having the product on the wall of a retail store may not be enough to motivate purchase as consumers will not understand the value they are receiving. The creator of the product can take the time to personally describe its use to potential buyers. However, there is an additional benefit that is only available when distributing directly, which is learning about the consumer's preferences. By learning these preferences, the producer can improve the product and may even be inspired to produce new products.

When selling directly to the consumer, producers retain the entire sales price. In contrast, when selling indirectly using a retail intermediary, the producer receives less money as the retailer must also make a profit. For example, if the intermediary is a retail organization that doubles the price, the producer must sell the product to the retailer at half of the final retail price. This revenue is then lost to the producer.

Advantages of using a retailer—they have the customers

However, there are advantages to indirect distribution such as lessening risk, higher sales, and sales expertise that can make up for receiving less revenue. When producers sell products to a retailer, they are relieved of the problem of finding the final consumer. While producers will need to sell the product to a retailer at a lower price, they are at least assured of receiving revenue. If the product does not sell, then the retailer loses

the money spent on purchasing the product. An additional advantage of using an intermediary is that they have access to more customers and, as a result, will be able to make more sales, as the retailer has an already existing consumer segment. This should increase the volume of sales that will make up for the lower profit on each item when sold to an intermediary.

A final advantage of distributing using an intermediary is that they would have sales expertise the producer lacks. While many creative individuals are excellent at selling their products to consumers, some lack the interest to do so as it takes time away from producing the creative product. In addition, they may lack the interpersonal skills that are required for selling a product.

Using a retailer may be an advantage if the producer believes that the store will be more skilled in displaying and promoting the product to the consumer. In addition, the producer may not have the right ambience to display the product to its best advantage. A quality product being sold at a high price needs to be displayed in a setting that demonstrates its status.

Choosing a retailer—-find the right fit for the product

If the decision is made to use retail distribution, the producer must decide what type of retailer will be used. The types of retailers vary by the depth of the product lines, the level of services offered, and the product price. Mass-merchandisers and discount stores will carry many different types of products but have a limited number of types of each item. They will also have limited services in order to keep costs low. These types of retailers offer the consumer low prices and the convenience of one-stop shopping. Because of the low price and the lack of services, such as sales assistance, they are rarely distribution choices for creative and cultural products. At the other extreme are specialty stores that sell handcrafted or unique products. These are the most common retail distribution choices for creative products.

The type of retailer distribution corresponds with both the types of product and the desired channel intensity. Convenience products are distributed intensively but priced inexpensively. Therefore, they will be distributed using mass-merchandisers and discount stores. At the other extreme are specialty products that have unique features or brand image and are sold at a high

price. These products will be distributed selectively through specialty stores. Shopping products that have many competitors are sold through general department stores. It might seem that once the correct retailer has been located, all that is necessary is to ask them to carry the product. However, getting a retailer to do so is difficult. It is much easier if the product already has established brand recognition through direct distribution as the retailer will face less risk.

Finding retail distributors—-first, do your research

An issue that is often overlooked when considering indirect distribution using retailers is the challenge of attracting the interest of a retailer and then negotiating a financially attractive arrangement. Brick and mortar retailers are limited in the number of products that they can sell by the amount of space they have available. Retailers want to maximize their use of this space by carrying only products that will sell and also that will sell at a targeted profit margin. A good retailer has no empty shelf space. Therefore if they agree to carry a new product, they must discontinue a product they are currently selling.

While it might at first not seem similar, finding a retailer willing to carry a product is the same as any other sales process. This process is too often misunderstood as simply convincing someone to buy something they do not want. If this is the understanding of sales, it is not surprising that it is seen as an unattractive activity. However, the purpose of sales is to help the customer, whether an individual or a store manager, by providing them with a solution to a problem. The solution to a problem for an individual consumer is to present them with a product that provides the benefits they desire but currently do not possess. The same is true of a retailer, whose problem is stocking the shelves with products their customers will want to buy.

The producer must understand that the store's purpose is not to provide an outlet to a creative organization so that they can make revenue. Rather, the purpose is for the retail store to make a profit by selling products that will be attractive to its customers. A store manager records and analyzes sales to determine how fast products are selling and the profit margin that is being produced. If products do not sell well, the price will be marked down until they do sell, hopefully at a high enough

price so that the store does not take a loss on the sale. However, they will not be reordered.

The store manager's problem is that they have limited time to research and find new products. Rather than respond to sales pitches from many entrepreneurs they may decide to only deal with a distributor (Ness 2018). The distributor plays the role of the advisor by bringing to the store manager new products that will be desired by their customers. If the creative or cultural organization decides to use a distributor they need to understand that the process of selling distributors will take time, effort, and money. In addition, being turned down by distributors is discouraging. Whether the organization decides to sell directly to retailers or use a distributor to maximize the probability of success the sales process should be followed.

THINK-ACT-PLAN: Retailer choice

Think: What retailer do you use to purchase products? Describe the type of products carried, the services offered, and the typical product price.

Act: Visit two retailers that carry products similar to yours. Why do you think they would or would not carry your product?

Plan: Describe the retailers you will use to distribute your product.

NEGOTIATING WITH RETAILERS

Going big time—multi-store retail distribution

A company may start with selling through one or two local retail stores. However, at some point in time, the company may start thinking why not more? Multiunit retail selling is entering the distribution big league. With a single retailer, a personal sales approach can be used, but getting a retail chain to distribute your product is a more complicated process:

Ask yourself: Can you produce the necessary volume? If you cannot do so, then stop now.

Rethink pricing: Now not only do both you and the retailer need to make a profit, if a wholesaler is involved, they must also.

Fill out the application: Large retailers will require an application that will also specify requirements such as manufacturing capability, labor standards, and insurance requirements.

Make the pitch: Many companies will pay a commission to a broker familiar with wholesale distribution to pitch their product. However, if you do get a chance to make a presentation to a buyer for a retail chain, here is what they will also want to see:

- Product and package sample;
- Product brochure and price list;
- List of retailers currently carrying the product; and
- Promotion plans and samples.

Getting into the big leagues of multi-retail distribution can result in a significant increase in revenue. However, it will also add to the complexity of managing the business.

Larson 2015

QUESTION TO CONSIDER: Are we ready for distribution through multiple retail store distribution? Why or why not?

A small creative company may initially sell their product directly to consumers. They may then set up an e-commerce site and sell online. As the company grows they may decide that they need to sell through retail stores in order to reach more potential consumers (Terlep 2019). When the product is sold through a retail intermediary any customer who comes to the store will see the product on the shelf. Even with the growth of e-commerce, most products are still sold in stores.

The process that a creative or cultural organization should follow to sell their product to retailers consists of four steps, which are: researching possibilities, preparing a proposal,

communicating the proposal, and asking for action. These steps are guidelines as the process will differ depending on the circumstances. For example, an interested retailer may express an interest at a networking event without any need for research. In addition, a small retailer may not require a formal proposal as they make their decision during an informal conversation. However, following the four steps will increase the likelihood of finalizing a deal.

Researching potential retailers—seek and you will find

A retailer will only be interested in carrying a product if it is of interest to their current customers or to a new customer segment they are trying to attract. There are two research approaches marketing can use to determine if a retailer is appropriate to target. The easiest approach is for the organization to find retailers that carry similar products. After all, if the store's customers are already buying similar products, it can be assumed they will be interested in the new product. In this case, if the new product is carried, the retailer is extending their existing product line. However, if the product the organization is producing is too similar, the retailer will not be interested. In this case, any new sales will probably just be a transfer of sales from an existing product to the new product. This would be acceptable to the organization as they would make revenue, but would have no advantage for the retailer who will still be making the same amount of sales. The product must be different enough so that the consumer will purchase it, in addition, to what they are currently buying.

However, the organization can also take the approach of finding retailers that do not carry similar products. In this case, the retailer is adding a new product line to its retail mix in order to attract a new target market segment to its stores. This is a riskier decision as it is not known if the consumers will respond positively.

While a salesperson for a large corporation will spend significant time researching potential customers, the process is simpler for a small creative or cultural organization. They can do an inventory of likely stores in the area and visit them personally to ascertain if they have similar products to sell. It is more difficult to find stores that may be interested in carrying the product because they want to attract a new target market segment.

One way to do so is to observe the customers patronizing the store to see if their characteristics are similar to the creative organization's targeted customers. Another way is to ask the organization's existing customers where else they buy products.

There is an additional issue that must be considered when choosing a retailer (Schaverien 2018). Even if the retailer is willing to carry the product, the reputation of the store might not be a good match for the image that the producer has created. Consumers are very concerned about the ethics and community engagement of a company and may not purchase even if they like the product being sold. This true of both younger and older consumers with the only between the age groups being social causes that they support.

Preparing the proposal—being professional takes preparation

Once a likely retail prospect has been located, a proposal must be prepared. At this stage this does not need to be formalized in writing. However, the marketer must be prepared to state the benefits of the product that will be attractive to a customer. In addition, they must already have an idea of both what the product will sell for at the retailer and what price the organization expects from the retailer. While this means that the organization will not receive the full retail price, a retailer may be able to sell the product at a higher price because of its brand image, ambience, and the income level of its customers. The organization must also be ready to commit to the amount of product that it will provide to the retailer. If the product sells well, the retailer will need to restock frequently. Finally, the retailer will want to know if the product has sold well elsewhere and of any promotion that the organization will continue to conduct. If the retailer is interested in the product, they may ask for an exclusive arrangement where they alone are allowed to sell the product. While this can be good for the retailer as it will attract consumers, it limits the options of the creative or cultural organization.

Presenting the proposal—you have to make the sale

Either the producer of the creative product or the marketer will need to make an appointment with the store owner or manager. A larger store may either have the purchase decision made

by each individual department manager or all decisions may be made through a centralized purchasing department. At the meeting, a sample of the product will be presented along with a written statement of product benefits, prices, and availability. It is at this meeting that the specific terms of any future agreement will be negotiated.

Closing the sale—don't sit by the phone and wait

It will be rare if a manager or buyer decides on the spot to carry the product. There may be other people to consult, or they may simply want to time to consider the decision. The marketer must be ready to be proactive and suggest a date when they will follow up rather than simply wait for a phone call. In addition, at this point the store may wish to prepare their own written agreement so that their interests are protected. Before the agreement is signed the creative or cultural organization should have it reviewed to ensure that payment, delivery, and other issues are acceptable and that they will be able to provide the amount of product specified.

Even after the product is in the store, contact should continue with the retailer. If possible, the marketer should visit the store to ensure that the product is properly displayed. In addition, the marketer will want to ensure that sales clerks understand the product so they can communicate the benefits to potential purchasers. Lastly, if the product sells better than anticipated, they will want to be ready to respond when new products have to be carried.

THINK-ACT-PLAN: Distributor sales proposal

Think: We sell ourselves all the time when we interview for a job. Think of a single instance and then describe the process you used. Were you successful?

Act: Look online and find a sample sales agreement. Is it something you could adapt for your own use?

Plan: Find a retailer that offers products similar to the one you produce. Write a proposal explaining how your product benefits will be of interest to their consumers.

You still need to get noticed

When online marketplaces were few, getting noticed once you joined was not difficult. However, with the growth of different types of online marketplaces, simply joining is not enough to ensure sales. Here's how to get noticed:

Use professional photos: The purchaser must rely on the photos to show both the features and the quality. It is impossible for a low-quality photo to show high quality in a product. Use the same photographic style in all photos for consistency.

Tell a story: Don't just inform consumers of the product details; tell them why you created the product and what it means to you. Tell the shopper a story about each product.

Give them something extra: When you sell a product, add something additional to the shipment. This could be a sample of another product or a promotional item. People love getting gifts.

Engage with your online customers: Once the sale is made, keep in contact by texting or tweeting a thank you. Add comments when people mention or show your products online.

State policies: Explain clearly your policies for shipping, returns, and complaints. You will then be perceived as a company that takes its responsibilities to customers seriously.

Kalt 2014

QUESTION TO CONSIDER: How will we incorporate these ideas if we decide to join an online marketplace?

While creative people need to understand the classic distribution system of using intermediaries such as retailers and wholesalers, they also need to understand how the new online marketplaces fit into a distribution system. The producer has always had the option of selling directly to consumers in

their own studios where they also produced their work. They also have had the option of taking their work to an event or fair where products are sold. Less common because of the expense is the creative producer having their own retail outlet for sales to customers. Now there are new types of both online and offline intermediaries that can sell products.

Digital and other new types of intermediaries—new ways of doing business

With the development of e-commerce, the creative producer had another method of direct distribution. At first, many believed that this method of direct distribution would make the selling process effortless. However, what was quickly learned was that having a website where a product can be purchased is only half of a successful distribution strategy. The other half is using promotion to attract consumers to the website. If the creative product does not have the necessary name or brand recognition, promotion will be needed to attract people to seek out the website so that they can then purchase the product.

A solution is to use an online marketplace which acts as a digital intermediary between the producer and the customer. These are companies that set up an online website that allow for many different creatives to use e-commerce to sell their products. These marketplaces are the online equivalent of the shopping mall. Just like shopping malls vary as to types of stores that they have, and the price level of the products available in them, so do online marketplaces.

Marketplaces can be of three types: vertical, horizontal, or global (Kestenbaum 2017). Vertical marketplaces specialize in selling one type of product from many different producers. The product might be music, visual art, or fashion for children. Horizontal marketplaces focus on a characteristic of the product such as selling only handcrafted goods or organic personal care products. Global online marketplaces will sell any type of product. Some online vertical marketplaces spend money on building a brand image of having highly priced products. These marketplaces may not accept goods that they feel will damage their brand image. Horizontal marketplaces are targeted at enthusiasts. These sites not only provide products of interest, they also allow enthusiasts of the product to communicate with

each other about their interest and purchases. Global online marketplaces brand themselves as providing a variety of products at different price points.

Just as renting a storefront costs money, so does selling through an online marketplace. The cost of selling through such as an intermediary may be a flat monthly fee, based on the number of products sold, the total dollar amount of products sold, or a combination of all of these methods. Online marketplaces will also vary on the amount of services they provide. Some will only provide the online template and e-commerce ability. However, some online marketplaces may conduct promotion that will attract consumers to the site. Some even provide additional services such as training on how to best present products online. In addition, some encourage interaction between sellers so that they can learn from each other.

Just as they would for a retailer with a physical site, the creative producer must shop carefully to find the right online marketplace. Fees should be taken into consideration as this will be a cost that will need to be subtracted from revenue, thereby reducing profit. Since consumers may visit more than one of the shops in the online marketplace, the creative product should fit into the product mix with comparable prices. There is no point in attempting to sell high priced visual art on a site that specializes in selling inexpensive prints. No matter the level of quality, the product will seem overpriced to the consumer.

Choosing an online marketplace—one size does not fit all

One of the reasons for choosing an online marketplace is that it takes care of all the technical issues of maintaining the site. Equally important is that the marketplace has a brand image that already attracts consumers. One decision that the creative organization must make is whether to join a site that sells a wide assortment of products and, as a result, attracts a broad range of potential customers. Or the organization may choose a site that attracts only a specialized target market segment interested in a specific type of product.

Some online marketplaces charge no fees for listing but a fee when a product is sold. The fee will be a percentage of the sale

or a flat fee depending on which is larger. The flat fee is charged no matter how small the sale to ensure that the marketplace makes some revenue. If a percentage is retained if maybe as low as 5 percent but also as high as 20 percent. In addition, the site may charge a listing fee, which is a set amount due when a new product is added to the site. Some marketplaces waive the listing fee if the organization pays a flat monthly subscription fee.

The other issue to consider is whether the marketplace provides any additional services such as marketing or advice. Some online marketplaces do not promote and it is up to the producer of the product to use marketing to attract consumers to the marketplace. However, most online marketplaces promote the website. In addition, the marketplace might provide marketing advice, a question and answers section for users, and a community forum for the merchants to exchange ideas.

Instore marketplace—merging of worlds

Retail stores have been struggling to make a profit as customers shop online because of the convenience. If a customer wanted to physically touch a product, try it on, or talk to a knowledgeable sales clerk, they would go to a store. But they then might go back to their computer or even just take out their smartphone and buy online. Retail stores still had the cost of buying a product, providing a space, and hiring staff but were getting less revenue.

A new retail model has been developed that addresses these issues. New instore marketplaces resemble both traditional stores in that products are on display and staff are available for consultation, but there the similarity ends. Instead of buying products, the retail stores are renting space to producers to display their products. The consumer can see and try the product but then buys, while in the store, online directly from the brand's website. It has been shown that having products in a retail environment also increases online sales (Mins 2019). To attract consumers to the store marketplace, stores are designed as experiences with both food and entertainment available. The retail store makes revenue from renting the space, not from sales. Entrepreneurs gain by being able to have potential customers directly experience their products before they purchase.

> **THINK-ACT-PLAN: Finding an online marketplace**
>
> **Think:** What products have you bought from an online marketplace? Did you check out other merchants on the site?
>
> **Act:** Look at two different online marketplaces. Describe their products, services, and fees charged. On which of the sites do you think your product would sell well?
>
> **Plan:** If you will use an online marketplace, describe the process of how you will find the right site.

Creating the strategic marketing plan

You are now ready to describe the distribution plan for your product. Include in the plan whether you are using a single channel or multiple channels. Then describe each channel in detail. If direct distribution, include information on the studio from which you plan to sell, any fairs or events you will attend, and your e-commerce ability. If indirect, provide information on the retailer or the online marketplace that will be used.

REFERENCES

Barker, Shane. "No Money to Start Your Online Store? Try These Four Options Now." *Forbes.* February 2, 2019. https://www.forbes.com/sites/forbescoachescouncil/2018/02/09/no-money-to-start-your-online-store-try-these-four-options-now/#4f8f4163e218. Accessed March 2, 2020.

Basu, Sid and Daniel Robles. "Supply Chain Planning in Emerging Markets: Four Points to Remember." *ToolsGroup.* March 5, 2019. https://www.toolsgroup.com/blog/supply-chain-planning-in-emerging-markets-four-points-to-remember/. Accessed April 13, 2020.

Enfroy, Adam. "5 Future Ecommerce Trends of 2020." *Ecommerce Platforms.* January 1, 2020. https://ecommerce-platforms.com/articles/5-future-ecommerce-trends-of-2019. Accessed March 3, 2020.

Dennis, Steve. "Omnichannel is Dead. The Future is Harmonized Retail." *Forbes.* June 3, 2019. https://www.forbes.com/sites/stevendennis/2019/06/03/omnichannel-is-dead-the-future-is-harmonized-retail/#33754f6765e8. Accessed April 13, 2020.

Hall, John. "Pay Attention to These 7 Retail Trends in Marketing." *Forbes*. December 30, 2018. https://www.forbes.com/sites/johnhall/2018/12/30/pay-attention-to-these-7-retail-trends-in-marketing/#49e979c50365. Accessed April 17, 2020.

Kalt, David. "5 Tips to Stand Out When Selling on an Online Marketplace." *Entrepreneur*. July 21, 2014. www.entrepreneur.com/article/235747. Accessed April 17, 2015.

Kestenbaum, Richard. "What Are Online Marketplaces and What Are Their Future?" *Forbes*. April 26, 2017. https://www.forbes.com/sites/richardkestenbaum/2017/04/26/what-are-online-marketplaces-and-what-is-their-future/#747b08ba3284. Accessed April 13, 2020.

Kumar, Braveen. "How to Sell Digital Products (Plus 6 Ideas to Get You Started)." *Shopify*. February 8, 2019. https://www.shopify.com/blog/digital-products. Accessed March 30, 2020.

LaFleche, Brian. "Why Retail Giants Like Under Armour, Disney and Amazon Are Merging E-commerce and In-store." *VisionCritical*. April 27, 2019. https://www.visioncritical.com/blog/why-retail-giants-like-under-armour-disney-and-amazon-are-merging-e-commerce-and-in-store. Accessed January 12, 2020.

Larson, Jackie. "Landing a Spot in the Retail Big Leagues." *Entrepreneur*. February 28, 2015. www.entrepreneur.com/article/159254. Accessed April 17, 2015.

Mins, Christopher. "Can the Internet Save the Department Store?" *Wall Street Journal*. July 27, 2019. https://www.wsj.com/articles/can-the-internet-save-the-department-store-11564200060. Accessed February 22, 2020.

Ness, Jesse. "How to Find Distributors for Your Product." *Ecwid.com*. February 9, 2018. https://www.ecwid.com/blog/how-to-find-distributors-for-product.html. Accessed March 22, 2020.

Radeschi, Loretta. "Ask These 18 Questions to Decide Between Wholesale and Retail." *HandMade Business*. n.d. https://handmade-business.com/ask-these-18-questions-to-decide-between-wholesale-and-retail/. Accessed January 2, 2020.

Schaverien, Anna. "Consumers Do Care About Retailers' Ethics and Brand Purpose, Accenture Research Finds." *Forbes*. December 12, 2018. https://www.forbes.com/sites/annaschaverien/2018/12/12/consumers-do-care-about-retailers-ethics-and-brand-purpose-accenture-research-finds/#6294397416f2. Accessed January 28, 2020.

Terlep, Sharon. "Big Brands, Online Startups Find Success Rests on Store Shelves." *Wall Street Journal*. December 9, 2019. https://www.wsj.com/articles/big-brands-online-startups-find-success-rests-on-store-shelves-11575895927. Accessed April 4, 2020.

Wertz, Jia. "Why the Rise of Social Commerce Is Inevitable." *Forbes*. June 25, 2019. https://www.forbes.com/sites/jiawertz/2019/06/25/inevitable-rise-of-social-commerce/#1e1aff3c3031. Accessed January 30, 2020.

Creating marketing media

Chapter 10

This chapter will answer the following questions

- How has the traditional communication model and the **categorization** of media changed even though it still has the same purpose?
- What forms of **paid** media are still effective in motivating consumer purchase?
- How does an organization use the new forms of social **owned** media to generate earned media?
- How are the traditional **promotional methods** still effective in building product and organization awareness?

RECLASSIFYING MARKETING MEDIA

Using social media to announce a new product

If your company has a website with a blog or a social networking page, you are your own media outlet. In the past when a company launched a new product, they had to rely on outside media to spread the word. This could be done through the purchase of paid media, such as advertisements, or it could be done through public relations with the hope the media would respond and run stories. Now companies can get the word out themselves using social media. How?

Launch site: Create a product launch website and social media sites to start hinting at the new product. If you don't even have a name for the product yet, give it a fun or interesting code name.

Video: Create a video that talks about the problem your new product will solve. Post the video on YouTube and other sites. Keep those interested informed with updated videos.

List: Create a list of influencers and bloggers who will get first notice of the product launch. People like to belong to an exclusive group.

Countdown: As the product launch date nears, start a countdown on all your social media sites to create buzz.

Spread: When the launch has happened, encourage everyone who has been following the process to help spread the word.

It is easy to see that while this will take effort, it is better than just hoping that someone will notice.

Barker 2018

QUESTIONS TO CONSIDER: How can we use owned media for our next product launch?

The organization developing a marketing strategy has now investigated the internal and external environment. In addition, the product has been analyzed to determine the benefits that it offers and a consumer segment targeted. Once this was done pricing and distribution decisions were made. Finally, the last component of the marketing mix, promotion, is ready to be tackled.

For promotion to be effective the organization must first have an understanding of the benefits the product offers. These benefits must then be matched with a segment of consumers that desires them. The more clearly the benefits are understood and the segment is defined, the easier it will be to develop a promotional message. This message will be part of a total organizational brand image that will not only communicate product benefits but also the values of the organization.

The image that is promoted will be a means of communicating to both customers and the public not only what the organization produces but also what it stands for.

New communication model—social media changes how we communicate

The communication model that has been standard since the middle of the twentieth century was based on sender, message, media, and receiver. First the sender developed a direct message using a form of media. This message was sent to a receiver who was waiting to listen. This message had to break through interference, or noise, to be heard correctly by the receiver. If there was too much noise the message could be misinterpreted or not heard at all. The only way that the sender knew if the message was received and understood was through feedback from the receiver to the sender. Of course, in marketing, this feedback was indirect, the purchase of the product. Outside of having a telephone number to call, there were few other ways for the organization to hear directly from consumers.

Social media has now allowed more direct contact between the sender and receiver of a message as it allows easy communication across distance and time. While receivers can now easily provide direct feedback they can also resend the message to others. The process still starts with the sender communicating the message. However, with online communication, the message is always available to the receiver. Therefore, there is less concern with interference as the receivers can consume the message at their convenience. What is new in the communication process is that due to online technology and social media there is a staggering number of messages waiting to be consumed. Therefore, any messages that do not entertain or assist consumers in some way will be ignored. Consumers are most likely to ignore any promotional message that simply communicates that they should purchase a product. With an abundance of products to choose from, each of which is saying "buy me" it is understandable that these messages will simply not be heard. Therefore, the promotional message needs to contain information of use to the receiver in the hope that once this information is consumed, the receivers will, on their own, seek out more information on the product.

Because consumers are inundated with marketing messages, it takes a marketing strategy time to break through the noise and be heard. The consumer must hear the marketing message from five to seven times before it is remembered (Peek 2020). This cannot be the same message communicated through the same channel, which will then be ignored, but rather new messages communicated through different channels.

The receiver of the message may provide direct feedback to the sender. However, they are more likely to amplify the message by resending it to other receivers. This will not be merely a passive resending, but will also contain the original receiver's comments and additional information he or she has added. These secondary receivers may then again amplify the message. Receivers may also communicate back to the sender, but do so indirectly by posting on blogs or online review sites. On these sites, people are free to express their opinions on the product to anyone who is interested. These indirect marketing messages are of more interest to potential consumers than the organization's direct marketing messages. Since these comments are so influential organizations must respond to these messages whether they are positive or negative.

New classification of media—social media changes everything

The traditional forms of promotion used to communicate the promotional message were advertising, sales incentives, public relations, and personal selling. A traditional marketing strategy would explain how each of these will be used to communicate the same marketing message to a well-defined target market segment. Because of the new technologies available to send marketing messages the categorization of promotional methods and communication has changed.

Advertising is still used to develop consumer awareness, which is particularly needed for any new products that are being introduced to the marketplace. Sales incentives, which are used to motivate interested consumers to purchase immediately, are still effective. Public relations, which is using other media to develop a positive image for the company, is still needed, especially when negative information can spread so quickly online. Personal selling, or direct interaction between the

producer and customer, is still necessary for products that are expensive or difficult to understand.

However, because the introduction of social media has changed the way communication is received and processed, the traditional categorization of media has been replaced. Sales incentives and public relations are still used. However other forms of media have been categorized as paid, owned, and earned media. Paid media, which is paid for by the organization, has a message that they can control. The purpose of paid media is to drive consumers to owned social media. Owned media is the organization's own website and any other social media sites they use to promote their company and product. Once on the owned media sites, it is hoped that consumers will discuss the company and products and link these comments on other social media sites resulting in earned media.

One of the difficulties organizations face when dealing with these new forms of social media promotion is content. Of course, when developing an advertisement, words and visuals must be created to communicate the message. However, once the ad is written the job is completed. With social media the creation of content is an ongoing challenge as the updating of current and posting of new content is a continual process (Cohen 2018). This content must be more than a marketing message as social media users expect to be entertained as well as educated about the product.

Development of product advocates—more than just customers

Paid media, such as traditional advertising both online and in other formats, is used by companies to communicate to consumers who are not currently purchasing the product. The purpose of the marketing message will be to build awareness so that consumers will seek more information on the company's owned media and hopefully become customers. Once aware of a product, a majority of consumers will first conduct online research for more information before purchasing. Some of these sources will be the company's owned media while others will be other social media such as product review sites. It is rare for a consumer to purchase simply based on a paid promotional message. Once on the company's owned media the consumer changes to a potential customer.

If a purchase is made, they convert to a customer. In the past this would have been the end of the process. However, now the goal is to have the customer not only purchase but also become an advocate for the company. An advocate then uses both word of mouth and social media sites to share information about the product with consumers who are still deciding whether to purchase. An organization should take an active role in building relationships with advocates (Lesonsky 2019). For example, if an advocate frequently blogs about the product, they can be provided with a new product at no cost. Hopefully they will like the product and then talk about it online. In addition companies can blog about advocates providing them with publicity. Building relationships with advocates can be one of the most cost-effective means of promoting the product.

Promotion costs—nothing is free

One of the tasks often overlooked is the need to analyze promotional expenditures to ensure that the money spent on marketing communications is resulting in enough revenue to not only cover the costs but also increase profits. It is common to dedicate to marketing a percentage of the business' overall budget. Equally important is to analyze if the money budgeted for marketing has generated sales (Evans 2017). To accomplish this task it will be necessary to track promotional expenses on a separate budget line. This is difficult because much of social media does not involve the traditional expenses of buying media time or writing broadcast messages. Instead it takes staff time. This time spent on social media is valuable as it is time that cannot be spent on other tasks such as producing the product. Therefore, the time spent on developing and maintaining social media must be tracked and given a dollar amount to determine if the promotion brings in sufficient revenue to justify the time and expense.

THINK-ACT-PLAN: Promotional media

Think: Do you use product review sites or post comments online about products and companies? What motivates you to do so?

CONTROLLING THE MESSAGE WITH PAID MEDIA

How to deal with social media convergence

Rather than deal with the traditional media terms of advertising, public relations and promotion, marketers think of media in terms of owned, paid, and earned. While these three terms help to develop a strategy it would be a mistake to believe that you can choose to do only one. Instead they need to be combined into a single social media marketing strategy. Here are some key elements that you must consider when designing this strategy. While there are many choices to use under each media category the most common types of media used by small companies are listed below.

Owned: Website, mobile site, blog, social media channels.

Paid: Display ads, paid influencers, sponsored events

Earned: Reviews, reposts, recommendations, mentions

There is a process that should be followed when using these in the same strategy.

First: Design your owned media sites.

Second: Identify where your customers are online and place your paid media on these sites.

Third: Find the influencers and bloggers that they follow and use paid media to get them to promote your product.

Fourth: Use paid media content marketing to communicate how your product benefits.

These steps will hopefully result in earned media that you will then link back to your owned media.

Prasanna 2018

QUESTIONS TO CONSIDER: What type of discounts, bonuses, or limits will work best to move my customers from awareness to purchase?

Paid media are marketing messages that are controlled by the organization and communicated using print or broadcast. One of the major forms of promotional communication, advertising, can be recategorized as paid media. Advertising has always certainly been the best-known form of promotion. In fact, most people still use the words promotion and advertising interchangeably. However, advertising, which is only one means of communicating a marketing message, is unique because it is an impersonal one-way communication using broadcast and print.

Advertising—it still has a purpose

A traditional advertising promotional message can be communicated using broadcast media such as radio and television or print advertising such as newspapers, magazines, flyers, billboards, and brochures. The advertising message can also be communicated using digital media. The purpose of advertising is to build awareness of the product. This is a task that is crucial when introducing new products into the marketplace or when a company is introducing an existing product to a new market segment. Of course, now broadcast messages can also be linked to the organization's own social media sites or the organization can pay to have the message placed on other social media sites. However, print advertising may be more effective than digital when targeting a local audience (Perri 2019). It can also be low cost. Traditional print advertisements on flyers and posters or placed in a local paper are still effective in communicating with local consumers.

Successful advertising works at both a rational and an emotional level. The rational message concerns the product features and the benefits they provide. The emotional message answers the question of why the consumer should care.

For some products the rational message is communicated first. These products are usually ones that solve a specific and immediate problem. If consumers have clogged drains, they want to know immediately if the product will unclog them. However, creative and cultural products usually do not solve an immediate need. They will most likely use advertising with an emotional marketing message to promote purchase. This message may remind the potential consumers that they are overstressed or bored and then present the product as providing a benefit that will either relax or excite them.

Digital advertising—now it's online

As consumers are spending less time before their televisions and more time in front of other types of screens, companies have expanded broadcast advertising to new digital formats. While Google and Facebook have dominated the market for digital advertising this may not remain true in the future (Wise 2019). The public has become increasingly concerned about the ability of the two private companies to determine what advertisements are seen by the public. The ability of small social media networking sites to collect visitor data is now allowing them to sell advertising space.

Online advertising has a great advantage in that while it is impossible to know how many people read a magazine ad, the Internet can track how many people clicked on a banner ad. Some advertising is even on a pay-per-click model where the company only pays when the ad is clicked on by a viewer. Digital advertising can use two approaches. The most common is the banner ad which includes text and visuals similar to a print ad but, since it is online, it can also include a video. The banner may appear at the top of a website or along the margins. Some ads are pop-ups that block the viewing of material. The second type of online advertising is sponsored search ads. These ads appear when people conduct an online search. If not able to do so themselves, companies may pay a firm specializing in SEO consulting to determine the best search words to which to affix their ad. Most online sponsored ads are click-per-view where the company only pays for the ad when someone clicks on the link and is taken to the company's website. This allows the company to carefully track the

effectiveness of an ad to attract interest. It can also then track whether this interest develops into a sale.

Advertising planning process—to say what to whom

Whatever the communication channels used for advertising, the purpose remains the same, which is to attract attention and motivate potential customers to seek out more information from other sources, including the company's owned media. The first issue when planning to use advertising is to determine a specific objective. To simply state the ad will build awareness is not specific enough. Instead, the objective should be stated in terms of what is hoped this awareness will achieve. For example, the objective might be to increase awareness of a new product to current customers so that traffic at the company's website will be increased by 20 percent. The objective should include the product, the target market, and an assessable goal.

Once the objective is established, the words and visuals for the advertisement need to be developed. This is a creative process and should involve more than just those working in marketing. Everyone internal to the creative organization should be comfortable that the message used in the advertisement is aligned with the organization's mission and values. After everyone internal to the organization agrees that the message is acceptable and will be effective, it should be tested externally on a sample of the target market segment to ensure the message it communicates is correctly understood.

The next step is to decide what media will be used to communicate the message. Of course there are the traditional means of newspapers, magazines, television, and radio. However, there are many others such as direct mail, billboards, posters, and Internet banner ads. The choice will depend on which media would be most likely to reach the targeted segment. In addition, the cost of the planned advertising must be within the marketing budget of the organization.

When using media it is better to build awareness by targeting smaller segments rather than to spread the message broadly (Szajda 2017). As a result the issue is no longer how many people will see an advertisement but by whom it will be seen. Thousands of people may drive by a billboard, but if the target market is college students who live on campus, the money

on the billboard is wasted. Even a billboard near the college campus may not be worth the expense if the college students do not routinely drive their cars while at school. Television broadcasting may be out of the reach of most companies, but radio and magazine ads can be used effectively as they can be of interest to very specific psychographic segments.

THINK-ACT-PLAN: Creating advertisements

Think: Look online and find an advertisement you find interesting. Is it targeted at you? What catches your attention? What benefits does the message communicate? How do think the words and visuals could be improved?

Act: Write the words and draw the visuals of an advertisement for your product. Remember that the message should communicate the product benefits to your targeted group of consumers.

Plan: Write a plan for how you will use advertisements to reach your strategic marketing goal.

MANAGING OWNED SOCIAL MEDIA

Content is critical

Providing content for owned media is a critical responsibility of marketing. The purpose of the content is to promote your brand. You do so by providing content that educates, entertains, and inspires while at the same time providing an incentive to purchase. Rather than haphazardly posting whenever you have the time, it is better to think of content marketing as a three-step process.

Planning: This stage involves considering what type of content will be attractive to your target market. Consumers want company information on new products along with any sales or discounts that are being offered. They also want general content that informs, entertains, and inspires.

Content that has engaging visuals and videos will be especially attractive.

Publishing: Rather than simply post whenever you have the time you should follow a content calendar that shows upcoming dates for posts and the topic, message, and images that will be included. Following such a calendar will ensure that content is publishing on a consistent basis.

Monitoring: To know if your content is effective, you need to monitor the results. This would include impressions, the number of times visitors viewed your content and clicks, and the number of times they interacted in some way. Most important is the times that viewing led to a sale.

Mendenhall 2019

QUESTION TO CONSIDER: How can we improve the content we provide on our social media sites?

Online owned media includes both the organization's website and other social media. Every organization now has a website. The first websites were impersonal forms of online advertising but that has changed. Now they are interactive and allow two-way communication between the organization and the public. The purpose of the organization's paid media is to drive consumers to the organization's online owned media. In addition, some consumers who do not pay attention to paid media will find the website and social media through online searches. Both the website and social media must instantly communicate the mission and values of the organization through the design and the information provided. It is on these sites that the consumer will find in-depth information about the product.

Website home pages—home is where you can always be found

While organizations are, rightfully, focusing on their social media, the role played by the organization's website home page should not be overlooked. The organization's own website is the base on which its social media strategy rests. It is on the website that video and podcasts can be added and it also can be home

to the organization's blog. It is on the website that icons linking all the social networking and microblogging sites will be added. Therefore, the ability of the organization's website's home page to attract and retain attention is a critical factor in its success in engaging the interest of the potential customer.

While in the past developing a website took technical skills, now it is easy to develop a webpage using a free platform. The fact that the technical skills are easy means that sometimes the issue of design is ignored. As a result, a webpage might be developed with little thought as to how its design will capture the attention of the potential customer.

The organization must remember that the first task of the website is to ensure the visitor that they are dealing with a real and legitimate organization. This can be done by listing on the home page a physical address and map to the location. If there is no physical office for the organization then it becomes even more important to use photos and stories to demonstrate the authenticity of the organization.

Besides the first words that are read, the visual impact of the site will also determine whether the consumer engages further. There is no answer to what design is the best, as it will depend on the image of the organization. The layout, whether simple or complicated, the visuals, whether sleek or complex, and even the colors must convey the mission of the organization and the benefits the product provides. If the home page is the visitor's first connection with the organization, it is the task of design to motivate them to stay and learn more.

Social media sites—where you reach out

Besides a website, the organization will also be using other social media sites either in conjunction with its website or separately. Facebook, Instagram, and Twitter may be the most frequently used social media sites for marketing. However new social media platforms are always being created (Balkhi 2019). Some are targeted for specific uses, such as short-form video, or for specific interest groups, such as those who love cats. While in the past sites used to only focus on photos, video, music, or the written word, they more commonly now allow all types of creative expression.

The organization should use social media sites that are popular with its target market of consumers. These sites should be linked to the organization's website. For example, the website may have a blog that allows for two-way communication. In addition, the company may link the website to a social networking site. The organization may also upload videos onto video sharing platforms and photos on to sites created for sharing images and then link both back to the website. In addition, they may microblog. Owned media, which is also paid for by the organization, differs from paid media in its purpose. The purpose of all online owned media is to get people to respond to the marketing message for two reasons. First, if customers are having any problems with the product, these problems can be communicated and then can be resolved by the organization. Second, any positive comments made by happy product users can be shared as they are more likely to be believed by potential customers than any paid marketing message.

Social media sites have been categorized as those that allow the sharing of the written word, music, images, or videos. While now more of the sites are allowing the sharing of multiple forms of content, some sites are still known to specialize in a specific form of sharing. The organization must determine which social media sites will be most effective in reaching their targeted market segment. These might include using professional networking sites such as LinkedIn to connect with other businesses or organizations. They may include personal social networking sites, such as Facebook, to encourage comments and sharing by customers. The organization may upload videos on YouTube or share photos on sites such as Pinterest to show products in use. They may blog using WordPress or microblog on Twitter to share interest on the products, organization, or the world, in general, that will be of interest to customers. The specific sites continually evolve and can be specific to a particular interest area or even specific to a country.

Social media has resulted in people having much more information about products than in the past. This has resulted in a change in the role of marketing within the organization. When marketing controlled the message, the marketing department would be praised if the product was a success and blamed if

it was a failure. Now everyone in the organization must accept responsibility for the success or failure of marketing. While in the past marketing's role was to sell the product, it is now to generate interest. Other people on social media, through their comments and reviews, will then sell the product. People no longer rely on a company or brand as a sign of quality. Even when a company promotes its quality it is in the hope that consumers will comment to validate the statement.

Content marketing—keep them interested

Promotional material has always relied on content such as words and visuals to communicate its message. However, the content that was provided was a marketing message on product benefits. Now rather than sell, promotional information must either share or solve. Another way to divide content is by whether it educates or entertains. The information it shares might be about the product, but it is more likely to be about the organization and its people. In addition, the content will share news stories that the consumer might find to be of interest. In fact, rather than promote its own products, it might even share information on other products of interest to its customers. The other purpose of content is to solve a problem for the consumer. There is a reason that the words "how to" are one of the most frequently used online search terms. Therefore, by providing content that solves consumer problems, the company engages the interest without selling.

A relevant issue for marketers using social media is how much of the content should directly promote the product. After all revenue only is received when someone buys. The common rule that has been used is the 80/20 rule. This stated that only 20 percent of the content should be direct promotion. This rule has become outdated as consumers no longer draw a sharp distinction between a brand, a product, and the owners of the company (Hall 2018). All content is in some way promotional if it draws attention to your company.

One of the challenges of content marketing is how to stay current with the posting. There are some simple steps that can help with the process. First, the organization should decide on broad themes for the content that will be provided. The organization may decide to focus on sharing community

Creating marketing media

news or news about a specific social cause. Another theme might be news about a specific art form or artist. Choosing a theme will give focus to the content provided so that people will return for similar stories, opinions, or ideas. The marketer must decide how often to use each content type. Developing a calendar, and even a time of day, when each piece of content will be uploaded will ensure that it gets done even on busy days. While a simple calendar can be used to list the frequency with which content needs to be posted, an editorial calendar determines what type of content will be provided. For example, one day may focus on local events while another day of the week will focus on product development news. This will help the employee, responsible for writing and posting the content, who is sitting at the computer not knowing how to get started. Developing templates for regular editorial features will speed the process of content writing. These might be highlights of the week, interview questions, and other standard content.

Other general guidelines when providing content include using multimedia whenever possible as people are drawn to images. In addition, adding personal opinions when sharing news stories adds to the interest. If stuck for a subject on which to write, following up on comments made on previous postings can provide a topic.

Promoting content—make sure it gets read

The new worlds of paid and owned media are not clearly divided. An example is how to promote content. If staff time is spent on creating content, the organization may not want to simply hope that it is noticed and read. This is particularly true if the content is on the organization's website. While current customers will probably see and may read the content, it is less likely that potential customers, and even less likely that prospects, will notice. Therefore, the organization may decide to use paid promotion to attract readers. This can be done by buying ads on social networking sites. This can be a particularly effective method of promotion for small and medium-sized businesses. Social media ads can be targeted at groups based on interests, geography, or both.

Content can also be shared by sending promoted tweets. While the organization will tweet links to their current followers,

these will not include prospects. Therefore, paying to be able to tweet to a group of people who may be potential customers may be worth the cost. Finally LinkedIn can also be used to place ads to attract people to content.

THINK-ACT-PLAN: Social media plan

Think: Find a website that gives you a bad impression of a company. Why does it do so? Look at an organization's Facebook page. Does the content solve or share? Does it educate or entertain?

 Act: List ten ideas for content that you could share with your potential customers.

 Plan: Write a plan for how you will use your website and other social media to share content.

USING OWNED PROMOTIONAL METHODS

Owned media: Sometimes it's best when it's yours

There is so much written about getting others to talk about you online that it might be thought that earned media is better than owned media. However, owned media should be used as part of a long-term marketing strategy. Its advantages are many.

 Control: You both control and own the content on owned media. This means that a blog, video, or article posted on your own website will remain until you remove it. If a complimentary video about your product is posted elsewhere by someone else, it may be gone tomorrow.

 SEO rankings: Owned media helps in moving your organization up in search engine rankings. If the content is posted on your own website and people click through, your website moves up. If it is on another website, their rankings improve.

Creating marketing media

Brand identity: The work you publish will express your identity, which will match the identity of your website and company. If your work is published elsewhere you may be identified with another company with which you might not wish to be associated.

So if the content is something you want to stay available online, if you want to use the same key words to improve your SEO rankings, and you have a specific brand identity, do not forget to focus on owned media.

Scott 2015

QUESTION TO CONSIDER: What social media sites should be used as part of our owned media strategy? For what specific purposes can it helpful?

Owned promotional media are forms of marketing that are both developed and communicated by the organization without paying outside organizations to do so. Three of the traditional methods of promotion, sales incentives, personal selling, and public relations are created by the organization but then are often communicated to the public using social media.

Sales incentives—buy now!

Sale incentives, another form of paid media, are short-term offers usually involving a discount or free gift that are used to motivate already interested customers to purchase immediately. They are still highly effective when communicated to consumers who are already aware of the product. They can be financial incentives such as discounts, coupons, or rebates. There can also be a gift or bonus such as an additional product that is received with a purchase. Contests can also be used to motivate purchase. The availability of the offers is often communicated using owned media.

Sales incentives play a very important role in motivating an interested consumer to purchase. Unlike other forms of promotion they do not aim to educate the consumer as to the benefits of the product. The assumption is that the consumer is already aware of the product and is interested in purchasing. Sales incentives are used to give the potential consumer one

more reason to buy and the current customer one more reason to purchase again. While businesses are using social media mostly to build brand awareness and to introduce new products fewer are using it as a platform to promote their sales incentives (Moorman and Lavin 2018). Social media is ideally suited to this role as excitement can build as site visitors share information about the promotion.

Some sales incentives are simply a discount in price. A financial incentive might also be in the form of a coupon or a rebate. The coupon, when presented, provides the consumer with a percentage off the purchase price. A rebate is for a dollar amount that will be returned to the customer after purchase. These types of promotions work well with price-sensitive shoppers. Hopefully once they try the product they will purchase again without needing a discount incentive.

Another form of sales promotion is to offer a gift or bonus with the purchase of a product. This not only motivates purchase but can also be used to introduce a new product to consumers. If the organization is selling an expensive product, such as handcrafted jewelry, a carrying case might be included as a short-term sales incentive offer to increase sales. For an organization that presents concerts, a free ticket to an upcoming performance with which customers might be unfamiliar and that has unsold seats might be offered.

Some sales incentives are designed to keep current customers loyal. Loyalty programs are designed to get the consumer to purchase again rather than trying a competing product. They can be designed to provide a free product after the purchase of a specified number of purchases. They can also be designed to reward either a certain dollar amount of purchases or the number of products purchased. It is an old saying in business that it is cheaper to keep a current customer happy then to find a new customer. By using loyalty programs, organizations with close competitors can help maintain customer loyalty. Loyalty programs need to be designed with the preferences of younger customers in mind (Cierzan and Kelly 2018). They are focused on instant gratification so smaller rewards should be given frequently. In addition the rewards offered should be able to be customized to the preferences of each customer.

While it is still possible to run a loyalty program using a card that is punched each time a purchase is made, there are now online alternatives. Besides convenience, these programs collect email information when a customer registers online to receive benefits. Because their purchases are tracked, the customer can be provided with marketing messages of interest. In addition the customer can be given a selection of rewards that are customized to appeal. Another unique feature of online loyalty programs is that they will provide the organization with information on the purchase habits of the consumers who are signed up in the system. The organization will be able to tell how frequently they purchase and the amount purchased so that it can be determined which reward most motivates behavior at the lowest cost to the company.

Personal selling—explaining why, not arguing why

Personal selling is another form of traditional owned media. Traditionally personal selling has meant having a sales force that went to customers directly or sales clerks in stores who persuaded customers to buy. Now personal selling is considered the task of everyone in the organization and can now be conducted online, which makes it part of owned media.

Personal selling may be defined by some as the process of convincing a customer to buy a product they do not want or need. This type of hard-sell approach has probably never been widely used and certainly would not be successful today. The vast majority of consumers are much too savvy to be manipulated in this way. Personal selling is more accurately defined as an honest exchange of information between the organization and the consumer. While the exchange might be between a consumer and someone who is employed full-time by a company to do sales, personal selling is done every time someone at the organization comes in contact with the public.

The sales process can take place in the studio, retail store, at an event, or in the box office. One might think that the first step in the process would be to explain the product, but this is not so. The first step is to ascertain the needs of the customer not by asking what product they want to buy but determining what problem they are trying to solve. For example, with a piece of art, the questions that need to be answered are for whom the

product is being purchased, what taste they have, and where it will be used. The salesperson can then suggest a product that will fulfill these criteria. Once this is done, the next step is to then explain the features and benefits of the product including the creator, the method of creation, and, most importantly, the benefits that specifically fit the needs of the purchaser. Finally, the salesperson moves toward action by answering any questions and explaining the buying process including financing, packaging, and, if applicable, delivery.

The sales relationship should be built on mutual trust. If the salesperson could manipulate a tired or stressed consumer into a purchase, there would be no long-term gain. As soon as the consumer becomes aware that the purchased product did not meet their needs, they would soon be online to spread the word and the trust between the organization and the public would be lost.

Business to business sales—the lines are blurring between work and personal

Personal sales when selling a product to another company or organization has been very much affected by social media. Cold calling was a phrase used to describe how a sales call would be made to someone only based on the fact that they worked at a company that needed the product. Cold calling is now rarely used. It has been replaced by what is called social selling (Newberry 2019). When using social selling extensive research is conducted online before the company is contacted. Another change has happened in how salespeople and prospects connect. While salespeople would formerly connect personally with each other at events such as trade shows and conferences, these connections are now being made online. As a result the direct sales approach is no longer as effective. Instead the salesperson needs to develop relationships with prospects by becoming engaged with them online prior to the sale. An additional change in the sales process is where information needs to be posted. There has been a blurring in the distinction between personal and work time and interests. People searching online for information on products for personal use are now just as likely to come upon information that pertains to products they may purchase as part of their work responsibilities.

Therefore, the salesperson needs to be engaged in online communities that pertain to their industry. For creative and cultural organizations this may be websites about creativity, culture, or the arts. They should connect with others in these communities but not to make a sales pitch. Instead information should be offered that can solve a problem posted online. Only one of the solutions offered will be the organization's product.

Public relations—get people talking about you

All organizations perform public relations even if it is not a formal part of their promotion strategy. This is because every organization wants a positive reputation in the community. Historically public relations were used only occasionally to announce a major change or to counter bad news. Now, because of social media, public relations is used to proactively engage in reputation management (Boitnott 2017). People now expect fast and continuous communication from brands using social media tools.

Public relations is a means of formalizing this approach so that communication from the organization includes information on the positive impact it has on the community. In addition, public relations can be used to counter negative information about the product. Finally, public relations is used to encourage other media to speak positively about the organization. The tools that can be used include sponsorship, and charitable giving.

Sponsoring events wholly or in part is a form of public relations. What differentiates sponsorship from advertising is that the event that is being held has a community purpose. Buying ad time on a widely watched sports broadcast is a form of advertising. Having an ad in the program for a nonprofit youth sports league is sponsorship. The youth leagues exist to provide young people an opportunity to play sport but it also focuses on character development. When sponsoring an event, because the organization is not making a direct sales pitch, the message will be used to communicate the mission of the organization. It is hoped that members of the public will be impressed by the fact that the organization is living up to its mission and values and, as a result, will seek out more information and perhaps purchase the product. If not, they will, at least, be left with a favorable impression of the organization that they might communicate online to others.

Sponsorship is particularly effective for small organizations trying to build awareness within the local community (Guta 2019). The organization can sponsor an event held by a local charity or host their own event in support of a charity or cause. The values of the event should be similar to the values of the organization. The sponsorship could involve donating branded products that are used during the event or given away as prizes. It can also involve providing employees who will donate their time.

Closely related to sponsorship is charitable giving. Some companies make it a policy that part of their revenue be used to support a charitable cause. If the organization is owned by a single person he or she can decide what cause they wish to support. However, as soon as there are employees of the company, it is wise to involve them in the decision of what charities to support with the amount of money available. It is useful to decide a system for handling charitable requests from the public as many people may approach the organization for support. A system will make it easier to say no to a donation request when it is necessary to do so. The organization might choose a charity that is close to the mission of the organization. However, a charity may decide to support a charity important to the target market segment of the company. The company may donate in the form of cash. However, if this not possible they may be able to donate a product, such as something that might be auctioned off at an event. An organization that provides entertainment might suggest that they will perform at no cost.

THINK-ACT-PLAN: Using sales incentives and PR

Think: Go online and choose a company's website. Do you see any evidence of public relations? Does the information change the way you view the organization?

Act: Develop five ideas for sales incentive programs and rank them by expense. Think of three sponsorship and three charitable giving opportunities that would be of interest to your target market segment.

Plan: Write a plan for how you will use sales incentives and public relations to meet your strategic marketing goal.

Creating marketing media

Creating the strategic marketing plan

You are now ready to describe your marketing message and what types of advertising, sales incentives, personal selling, and public relations you will use to promote your product. In addition, the plans for website development should be included. Finally, explain what social media you will be using.

REFERENCES

Balkhi, Syed. "5 Rising Social Media Platforms to Watch." *Entrepreneur.* September 26, 2019. https://www.entrepreneur.com/article/338073. Accessed February 10, 2020.

Barker, Shane. "7 Ways to Build Buzz on Social Media for Your New Product Before Launch." *Social Baker.* September 4, 2018. https://www.socialbakers.com/blog/7-ways-to-build-buzz-on-social-media-for-your-new-product-before-launch. Accessed March 30, 2020.

Boitnott, John. "5 Ways You Should Be Using Social Media As Your Top PR Platform." *Inc.* July 7, 2017. https://www.inc.com/john-boitnott/bhow-social-media-is-now-your-primary-public-rel.html. Accessed April 15, 2020.

Cierzan, Guy and Andrew Kelly. "How Loyalty Marketing Can Survive in a Gen Z World." *Adweek.* March 1, 2018. https://www.adweek.com/brand-marketing/how-loyalty-marketing-can-survive-in-a-gen-z-world/. Accessed January 15, 2020.

Cohen, David. "Social Marketers Aren't Giving the People What They Want." *Adweek.* June 22, 2018. https://www.adweek.com/digital/social-marketers-still-arent-giving-the-people-what-they-want/. Accessed January 30, 2020.

Evans, Michael. "6 Steps to Developing a Small Business Marketing Budget." *Forbes.* May 2, 2017. https://www.forbes.com/sites/allbusiness/2017/05/02/6-steps-to-developing-a-small-business-marketing-budget/#55a6b549355c. Accessed March 2, 2020.

Guta, Michael. "How Sponsoring a Local Event Can Grow Your Business." *Small Business Trends.* December 12, 2019. https://smallbiztrends.com/2018/09/benefits-of-sponsoring-an-event.html. Accessed March 18, 2020.

Hall, Tanya. "The New 80/29 Rule of Social Media Marketing." *Inc.* November 16, 2018. https://www.inc.com/tanya-hall/the-new-80/20-rule-of-social-media.html. Accessed February 14, 2020.

Lesonsky, Rieva. "How to Market with Brand Advocates." *US Small Business Association.* September 5, 2019. https://www.sba.gov/blog/how-market-brand-advocates. Accessed February 10, 2020.

Mendenhall, Nathan. "How to Create a Social Media Content Strategy." *Social Media Today.* February 23, 2019. https://www.socialmediatoday. com/news/how-to-create-a-social-media-content-strategy/549035/. Accessed February 7, 2020.

Moorman, Christine and Aaron Lavin. "Getting the Most Out of Social Media Investments." *Wall Street Journal.* 2018. https://deloitte.wsj.com/ cmo/2018/05/18/getting-the-most-out-of-social-media-investments/. Accessed January 13, 2020.

Newberry, Christina. "Social Selling: What It Is, Why You Should Care, and How to Do It Right." *Hootsuite.* April 23, 2019. https://blog.hootsuite.com/ what-is-social-selling/. Accessed March 24, 2020.

Peek, Sean. "Social Media Integration: What It Is and How to Implement It." *Business News Daily.* January 22, 2020. https://www.businessnewsdaily. com/10525-social-media-integration.html. Accessed February 26, 2020.

Perri, Janine. "Will Print Advertising Help Me Grow My Business?" *SF Gate.* September 30, 2019. https://marketing.sfgate.com/blog/will-print-advertising-help-me-grow-my-business. Accessed March 25, 2020.

Prasanna, Rohit. "Content Marketing Using Earned, Owned and Paid Media." *Medium.* June 11, 2018. https://medium.com/@rohithpras/ content-marketing-using-earned-owned-and-paid-media-529124636a45. Accessed April 7, 2020.

Scott, Samuel. "How to Approach Earned and Owned Media." *The MOZ Blog, MOZ.* February 1, 2015. https://moz.com/blog/how-to-approach-owned-and-earned-media. Accessed April 20, 2015.

Szajda, Emily Dawn. "Narrow Segments Capture Attention in Marketing." *GBSB Global.* April 10, 2017. https://www.global-business-school. org/announcements/narrow-segments-capture-attention-marketing. Accessed March 2, 2020.

Wise, Bill. "5 Trends that Threaten Facebook-Google Duopoly in Digital Advertising." *AdAge.* November 29, 2019. https://adage.com/ article/opinion/5-trends-threaten-facebook-google-duopoly-digital-advertising/2219116. Accessed April 30, 2020.

Using owned media to gain earned media
Chapter 11

This chapter will answer the following questions:

- Why is earned media effective in motivating purchase throughout the **AIDA** process?
- How does the **relationship** between the consumer and organization allow co-promotion and co-creation of the product?
- How are online **communities** developed and maintained?
- What types of **content** are successful in creating earned media?
- How can **analytics** be used to measure social media success?

INCREASING EARNED SOCIAL MEDIA

Social media and the AIDA model

While the AIDA model of attention, interest, desire and action, has been used to describe how the company develops a relationship with consumers using traditional media it can now be adapted to include social relations between the consumer and organization. Here is how the AIDA model can be expanded.

Attention: The organization needs to consider how they can get the consumer's attention on a search engine results page. You need to ensure that your website appears when product information is searched by having the right keywords in your description.

Interest: Once the consumer is on the website the company has only seconds to hold their interest. To do so the company must understand why they are coming to the site and what information they need. To hold their interest this information must be written in an engaging manner.

Desire: The way to create desire online is to let the consumer experience the product first hand. This can be done through videos demonstrating the use of the product. In addition the organization should encourage consumer reviews on their site and also link their website to other review sites.

Action: The website or other social media site must have a clear and easy call to action. Where and how the product can be purchased must be explained. The words used, such as buy now or purchase here, should imply immediate action.

Third 2019

QUESTION TO CONSIDER: How do our social media sites promote attention, interest, desire, and action?

The purpose of paid media is to build awareness and attract consumers to owned media. The purpose of owned media is to get people to create earned media by communicating with each other about the product. Earned media is the mention of the company and the product on other social media sites. In order to generate earned media, the organization will use content marketing. This is the placement of information on owned media that will either educate or entertain the consumer. This can be informational content created by the organization or news from elsewhere that is shared.

AIDA—not the opera

A promotion campaign is developed with the objective of encouraging the consumer to take some form of action.

This action might be to purchase a product, attend an event, or change an attitude. However motivating a consumer to take action is rarely a one-step process. Because people are surrounded by promotional messages from both traditional and new media they tend to tune them out. To reach consumers in this environment it is necessary to understand the process consumers move through from product awareness to making the purchase decision.

Promotion needs to be thought of as a process rather than a single event. The AIDA model explains this process of attracting attention, developing interest, creating desire, and motivating action. Because of the many promotional messages that people experience everyday they tend to disregard the message. As a result simply getting the attention of a consumer with an advertising message is a challenge. To do so the promotional message must speak directly to the consumer's needs. Generalized messages that a product should be purchased will not be heard. In addition the promotional must quickly attract the eye and engage the viewer long enough to communicate. This is particularly challenging because of the practice of multi-screening (Buckley 2019). When watching a program on TV, the viewer is often simultaneously looking at information on their phone. The message has only seconds to make an emotional connection with the viewer. A positive aspect of this practice is that if a promotional message is seen on one screen it can prompt a search for more information on another.

However getting attention is only the first step. The promotional message must now cause the consumer to develop an interest in learning more about the product. To do so the style of the ad must communicate an affinity with the psychographic characteristics, values, attitudes, and lifestyles, of the targeted consumers. Depending on the product the promotional message might use humor, dramatic visuals, or straightforward information on the product benefits to develop interest. Social media postings incorporating these words and visuals along with content can be effective in gaining interest. After the promotion has caught the attention and developed interest, the next step is to create in the consumer the desire for the product. This is when the product's competitive advantage must be emphasized with an emotional message. At this step

in the process content from both the organization and other consumers becomes critical. The promotional message plus content must convince the consumer that no other product can meet their needs. Social media sites that show product reviews are effective in creating desire.

It might be assumed that after creating desire, the consumer taking action to purchase the product would be automatic. However this is not the case. The organization must make the action step as easy as possible by providing all needed information on how to purchase the product including a physical or online address. In addition, sales incentives can be used to motivate purchase by providing a discount or premium if purchase is made quickly. If the potential customer should have any difficulty in purchasing, the process will come to a stop. This might happen because the website might not load, a store clerk is not helpful or the product is not available.

Earned media and purchase decision—getting them to purchase is not easy

The importance of earned media in the purchase decision process is difficult to overstate. In particular information posted online by credible experts has more effect on purchase than either paid or owned media. Expert testimonials have even more effect on purchase decisions than the information posted by members of the public. While people will use the organization's social media websites and its branded content as sources of information, they also use a variety of other online sources. These include other social media sites where they read both consumer and expert reviews. The use of reviews when making the purchase decision has become almost universal (Power 2019). In fact 97 percent of shoppers check online reviews before buying. Even when buying in a store, one-third of shoppers will first research the product using online reviews. Not only do almost all consumers read reviews, 50 percent will write a review after purchase.

The effect of branded content, consumer reviews, and expert reviews varies based on the type of product. Branded content supplied by the organization is most effective when marketing technical products. Consumers want the specifications on product details directly from the company. User reviews are the preferred source of information for product categories where

consumers feel they have expertise, such as video games or fashion. Expert review is most used when purchasing high-priced items. While branded content and user reviews should still be used, experts are seen as neutral providers of information.

Cultural and creative products also are affected by expert reviews. However in the past the expert would have been a critic who would have educational credentials and work for a well-known publication. Now the expert may be an influential blogger that critiques products. This is the reason why it is critical that the organization build relationships with these influencers. They have taken on the role of critics in the new online world. In addition blogs or other types of postings by experts should be directly linked to the organization's website and social media. This is the information that people are searching for to make the purchase decision.

THINK-ACT- PLAN: Motivating using social media

Think: Can you think of a product with which you have an emotional involvement? Do you ever discuss the product online? Have you ever looked at people using a product on an image- or video-sharing site?

Act: Look at an organization's website and other social media. Analyze how they are moving the consumer from awareness to interest to desire and finally to purchase.

Plan: Write an explanation of how your organization can motivate purchase using social media.

BUILDING SOCIAL MEDIA RELATIONSHIPS

Customer relationships can be built through co-creation

Asking customers what they want in a new product has always been part of the strategy of many companies. However because this is a question that takes thought and time to answer, it could only be asked in small personal

settings such as a focus group. Technology now allows a company to ask questions to anyone who is interested in answering and this has resulted in the concept of customer added value. This is the value that the customers of the company are adding to the product through their suggestions for improvement or even entirely new product ideas. Here are four ways that a company can get this co-creation process started.

Competitions: Have a competition hosted on the company's social networking site for the best product improvement idea. There should be recognition and even rewards for the best ideas.

Idea solicitation: Dedicate a page on the company's website to soliciting new product ideas. Current customers should be interested as they are already emotionally involved.

Troll comments: Use comments on other social media sites to troll for product improvement ideas. By the way, customers are more willing to share data if it is going to be used for product improvement.

Listening: Companies should not only use their own social media sites, they should listen in to the conversations on sites of competing products for improvement ideas.

Kaplan 2020

Questions to Consider: How are we gathering data on product improvement ideas? How can we set up a system for gathering ideas for new products?

The term social media is used to describe communication technology that allows two-way communication across distance and time. While much social media activity is sharing of personal information, the preference and consumption of products are also discussed online. Social media is a broad category of communication methods that can be broken down into categories. Social networking sites allow communication between two or more people. Media sharing sites allow people to post videos or images online on a single or a variety of subjects. Readers then post comments that agree or disagree which are

then read by others. Microblogging does the same but in very small increments of information.

Organizations can use these sites to build relationships with current and potential customers. In addition, the organization can use social media to build an even stronger relationship with consumers by co-branding of the organization and even co-creation of the product.

Co-creation of products—partners building together

The idea of members of the public not just passively consuming products but also co-creating content is now new. Children have always been inspired by watching a movie to then act out one of the character roles at home. Adults have put on amateur performances of plays or concerts for the enjoyment of friends. However no, one but their family and friends, was available to see their creative efforts. Today people are still being inspired by the content they see in public and online. However now they can share their co-creations online with everyone.

There is the myth of the solitary creative genius who produces a new product and then it is introduced to consumers in the marketplace. Instead the trend today is to allow consumers input into the design of a new product. This might involve having consumers suggest entirely new product ideas or simply suggestions for improvement. It can also involve a choice of one feature such as color or size. The organization should then share their suggestions on the company's website. The sharing of creativity is based on a love of what the organization produces (Winsor 2019). Some organizations even curate and judge the entries.

One way to encourage this collaboration is to use sales incentive ideas to reward individuals who provide content. For example, people who contribute photos could receive a discount on their next purchase. Stories could be rewarded with a gift of a free product. This can be particularly helpful if they are sent a sample of a new product that they will hopefully then discuss online.

Co-marketing using social media—creating brand advocates

One radical difference between traditional promotion and using social media is that social media allows for the consumer to

become part of the promotion process. The traditional term often used to describe this process is word-of-mouth marketing, but now this includes sharing information about products online where the consumer becomes a brand advocate. When using social media, it is hoped that the media message that is broadcast by the organization gets re-communicated online by consumers. While personal discussions about products have always taken place between individuals, online communication amplifies the process.

Not only is it amplified, the message will also be changed by consumers who are communicating about the brand and product. In fact some individuals will become so knowledgeable about categories of products that they will have followers that use them as sources of product information. These expert reviewers may have blogs, their own websites, or both. Organizations that wish to have their products mentioned must build into their marketing strategies a means of providing product information to these expert reviewers so they can become advocates. Creating brand advocates is not something that just happens. Instead it must be an active part of a marketing strategy (DeVries 2020). To create brand advocates the organization must first establish the trust that they both produce an excellent product and then establish a personal relationship with consumers.

Social media strategy—it doesn't just happen

The organization must understand that social media sites are not direct promotional channels. Instead they are communication channels that allow content to be shared. The content that is chosen to be shared must be of interest to the organization's target market as it is the content and not the site that generates interest. The purpose of the content is it to elicit a response from the potential customer. This response may be in the form of comments that agree or disagree with the information that was posted. It is even better if, rather than just posting a comment, customers collaborate by providing their own content such as stories of how they use the product or photos of the product in action.

The models for an effective social media strategy that will connect organizations with consumers continue to evolve.

In reality there may not be a single social media strategy that works for all types of businesses and organizations. However, almost all strategies recommend that the organization first connect with the public by having its own social media sites. However having the sites is the easy part of the model. The challenge will be in using the sites effectively.

There are four steps in creating a social media strategy (Sharma 2019). The first is the same as with any strategy, which is to define the organization's goals. The goal might be to simply attract more visitors to the site. However this does not on its own create additional revenue. Other goals might be to increase sales from existing customers or to reach new customers both of which would increase revenue. If there is a new market segment of consumers that will be targeted, their characteristics must be understood. The next choice would the social media sites that are to be used as part of the strategy. The last step is then to analyze the results in either increased number of visitors, increased sales, or both.

Some organizations are concerned that having their own social media sites will only encourage the public to post negative comments whether or not they are based on truth. However people already have the ability to post these comments on other social media sites. When they do so, the organization may not even be aware of the comments and therefore not respond with information to correct any misinformation. By having their own social media sites these comments can more easily be monitored and then countered with a response (Chioconi 2019). The response should be public so other site visitors can see the response. The response needs to be prompt. Lastly the response needs to be human with genuine caring and with a real name attached.

Negative comments can be helpful for the organization. First, the comments may reveal problems with the product that need to be resolved. For example, the product may have a flaw that can be corrected. In some cases the product is perceived as flawed because the marketing message is being interpreted by the public as promising benefits the product does not have. In one case the product must be improved, in the second case the marketing message must be corrected.

Sometimes the negative comments are incorrect. This may be the result of the consumer using the product incorrectly. Or, it may be that the consumer was having a generally bad day when they posted the negative comment. People are aware that some people generally tend to post negative comments. When responding the organization must keep the conversational tone friendly and helpful as other people will also read the response.

THINK-ACT-PLAN: Encouraging positive comments

Think: What positive or negative information have you shared online about a product? Have you made suggestions for improving a product? If not, what would motivate you to do so?

Act: Go to an online product review site. Analyze how the comments help to promote the product's benefits. Analyze the negative comments for product improvement suggestions that could be incorporated by the company.

Plan: Decide on a plan for how you will encourage your customers to share positive comments online.

SOCIAL MEDIA AND ONLINE COMMUNITY BUILDING

Can you see the future?

Social media continues to evolve. New services and platforms are continually added while others disappear. Do you remember Vine? Some of the trends that are predicted to shape the future of all social media sites if the public's concern for privacy, the increased use of visual content and voice over typing and sharing rather than creating.

Privacy: There will be a rise in what is known as Dark Social where friends can communicate privately without having to opt out or create private connections on a social networking site.

Visual: Video will continue to grow in popularity as it has been found that people stay longer on a video than text site.

Voice: More content will be sent using voice to text as users no longer want to type. Searches will also be conducted using voice and even using only visuals.

Sharing: Rather than send personal messages to others, people will simply share content with which they agree or find entertaining.

Companies and organizations need to consider how they will respond to these trends. The content that is posted online must be highly entertaining or informative so that it will be shared. Social media users are looking for content that they can use to connect with others. This content must be primarily visual with few or no words. Social media users are simply not interested in taking the time to read!

Ni Chiaruain 2019

QUESTION TO CONSIDER: How will we change our social media practices to react to these trends?

While the types of social media primarily used by organizations are social networking, media sharing, and also blogging and microblogging, there are many other types of sites that may be useful. These include social bookmarking sites where users post bookmarks to their favorite sites along with comments. By viewing the websites that are bookmarked by individuals, the organization can discover new trends. Other sites that could be monitored for such insights include DIY sites that allow both individuals and businesses to start forums on how to undertake projects. Geosocial networking sites allow companies to highlight their location relative to the social media user. Since new types of sites are always being developed, continual online research is needed.

Categories of social media users – not all are equal

The level of involvement people have who use social media can be categorized as observers, occasional users, and participants. If the goal of the organization is to get potential consumers to move from observer to participant they must track content usage to determine what subjects engage them emotionally. Observers are the majority of social media users. They may visit online sites to read the content but make no attempt to interact

and add their own. They see no reason to do so and may never become more active online. Occasional users are people that are motivated to interact online only when highly engaged emotionally. This may because they had a very positive or negative experience with a product, experience, or social cause.

Participants are individuals who routinely check the online site and add comments or content on a regular basis. For these individuals visiting the site is part of their daily routine. The comments and content added by participants are read by both observers and occasional users. The organization should also read these comments and respond.

A few participants become opinion leaders, people who are so often on the site that their presence is remarked on by others. These individuals become opinion leaders on the site when their comments are taken more seriously than those of occasional users or participants. Psychology explains that people want to be noticed and matter within a larger community. Hopefully they matter to their family, friends, and colleagues. By posting information online and receiving feedback they become co-marketers and even co-producers. They do so as it is important for them to become part of a wider community.

Online communities—only in cyberspace

Online communities can be categorized into four types (Vision Critical 2020). First are social communities that are public such as Facebook, Twitter, and Instagram which are used for targeted marketing messages. The second are support communities that users join. These might be around a social cause, such as the environment, or a shared interest, such as home design. Organizations could use these sites to share how their products are a solution to a problem or get ideas for product improvements. Advocate communities consist of users who share an interest of a particular brand. They share with others why they love the product and how it is used. Organizations use these types of communities to get feedback on current products and ideas for new products. Lastly, insight communities are started by the organization. These communities are involved in product co-creation.

Done well, content marketing can result in those most involved online in building their own community around the organization's

product. This may happen on the organization's social media site. However it is more likely that the community will build on its own social media site. Such communities will develop their own rules of behavior. As a result community members will self-monitor and self-correct. However someone in the organization also still needs to monitor the conversations. Negative comments about the organization and the product may appear, which will need to be addressed by the organization. However in an online community it may be that the organization does not need to address the negative comments directly as the community members will address the issue. For example it may be that the person who posts a negative comment has used the product incorrectly and this will be explained by other community members.

In addition to marketing to others on the site, consumers may be on other sites where they contribute information. If appropriate to the discussion, they will also then mention their satisfaction with the company's product. This multiplies the effect of the marketing that originated at the organization's owned media and becomes earned media.

Stages of involvement in online communities—from lurkers to elders

A model has been developed to describe the behavior of people who are involved in online communities. These types of individuals can be described as lurkers, novices, insiders, leaders, and elders (Safko 2014). Lurkers are individuals who occasionally visit a website to view content but do not add any content of their own. If they continue to return to the site they may become novices and start to add their own content to the site and also comment on the content that other people have added. Insiders are visitors who regularly visit the site to add content and also participate in ongoing discussions. Leaders in an online community have been contributors for a long period of time. Others in the online community will seek out and view the content that leaders have contributed. It can be counted on that leaders will always comment on new content. A leader may turn into an elder who then leaves the community, perhaps because their interests have changed. The organization needs to pay particular attention to the contributions made by leaders as their postings will affect other members of the online community.

Sharing your human side—everyone is interested in the personal

If the organization wants to build a relationship with the public, they will need to show their human side. This is particularly effective for creative and cultural organizations because their mission, vision and values are part of the identity of their employees. To do involves sharing appropriate personal information, such as birthdays and personal achievements. Posting photos of staff members at community events or at the company site can make people real in a way that only a blog posting cannot. Having fun online by posting humorous stories or comics, particularly if they poke fun at the organization, can help people relate. Even sharing mistakes can help build the organization's reputation if they are shared with humility and a commitment that the mistake will not be made again.

THINK-ACT-PLAN: Creating an online community

Think: Have you been involved in any type of online community, such as for a consumer product, a political issue, or an online tech forum? Why and how did you get involved? How did your involvement help you in some way?

Act: Join an online community to find out what types of comments are posted and what product issues are resolved. Read how the organization responds to negative comments.

Plan: Write a description of how your organization will create and maintain an online community.

POSTING CONTENT TO EDUCATE AND ENTERTAIN

What sort of people use social media?

Everyone seems to be on some type of social site. While some users may use only one site, most use more than one site. If the use is almost universal is there any way that types of users can be segmented? There needs to be if we

are to understand who we want to reach and how to do so. Here are four categories that might be of use:

Relationship builders: They use social media the way it was originally intended, which is to stay connected with friends and family. They also use social media to make new friends.

Selfies: Rather than use social media to connect with others, these use it to send messages about themselves. They record their life day by day and, for some, minute by minute.

Town criers: These users give their opinions on any hot topic of the day. They are not interested in hearing from others, only is giving their ideas.

Window shoppers: These are the people watchers of social media. They are online looking and reading but rarely post or even like.

Majors 2018

Questions to Consider: How we will reach these different types of users with our message?

A common term that is being used today is content marketing. The term refers to marketing a product without using a direct sales approach. According to the Content Marketing Institute the content must be 'valuable, relevant, and consistent.' Content marketing is used to attract a specific target market segment, to turn them into purchasers of the product, supporters of the organization, and then keep them loyal. The content that is provided must be relevant to an issue or concern of the target market segment, but it does not need to directly relate to the product sold. For example, an organization may produce and market a creative product targeted to parents who are concerned about their child's education. These parents will want to read about what are the latest findings regarding child development. If the company provides content that is valuable because it helps solve a problem, such as how to choose the best school for your child, it will be read. By coming back to the website to read more content, the consumer trusts that the organization understands children and their needs. As a result they are more likely to purchase their product.

Attracting attention with content—make it worth their time

Content marketing is not the only method organizations need to use to motivate purchase. It is best integrated with other promotional media that has a more direct sales approach. In addition it will not be immediately successful. However over time content marketing is successful because it allows the consumer to learn about the product without a sales pitch. Instead its aim is to help the consumer by posting content on their website or social media site that is of interest. It then allows consumers to discuss the subject of interest by allowing them to comment and share. Once they start to participate they are likely to often return to the site to interact. As a result, if the consumer learns the product has the benefits they desire, they will in turn market it to others. Besides attracting consumers with content of interest, the online conversations will help the organization to learn more about their customers' concerns and be able to offer better products.

Just as with paid media such as print ads, billboards, and brochures, the aim of social media is to capture the attention of the targeted customer as quickly as possible. This need to capture attention in seconds means that if the content does immediately attract, the reader moves on. This is particularly true online where browsing many pieces of information on a single screen is common.

While the reader may not be conscious of the fact, the reader who is viewing an online site is asking the question if the content has any meaning for them. If the first few words or the image do not convey any reason why the specific reader should stop, they will move on. The reasons for stopping might be that there is an emotional connection to a past or present event portrayed by the words or pictures. Or, it might have to do with the words or images presenting the viewer with a solution to a problem, such as what to eat for dinner or what to buy for a gift. For the organizations owned media, this means that the potential customer surfing online will only stop on the social media site if an emotion is evoked or if it answers their specific question. If it does so, the reader will then stay long enough to read or view content whether the written word, image, or video.

When these sufficiently convince consumers that the product will provide them with the desired benefits, they will then act by purchasing.

Content for blogs and other postings—keep them coming

One of the issues shared by all marketing professionals is what content to add to their website and social media. Adding blogs to websites can greatly increase an organization's SEO rankings (Kline 2020.) Coming up with ideas for postings that are not direct sales messages is difficult. While an online search for ideas of what to post will result in numerous suggestions they can be categorized under a few main posting types, which are publicity, sharing about others, personal messages, and solving problems. First are publicity postings. If the organization or its product has been featured on any other website, news story, or blog, this information should be posted as it provides credibility. When the organization sponsors an event in the community or supports a charitable cause, this should be featured in a publicity posting. Hopefully people reading the posting will be impressed by what the organization has done and it will then share the information with others.

The organization may wish to post information about other organizations and their products and actions. The information posted may be complementary as competitors also have good products and support the community. This at first might seem counter-intuitive as the organization is now providing free promotion for competitors. However someone searching online for the name of competitors might come to the organization's website and by doing so learn more about the organization and prefer their product.

Some postings are not about the organization or its competitors. Instead they are inspirational or personal sharing. Such postings could be sympathetic comments to readers about the current bad weather conditions or sharing the joy of good weather. The postings also simply may be seasonal greetings. Sharing interesting news can also be the basis of a post. Also artwork, videos, or music that it is believed the readers will enjoy can be posted.

Another type of post provides helpful information to the reader. This information does not need to be connected to the product but rather to the interests of the public. Posts that start with the words why or how are the ones that most frequently show up in search results. This is because these are the words that are being inputted into search engines. Using Google analytics organizations can quickly learn which of their posts receive the most response from readers. Since it is the headline that is used when the search engine looks for information to provide to a searcher, extra attention must be given to writing one that is successful in attracting readers.

Microblogging content—even if you don't, others may be tweeting about you

Microblogging, of which Twitter is the most popular, refers to an ongoing posting of very short communications. Even organizations that chose not to microblog need to be aware of how it is used as they need to know if people are talking about them and what they are saying. Twitter is used to update followers, people who subscribe to an individual's feed, on the sender's thoughts and actions. It also can be used to share links to stories, videos, and posts that are of interest. In addition it is easy to share content on other sites by tweeting. If an organization is already posting content using a blog, a shorter tweet post can be made that will alert people of the new content.

Using microblogging has advantages over traditional blogging and posting (Nations 2019). There is less content to create so communications can be more frequent. It also is critical when information is time-sensitive such as a product recall or event cancellation. It can be used to make positive announcements on sales and contest winners. Microblogging is not successful if it is only used to send a promotional message. No one will be interested in receiving a stream of marketing messages. However it can be successfully used by organizations to provide information on special deals that are available to the customer. These might be timed discounts that are only available during a specific time period. For example, they may be last-minute deals for tickets if an event has empty seats. Besides providing a deal, the information sent must be written in a way that is both easy to

understand and compelling. The best way to learn how to write successful tweets is to follow others and learn from examples.

After establishing a Twitter or other microblogging account the organization should link the account to its webpage and other social media sites. In addition an application can be used that will track who is following the Twitter feeds and how often they are being retweeted. Using this information can help the marketer learn what tweets are of enough interest to the reader for them to send them to someone to whom they are connected thereby creating earned media.

Press releases as content—now everyone is a journalist

The traditional method of sharing press releases was to send them to news media. Now with the growth in the importance of blogging, the organization should also send the press release to bloggers who regularly comment on similar organizations and products. Both of these methods are appropriate methods for getting publicity or earned media. However by adding them to the organization's web or social networking site, press releases are increasingly being read directly by the public (Scampoli 2018).

It is difficult to get other media to respond to and comment on the organization's action unless the news is exciting such as an innovative new product launch or of sponsorship of a popular event. However, because press releases are now being read directly by the public, they can be used for communicating more routine information. Rather than wait for a big announcement, organizations should send more frequent press releases. These online press releases should be written with search engine optimization in mind using the appropriate keywords. The press releases will not be direct sales appeals, which would put them in the category of advertisements, but they should contain links to the organization's website for those readers who may wish to know more about the product. In addition links to the other social media sites such as a Pinterest page, YouTube channel or Instagram account can be added. This not only aids the potential consumer who may wish to purchase the product. It will also help the member of the media or blogger who needs to know more about the organization so they can write their own content which they will then post online.

ANALYTICS AND MEASURING EFFECTIVENESS

What is big data?

The term big data is often used when discussing analytics. However the meaning of the term can be confusing as its definition can vary. Here is one definition Data is big if:

Volume: It is too large to manage on the average PC.

Variety: It contains both structured data that can be easily quantified and unstructured data from blogs, emails, webpages, and transcripts.

Velocity: It, along with the reporting format changes, over time.

More important than a definition is how big data can be used. It is a four-step process of seek, store, analyze, and act.

Seek: Rather than just use internal data actively look for new sources from private companies, government sources, and online users.

Store: All this data must be somehow quantified and stored in the same database.

> **Analyze:** Look for insights as to what people have done, what they are doing, and what they will do.
>
> **Act:** Based on what you learn make decisions about your own actions.
>
> *Finlay 2015*
>
> **Question to Consider:** Do we have any data that we can use to predict behavior?

Social media sometimes is, incorrectly, thought of as a free form of promotion. While social media does not require the purchase of media time for advertising or the printing of expensive brochures, it still has costs. Maintaining social media sites and developing content takes the time of employees, which is a cost to the organization. Therefore there needs to be a return on the social media strategy investment. The organization should use analytics to determine if this return is being achieved. Analytic programs that are available at no cost can track the number and location of visitors to social media sites. If ecommerce is being used it is easy to track sales over time. In addition analytics can be used to examine the visitors' actions while on social media sites. Programs for which a fee must be paid can provide even more sophisticated information.

Social media objective and conversions—did they do what you hoped

The first issue when considering return on investment is deciding on the objective that needs to be tracked. For ecommerce sites it will be the number of completed sales. Even without ecommerce the organization will still want to learn how many people visited their site. They will also want to know what page images and words increase the length of time on the site and encourage more page views. For sites that depend on attracting the public through the posting of content, the organization will want to know what content attracted attention and which resulted in comments.

The organization needs to track both micro and macro conversions. Micro conversions are when a potential customer takes a small action such as signing up for an email list or

spending time to read an article. When a customer reaches the intended final action such as purchasing a product or leaving a comment, it is called macro conversions. Both macro and micro conversions can provide data on consumers' behavior.

The behavioral data that results from tracking macro and micro conversions can then be segmented. The organization can learn the day of the week or the time of day when people are on the site. This provides information on what time is best for posting new content. It can also be determined if people are looking at the site from a computer, tablet, or phone. This information is needed so that the site can be designed to fit the device. The conversion data can also be segmented geographically. Using geographic segmentation tells the organization where the viewers live. In addition the data can be segmented to determine the number of unique visitors and the number of repeat visitors. This information is more important than the total number of visits as the organization needs to know if they are both building loyalty and attracting new visitors to the site.

This conversion information can be used by organizations to improve their sites. For example they can learn how many people got as far as putting an item in the shopping cart but did not complete the purchase. Sophisticated systems can then be designed to send these shoppers an email reminding them of items still in their basket and even offering a discount for a completed sale.

If macro conversion is when the consumer takes the final step desired by the organization such as a purchase or commenting on a posting, the attribution is how they got to that final step. The organization wishes to know this information so that it can emphasize the content that got the consumer to the desired behavior. There can be two ways to track attribution. The first is to track where the consumer first landed on the site that started the process. It is even possible to learn from what site the consumer was on that lead them to the organization's website. It is also possible to track what was the final step before the conversion took place. If possible, organization should track one or both behaviors.

Google analytics—it can tell you so much more than you realize

While very sophisticated tracking reports can drill down into data, the normal setting for Google analytic reports should meet all the reporting needs for a small to mid-sized creative or cultural organization. The four standard components of Google analytics reporting are collection, processing, configuration, and reporting.

Every time a page is viewed it is called a hit. Google analytics collects and reports these hits. Data on hits can be collected from all the organization's websites, mobile apps, and e-commerce sites. To obtain this data Google analytics uses javascript which is already embedded into software used to design websites. Google analytics can also be added to an organization's social networking site for collecting data. However to use the analytics to track activity on a mobile app requires that extra code be added. A complication of collecting data on people's use of the website on a mobile device is that the device might not always be online even though the owner is looking at a previously downloaded website. Therefore the results may not be in real time but be posted the next time the device is connected. After the data has been collected it is processed into information that is useable. The data can be then configured using filters that the organization has specified. Finally the data is reported on to the Google analytics webpage or using an app on the website.

The analytic report consists of two types of information, which are dimensions and metrics. Dimensions are what are used to describe the users. Even free analytics will tell the organization how many unique visitors there have been on their sites and how many are repeat visitors. They will also provide information on the geographic location of the visitors. Metrics quantify the actions of the visitors such as what pages did they view, what content they read, and if they posted information. To obtain the dimensions and metric data the marketer must open a Google account. Once the account is opened the website needs to be registered. This is made easy for even non-technical people, as a bit of Javascript is provided that can be simply cut and pasted.

This bit of script must be added to every page on the website. While this may seem cumbersome, in fact it is made easy using Google Tag Manager.

Cost of customer acquisition—nothing is free

While promotion can be used to encourage more frequent purchases by new customers, its main function is to attract new customers to purchase. The cost of the promotion needed to attract a customer to the point of purchase must be balanced against the additional revenue the customer will provide. The first step to determining the cost of customer acquisition, which is how much money needs to be spent to entice a new customer to purchase, is to determine the costs of the paid and owned media that is being used. This is easier to accomplish when examining the use of traditional paid media. This can be done by dividing the monthly cost of paid media with the number of new customers that are purchasing from the organization. In addition the cost of maintaining the organization's social media sites for a month needs to be added. Using this process is the only way to determine if the promotion being used is effective. Another means of determining if paid promotion is effective is return on investment or ROI. This divides the amount of money spent on promotion not by the number of new customers but by the additional revenue received. ROI focuses on additional revenue whether from new or existing customers.

THINK-ACT-PLAN: Analyzing analytics

Think: The last time you bought something online, what was the last image or content you viewed before you made the purchase?

Act: Go to the Google analytic website. What data do you believe would be helpful for a company?

Plan: Decide what analytic data you will need to collect and analyze on your web and social media sites.

Using owned media to gain earned media

Creating the strategic marketing plan

You are now ready to plan how you will use social media to build a relationship with your customers. Describe the sites you will use and what content will be posted. In addition describe any online communities you will be targeting. The more detail you include now, the easier it will be to implement your social media plan.

REFERENCES

Buckley, Pete. "How Brands Can Thrive Despite the Squeeze on Consumers' Attention." *Marketing Week*. February 12, 2019. https://www.marketingweek.com/facebook-brands-thrive-squeeze-consumers-attention/. Accessed January 13, 2020.

Chioconi, Emily. "How to Respond to Negative Comments on Social Media [Examples Included]." *Marketing Circle*. December 11, 2019. https://www.marketcircle.com/blog/how-to-respond-to-negative-comments-on-social-media-examples-included/. Accessed January 23, 2020.

DeVries, Henry. "How to Create Brand Advocates." *Forbes*. January 30, 2020. https://www.forbes.com/sites/henrydevries/2020/01/30/how-to-create-brand-advocates/#2ba8fc6fd629. Accessed March 4, 2020.

Finlay, Steven. *Predictive Analytics, Data Mining and Big Data: Myths, Misconceptions and Methods*. New York: Palgrave Macmillan, 2015.

Kaplan, Jennifer Lacks. "All Hands In: Brands Amplify Customer Participation." *Wall Street Journal*. February 3, 2020. https://deloitte.wsj.com/cmo/2020/02/03/all-hands-in-brands-amplify-customer-participation/. Accessed March 11, 2020.

Kline, Kenny. "Why Everyone Is Adding Blog Content to Their Websites." *Inc.* February 4, 2020. https://www.inc.com/kenny-kline/why-everyone-is-adding-blog-content-to-their-websites.html. Accessed March 20, 2020.

Majors, Tim. "The 4 Types of Social Media Users." *Uptick*. March 22 2018. https://uptickmarketing.com/4-types-social-media-users/. Accessed February 13, 2020.

Nations, Daniel. "What Is Microblogging?" *Live Wire*. December 19, 2019. https://www.lifewire.com/what-is-microblogging-3486200. Accessed March 1, 2020.

Ni Chiaruain, Anna. "What Will Social Media Look Like in the Future?" *Logograb*. February 15, 2019. https://blog.logograb.com/social-media-future/. Accessed March 23, 2020.

Power Review Team. "The Growing Power of Reviews: Understanding Consumer Purchase Behavior." *Power Review*. January 2, 2019.

https://www.powerreviews.com/insights/growing-power-of-reviews/. Accessed February 21, 2020.

Safko, Lon. *The Social Media Bible: Tactics, Tools, and Strategies for Business Success*. 3rd ed. Hoboken, NJ: John Wiley & Sons, 2014.

Scampoli, Rosalia. "In the Age of Social Media Why Are Press Releases Still Necessary?" *PR Daily*. February 5, 2018. https://www.prdaily.com/in-the-age-of-social-media-why-are-press-releases-still-necessary/. Accessed March 29, 2020.

Sharma, Gauray. "4 Steps for Creating a Social Media Strategy [Infographic]." *Social Media Today*. July 15, 2019. https://www.socialmediatoday.com/news/4-steps-for-creating-a-solid-social-media-strategy-infographic/558752/. Accessed January 30, 2020.

Third, Jake. "How to Apply the AIDA Model to Digital Marketing." *Hallam*. November 11, 2019. https://www.hallaminternet.com/apply-aida-model-digital-marketing/. Accessed March 27, 2020.

Vision Critical. "Beyond Facebook: 4 Types of Online Communities and Best Practices on How to Use Them." *Vision Critical*. February 6, 2020. https://www.visioncritical.com/blog/types-of-online-communities-best-practices. Accessed March 21, 2020.

Winsor, John. "Tap into the Power of Co-Creation for Crazy Good Business Results." *Forbes*. July 3, 2019. https://www.forbes.com/sites/johnwinsor/2019/07/30/tap-into-the-power-of-co-creation-for-crazy-good-business-results/#32a9f504290c. Accessed April 3,2020.

Implementing the marketing plan

Chapter 12

This chapter will answer the following questions:

- How can organizational **culture** be used to motivate changes needed for implementation of the plan?
- Why is creating a marketing **budget** necessary for successful implementation?
- Why are **timelines** and accountability necessary for goal achievement?
- What unique challenges are posed by implementing a **social media** plan?

USING CULTURE TO IMPLEMENT CHANGE

Six steps to successful organizational change

Making organizational change happen requires the support of the organization's employees. However, implementation can be challenging when most people are happy with the current situation. Here are six steps that can help when implementing change:

Communicate: You cannot communicate too much. Rather than just explain the need for change, go over in specific detail what is going to happen. If people don't know, they will guess, which is how rumors get started.

Get personal: Once the steps to change are explained, people will want to know how it is going to affect them personally. They want to know if they will have the needed skills and resources to be successful.

Plan: After the overall change process and its impact on employees have been communicated, explain the detailed steps that will need to take place. People need a clearly detailed timeline.

Sell: Sell the outcome that will result from the change, including the benefits to the organization and also to individuals. Communicate to employees the success of the already implemented changes even while the process is going forward.

Collaborate: Once the change effort is underway, share early signs of success. It is now time to focus on ensuring that all employees are collaborating so as to keep the momentum going, but also as a way of bonding with employees.

Refine: As the changes are being implemented, ideas for improvement of the original plan should be explored and possibly adopted.

Blanchard and Blanchard 2013

Question to Consider: What would be our plan for implementing change?

Implementing a marketing plan requires motivating people, having sufficient funds, and allocating time and responsibility. If the marketing strategy depends on the organization moving in a new direction, such as introducing new products or targeting new customer segments, the marketing department must consider how to get everyone in the organization to support the effort. Employees also have to be given the autonomy to make decisions. One way to do so is to use the organization's culture to promote working together while supporting individual actions.

Organizational support—back to the mission

To be successful in getting support from employees, the new marketing strategy must be based on the mission of the

organization. If the marketing strategy depends on having the product produced in a different geographic location while the mission statement states the importance of supporting the local community through providing employment, there should be resistance from others in the organization. However having a mission-based strategy will encourage employees to take the steps necessary to implement the marketing plan.

Besides ensuring a focus on the mission, the marketer must determine is if there are any existing organizational principles or beliefs that must be changed if the strategy is to be successful. If part of the strategy is to develop a high priced line of goods to increase revenue, but an organizational belief has always been that the company's products should be affordable, there will be resistance to implementation. While the production of low priced goods may not be part of the organization's mission, it still might be an unspoken assumption of employees. If this is the case, marketing must communicate to everyone in the organization why the strategic goal targeting wealthy potential customers will help the organization in its mission by supplying the revenue that supports its community involvement efforts. In addition it should be carefully and respectfully explained that the new goal of introducing a higher-priced product will allow the organization to continue to exist so that it can also produce the lower-priced product that is affordable to a larger segment of the local population. Respect is important because these basic beliefs are part of the organization's culture and should not be carelessly disregarded.

Using tangible reminders such as symbols can help with the transition to a new marketing strategy. The symbols can be difficult to get right as they must be chosen taking into account what will motivate the creative employees. A top-down approach to change does not work. For example, management might believe that giving employees a T-shirt printed with the organizational symbol will be appreciated. However if the employees have not been involved in the design, the T-shirts may well be resented as a waste of resources. If they are involved in the planning, they may be worn with pride.

Organizational change framework—seeing the organization through a new lens

Creative individuals often work alone as they need time to contemplate before they can develop their ideas. This time working individually may be absolutely necessary for the creative process. However, working in an organization also requires people to work together to accomplish common goals. This process may not come naturally to the creative personality. While they may intellectually agree that working together is necessary, emotionally they may have a problem doing so.

Working together within an organization does not happen without leadership. Historically the idea of a large group of people working together for an organizational goal is rather new. Throughout history individuals were motivated to follow leaders either because they were forced to do so or they were motivated by the hope of personal gain. The idea of a large group of people who freely work together in an organization as equals to achieve a common goal is new as previously few such organizations existed. Therefore it is necessary to learn how this can be accomplished. One means to do so is called organizational framing (Bolman 2017). Framing is using a sociological concept to explain how individuals in organizations work together to achieve common goals. The four frames that are used to understand motivation toward group goals are structural, human resources, political and symbolic. If a manager understands what frame best describes their organization, they can then use specific tools to motivate employees to move toward a common strategic goal.

Structural frame: The structural frame is a concept that is based on management science. This frame looks at the organization as a machine. And just like a machine, the organization has different parts or departments, which are designed for the completion of specific tasks. The manager who uses the structural frame believes that if everyone is carefully assigned the correct task, which they then perform as specified, organizational goals will be met. Work is divided by management based on the tasks that need to be accomplished and then assigned to individuals who have the necessary skills. Finally a system for coordinating and reporting is designed.

Implementing the marketing plan

The manager takes a rational approach toward organizational change believing that if the need for the task is explained, people will agree and do what is necessary for its completion.

Some organizational structure is necessary if the strategy is to be successfully accomplished. A total lack of structure will result in everyone doing the tasks that they prefer. As a result some tasks will be duplicated while other tasks will not even be started. However a top-down structure that does not take into account the desires of employees will fail. The internet and social media allow individuals almost unlimited avenues for self-expression. Using technology people can find their own answers to problems. A too rigid structure will feel stifling for any employee but particularly for creative individuals who thrive on autonomy and resist being told what to do (Gulati 2018).

This balance between control and autonomy is particularly difficult to achieve in a creative or cultural organization. At the time that the marketing plan is introduced there may be insufficient structure to ensure the plan is implemented. Designing a structure that assigns tasks and controls while still empowering individuals is the challenge. What needs to be considered is what will motivate creative individuals to agree to assist in implementing the necessary structure. In addition in a creative organization, there must be room for flexibility as new ideas may arise during the implementation process.

Human resources frame: The human resource frame views the organization not as a machine but as a family. The view that the human resources frame is best is common for individuals working in creative and cultural organizations. After all, creativity is seen as the result of individual inspiration. And, just like in a family, the needs of individuals must be met. Some would make the argument that the structural frame treats employees like children who are assigned chores and then punished if the chores are not completed. When employees are treated like children, they will react as children by either becoming withdrawn or by lashing out. The human resources view is that one of the reasons for the organization's existence is to meet employees' emotional need for respect. There are two types of respect that can be given (Rogers 2018). Owed respect is accorded to everyone in the organization simply because they

are an employee while earned respect is given to employees who provide unique contributions to the organization. Too much owed respect with little earned respect is appropriate for an organization where team effort is critical but can also result in little innovation. Creative employees thrive on earned respect but there is a danger that it can lead to excessive competition rather than team effort toward goals.

If the marketing plan is to be implemented, people need to feel both valued and respected. This can be accomplished by listening to their concerns and adjusting the plan to ensure that these concerns are addressed. Employees should also be provided the training that is needed to ensure they have the skills necessary to implement the plan. In addition they should be rewarded when the plan succeeds. In this way when the new plan is implemented they will feel a stake in its success.

Political frame: While the structural frame views organizations as rationale with assigned roles and responsibilities and the human resources views them as families where people should have their needs met, the political frame views them as shifting coalitions of power. In this view, organizations never have enough resources, whether the need is financial or emotional, to meet the needs of every employee. Organizations have an official ranking of authority and it is the people who have authority that are able to provide or withhold these limited resources. In reality, authority may not be held by people with official titles. Other individuals gain authority because of their skill, their character, or their seniority. These people with unofficial power can either support or oppose the implementation of the marketing plan. Their support must be negotiated if the plan's goals are to be achieved.

To do so, those in charge of implementing the plan must first understand who will oppose and who will support implementing the new marketing strategy. Those who want the plan to succeed will need to negotiate with those who are opposed. These negotiations will attempt to motivate support of the plan by providing either the financial or emotional resources desired by the reluctant employee.

Symbolic frame: The symbolic frame views an organization as a group activity that has a meaning beyond simply attaining

a goal. The focus is not on negotiating with the individual, but rather motivating support based on the need of everyone to meet the organizational mission. Based on the type of organizational culture the symbolic frame may emphasize individual achievement, making money, or achieving a community mission using symbols and stories. The organization that focuses on achievement will use symbols and stories to make this clear. The photos of individuals who have achieved a goal will be prominently displayed while their stories will be shared in blogs and videos. These individuals will be recognized at events and be rewarded with promotions. Organizations that encourage wealth will reward employees with expensive gifts, such as new cars. The offices will be furnished without regard to cost. Any employee who does not meet a financial goal will be terminated without a second thought and this action will be accepted as fair by the other employees.

On the other hand, creative and cultural organizations will use symbols to stress the importance of the mission of the organization. These organizational cultures are not based only on profit and growth. Instead they are often based on employee and community wellbeing. Symbols will be used that express the importance of creativity to living a quality life. The offices will reflect this through the choice of art, music, and furnishings. Using organizational resources to share their talents with the community will be rewarded rather than individual achievements. Social media is used to share these organizational symbols (Grantham 2016). When implementing a new marketing strategy, symbols should be used, such as a kick-off event, which will emphasize how the changes are needed to fulfill the mission of the organization. In addition, progress can be visually tracked throughout the organization using graphics. Once the goals are reached a celebration will be held.

THINK-ACT-PLAN: Implementing the plan

Think: What was a situation where you either resisted or supported change? Why did you do so? If you resisted did you prevail or what changed your mind?

Act: Analyze the structural, human resources, political and symbolic frames of your current organization. Which would need to be addressed before a change could be successfully implemented?

Plan: Develop at least three actions you will need to take to implement the marketing plan.

CREATING A MARKETING BUDGET

If you only had $100 to spend on marketing what would you do?

Hopefully your organization will have more money than $100 in your marketing budget. However there may be times when you have an event or a product that you need to promote and very little left in your budget. Here is one idea on what to do when you have such limited funds.

Facebook: First you can always post information on your Facebook page for free but if you want more people to see the posting you will need to pay to promote your page. When you do so, the page will show up on the news feed of the Facebook page. You determine for how long you want the information to show and to whom it will be shown. You can choose from different options including people connected to you or other people based on interests, demographics, or geographic area.

Google Ad words: We have all seen the ads that show up when we use the Google search engine. This is also an option for Google-owned sites such as YouTube. You choose the search words to which you want your ad to be linked. The chance of your ad appearing depends on the amount you are willing to pay and the quality of your ad. Because you control the budget, this can be a cost-effective method of promotion.

Social media: You can spend the remainder of your budget on upgrading your social media sites. Perhaps you can invest in better design, having copy written, or a video

produced. Because you are only talking about one posting, not your entire site, this can be inexpensive while also being very effective.

With technology you can now promote even when funds are short.

Allen 2015

Question to Consider: How would I spend $100 dollars when I need to increase sales?

The organization may have tracked marketing expenses in previous years. Although this information will be of interest, if a new marketing plan is to be implemented, spending in previous years may not be relevant. This may be particularly true if sales were lower than desired. If spending on marketing activities was not tracked in the past it is imperative that the organization starts to do so. The success of any marketing effort is judged by the amount of money spent versus the additional revenue generated. Even if sales increase, if the additional revenue received is less than what was spent on marketing, the plan has not succeeded. This does not mean that the entire effort was a failure. Rather it means that the organization must look at expenses and see what can be cut.

Tracking expenses—every dollar counts

A strategic marketing plan is not completed until a budget has been developed. First the cost of implementing the plan needs to be calculated. Besides preparing a detailed list of any new product development outlays and any additional distribution costs, a complete listing of promotional expenses must be developed. These costs will be compared to estimates of additional revenue. The amount of additional revenue from the strategy must not only cover the costs of the plan, it must provide a profit. Therefore the budget must include all the product, distribution, and promotion costs related to the implementation of the marketing plan. Rather than simply list all expenses it is better to calculate the costs related to the specific tasks needed to achieve each marketing objective.

The cost of promotional materials that are designed should be tracked including both staff time to design and production costs. Media costs would include any traditional paid media, such as ads or radio. A media campaign could also involve the cost of the creation of a brand or logo. In addition, expenses must be calculated for any printing of brochures, posters, or flyers. Promotional incentives such as free gifts should also be included in the budget. Public relations costs should be calculated for sponsorship or charitable giving. Traveling to trade shows or to visit retailers would also be a marketing expense. Of course the more of these tasks that can be completed by current employees, the lower the overall cost of the marketing plan. The tasks associated with owned media, such as developing a social media strategy might include hiring specialized services to help with the development of social media platforms. Expenses should also include the cost of hosting and maintaining social media sites. Lastly, the staff time of writing content and responding to social media comments needs to be added as this time is valuable.

Finalizing the amount to spend—getting to the bottom line

One question that must be answered is how much money should be spent on implementing the marketing plan. One method of approaching this question is to expense all the marketing tasks that are detailed in the plan and then add up the total amount of their cost. However another method is to start with a set cost the organization can spend. The amount available to spend is then allocated to each task based on importance until the budget is spent. On average US companies spend 7.5 percent of revenue or 10 percent of the overall budget on marketing (Moorman 2020). However the percentage could be different based on several factors including the age of the business and the businesses' competition. Also the type of product sold directly affects the percent of total expenditures on marketing. Packaged consumer goods spend on average 10.9 percent of their budget on marketing while technology companies spend 13.8 percent.

When a business is new there will be little or no revenue. As a result it will be tempting not to spend money on marketing, but the opposite is true. If the business is new, more money will need

to be spent on marketing to build product and organizational awareness. Without funding marketing to build awareness, all the other money spent on establishing the business may be wasted. Another factor to consider is that the competition will influence the amount of money that needs to be spent. If the business has numerous competitors, it will have to spend more money on marketing to convince consumers purchasing a competitor's product to switch brands.

However success is not guaranteed even when a large amount of money is spent. The more critical issue is how the marketing budget is being spent. It is easy to spend a large amount of money on expensive media with little increase in sales, when less money, spent more effectively, could have resulted in more profit. Sometimes organizations will spend money on promotional media simply based on the advice given by others. Unfortunately sometimes that advice is biased as it is being given by those who are promoting a particular media. For example, salespeople from social media consulting companies might try to convince the organization to spend money on SEO optimization, website design, or content creation based on what they are selling. There is nothing wrong with them doing so, as they can provide helpful information. However the use of the services they are selling may not be the best choice for the company's marketing strategy. There is no reason to spend money when low cost paid and owned media may be just as or even more effective in reaching the targeted market segment.

The amount of money spent on marketing will also depend on organizational goals. There are theories that say an established business that is not trying to grow its revenue only needs to spend three to five percent of gross profits on marketing. However for businesses trying to grow their revenue, the amount should be more in the six to eight percent of gross profits range. Established businesses trying to grow market share by introducing new products or targeting a new consumer segment may need to spend nine to ten percent on their marketing budget. However in very competitive situations, spending more than ten percent may be necessary. In reality, companies may not need to spend so much money as 58 percent of businesses only spend up to four percent (Evans 2017).

Marketing budgeting methods—one method does not fit all

There are several methods of deciding the total amount of money to be spent on budgeting, which includes objective budgeting, percent of sales, or flat rate budgeting. In addition, the amount to spend on marketing can be based on what competitors spend. Adding together the tasks called for in the plan and then budgeting what they will cost is referred to as marketing objective budgeting. While an accurate means of determining the cost of the marketing strategy, it may be that this amount of money is not available in the budget. There might also be a concern within the organization as to whether the amount is appropriate.

A different means of deciding upon the budget is the percent of sales method. With this method a percent of revenue is allotted to cover marketing costs. This method might seem fair as the more sales that are made marketing, which drives sale, can then spend more money. However it does not take into account issues that are outside the control of the marketing department. These outside influences, such as new competition or the state of the economy. More money may need to be spent because of competition even if there will be no increase in sales. In addition using the percent of sales method when there is a decline in sales due to a slow economy will result in less money for marketing just at a time when more money may need to be spent.

Another method is to simply set a flat amount to spend on marketing based on what can be afforded. The marketing department can then spend this money as they see fit. This method has the advantage of guaranteeing money for marketing and also allows the department to budget long term. The problem with this method is that it does not answer the question of what this flat amount should be. A last method of setting the budget is based on estimating what competitors spend and then matching this amount. The problem is that the competitor might be spending too much or too little.

Whatever method is chosen, the critical issue for the organization is to carefully track marketing expenses and match them with any increase in revenue. If it is determined that when money was spent on giving out t-shirts as an incentive

to customers who purchased, but sales did not increase, then this item will be taken out of next year's budget. Likewise, if it is determined after sponsorship of an event that sales increased ten percent, then more money might be budgeted for this type of sponsorship next year.

Of course, the only way to know what marketing is effective is to track how customers become aware of the organization or product. This can be done by simply asking customers what brought them to the store, studio or event. When purchasing online, this question can be asked as part of the purchase process. Only by obtaining this information, will the organization be able to use future marketing funding more effectively.

THINK-ACT-PLAN: Developing a budget

Think: What method do you use to budget your own expenses? Does it work?

Act: Go online and watch a video on how to set up a budget using Excel. Check out commercial software packages that can be used for budgeting.

Plan: Develop the budget for your strategic marketing plan.

DEVELOPING A TIMELINE FOR COMPLETION

Social media tasks

Part of developing a template and assigning responsibility is to break down objectives into tasks. To do so you will need to understand the various aspects of each job. For a social media strategy to be implemented, the tasks that might be needed to be done are:

Content creator: Write the blogs, articles, and Tweets.

Analyst: Look at the analytics of the social media platforms to see what has been viewed and if it has resulted in the desired action.

News junkie: Be online looking at other sites and reading other blogs and tweets as it is necessary to know what ideas and information are trending.

Customer service representative: Respond to online complaints, questions, and suggestions from customers.

Community facilitator: Monitor conversations between users of the site and introduce new topics for discussion.

Marketing funnel monitor: Oversee the process of turning responses into sales.

However, thankfully, each of these roles does not be done by a separate individual!

Mirman 2019

Questions to Consider: How are we going to assign social media responsibilities?

Implementation of a new marketing strategy is a creative process similar to any other creative work. It is helpful to understand that there are components necessary for the successful completion of any innovative process (Baumgartner 2020). First the new marketing strategy must make financial sense. Second, the people must be motivated to participate. To do so the organization must understand the mindset of the creative talent and the motivation they have in producing their work. The plan will not succeed if its implementation results in their emotional needs not being met. Lastly, the strategy must be technically feasible including having the staff, time, and money. Marketing goals that the organization does not have the skill to implement will not succeed.

Developing timelines—keeping everyone on track

One final step remains before a marketing plan is complete, which is to develop a timeline that assigns deadlines and responsibilities. When the strategy is first implemented everyone may be very enthusiastic about the new marketing plan. However as everyone is already busy with their everyday responsibilities it might quickly become apparent that the marketing tasks are not being completed. A timeline will ensure that the needed tasks are being accomplished by the

dates specified (Moon 2019). This is critical for success as some tasks cannot be performed before others have been completed. As a result one unaccomplished task can stop any further progress.

A finished detailed timeline should break down the objectives into the individual tasks that must be accomplished. These tasks will then be arranged into the order in which they need to be completed. To be sure that the tasks that depend upon others are listed correctly in the timeline, the time needed to complete each task will be allocated. Finally the person or department responsible for the task will be assigned.

Developing the timeline should be done in consultation with others in the organization. If an individual or department is to be assigned a task, they should have input into whether they have the needed skills. If not it will be necessary to either provide training for the employee or to bring in someone else to complete the task. Also the employees should have input into the decision as to how much time the task will take to complete. Assigning a task and a completion date without consultation will result in little cooperation or even sabotage of the plan. Everyone in the organization already feels that they are working up to their full capacity. If employees feel they are not being listened to, they will not cooperate.

Assigning responsibility—everybody must do their share

While developing the timeline, the organization needs to consider the need for any additional staffing. If the marketing strategy makes fundamental changes in the product and its distribution, there might be a need to hire full time employees. As this is expensive it is more likely that tasks will be assigned to current employees. However if they do not have the needed skill some marketing tasks may be contracted out to specialists.

For example, the implementation schedule may include such marketing tasks as blogging, updating the website, or handling customer comments and complaints. The marketer must decide which of the tasks can and should be delegated to others. It is tempting to handle all the tasks personally, as this way it is assured they will be completed. However the marketer should instead estimate the value of their time and decide if it would be

more cost-effective to delegate the tasks to someone else. While hiring staff would mean an additional expense, it will provide the marketer with time for more productive tasks. As a result it may be worth the cost.

One way to decide if someone else should be hired is to analyze tasks based on their importance to the success of the plan as well as the skill required (Adams 2017). First there are marketing tasks that are critical to complete and require a high level of skill, such as creating an e-commerce site. These tasks will have priority and if they cannot be completed by the marketing staff someone else must be hired to ensure they are completed. There are also tasks that require skill but do not need to be implemented immediately, such as maintaining social media sites. These tasks can be completed by the staff internal to the organization by providing them with training. Even if they are not performed as well as they would have been with an expert, having them completed internally saves money. When marketing tasks are either outsourced or delegated within the organization, progress must be verified to ensure the strategy stays on track. However that does not mean that others in the organization should be micro-managed. Instead progress should be checked on a regularly scheduled basis.

Using a template—help is online

If a marketing strategic plan has more than one objective, the use of an electronic template to track objectives and tasks should be considered as it will save time and also help ensure compliance. A Gantt chart, templates for which can be easily found online, is often used by organizations for this purpose. It is a bar chart that can track the progress of many tasks simultaneously using a visual method that makes it easy to understand where the organization is in relation to deadlines for completion of the strategy.

The first step in using this method is to determine what will be the start and end date for implementation of the entire plan. Then each task is listed along with the time it will take to complete. Whether any task must be completed before another, or if some tasks must be completed simultaneously, should be determined. These tasks and times are then inputted into a chart.

Implementing the marketing plan

One of the major advantages of using such a chart is that it explains visually all the tasks that need to be completed and their interrelationships. By doing so it reduces the risk that a task will not be completed and cause the plan to fail (Aramyan n.d.). Many creative individuals can relate more easily to a visual representation than a written list. This will help to explain to employees how others in the organization depend on the completion of tasks. Another advantage is that if a task does take longer than needed this information can be recorded so a more accurate timeline can be developed in the future. Lastly if a task is not completed, there is a record of accountability that can be easily seen by everyone in the organization. This should keep individuals motivated to complete their assigned tasks.

Understanding time—it's not the same for everyone

Creative individuals often have a task-oriented relationship with time. They may struggle for inspiration but, when inspired, they will work until the task is completed with little awareness of the time that is passing. Managing a marketing strategy takes a different approach. To keep on task requires thinking of time as having a pre-existing structure that must be used efficiently. Sometimes it is thought that working intensively for long periods of time means that people are working hard. However it may only mean that people are staying stuck on the same task.

Tracking the implementation of a marketing strategy means that it will be necessary to help creative employees to structure tasks. The best way to do so is to start each day reviewing where each task is in relation to where it should be on the timetable. Once this is done the employees who have tasks should be encouraged to handle a small but difficult task and get it out of the way. For many employees the morning is the best time to accomplish needed tasks because a sense of success can result in the remaining tasks not seeming to be so difficult. After the first task is completed the remainder of the day's marketing tasks can be done. Some creative employees may find this type of structure difficult when they are not inspired (Rue 2018). To help keep them on track the tasks assigned should be of interest. Creative employees work well independently when inspired but can become quickly bored and stop contributing to the marketing effort.

SOCIAL MEDIA IMPLEMENTATION CHALLENGES

Social media needs more than an intern

Often when organizations realize that they need to start engaging on social media, their first response is to hire an intern. After all interns are cheap and aren't young people on social media all the time anyway? However while an intern may be adept at updating their own Facebook page and actively following sports stars on Twitter, this does not mean they should be left in charge of your social media strategy. Here is why:

Organizational knowledge required: Social media for an organization is not posting photos of what you did last night. The technical skills required for social media are easy; it is the content that is difficult. An intern will not understand the organization well enough to develop appropriate content.

Mistakes cost money: While interns are free (or at a low cost) fixing problems costs staff time and money. Problems can result from an intern innocently posting something contrary to the mission, vision and values of the organization.

Lack of customer service skills: Whoever is in charge of managing the organization's social media platforms must

be available to handle responses quickly. It is a difficult task to respond to comments both quickly and effectively. This is especially true of negative comments.

Sanfilippo 2015

Question to Consider: If we do need to use an intern, how can the problems stated above be avoided?

Implementing a social media marketing strategy either on its own or as part of a comprehensive marketing plan presents unique challenges. The first of these challenges is getting everyone to understand that marketing is no longer a task that is the sole responsibility of the marketing department. Secondly, this means that everyone will need to take an active role in being involved in social media. In addition there must be an understanding of how the return on investment is measured to ensure goals are met. Finally, the social media plan must be integrated with other marketing mix components.

Social media mindset—it's not just another task

Social media personally can be used not just to market externally but also used to internally to implement the marketing strategy. Maintaining internal social media sites to connect employees for internal communication and problem-solving can increase creativity and job satisfaction. It is often overlooked how social media can be used to share communication within the organization. Integrating technological communication tools to improve internal communication on the progress of implementation allows the ability to share innovative ideas and progress reports within the organization.

One of the tasks of the marketing department is to educate the organization's employees as to how social media is also a business tool. Most employees use social media daily in some way to improve their life but do not make the connection as to how it can improve their internal business communication. All employees need an understanding of how social media functions and should be comfortable with maintaining and posting information on one or more platforms. In addition as new platforms are introduced, it is marketing's responsibility to train everyone on the application. Lastly, the marketing

department must ensure that there is someone in the company that can handle any technically difficulties with the social media platforms that are being used.

Delegating social media tasks—spread them out so everyone has a voice

Once employees are sold on the idea of using social media tools, and have the technical skills the next step is to delegate responsibilities. Even small organizations should perform most of the tasks internally rather than outsourcing. After all it is the employees who can best communicate the culture and mission of the organization. In addition they will best know the features and benefits of the product.

The social media tasks that can be delegated range from challenging tasks such as blogging to easier tasks such as posting articles written by others. A task that requires excellent communication skills is responding to online comments. Internal postings and communications can be handled by someone who may not have the sensitivity to respond publically.

Employees' existing skills should be considered when assigning tasks. If someone is already personally active on photo and video sharing sites, he or she may be the best person to perform the task for the organization. In addition the employee's level of communication skill should be considered. For example people who are skilled communicators can be assigned to write blog posts. While there may be employees that explain they do not have the ability or time to contribute, it should be explained that successful social media strategies are integrated throughout the organization.

Measuring success—conversion, not just action, is the goal

Since organizational resources will need to be spent to initiate and maintain a social media marketing plan, the success of the plan as compared to the cost must be determined. The success of traditional paid media is usually measured by comparing cost to an increase in sales, which is a direct measure that is easily understood. However social media is about building relationships that will indirectly affect sales (da Silva 2020). For example an individual who reads reviews may suggest the

product to a friend. It is difficult to track the purchase by a friend to the individual making the recommendation back to the person who wrote a positive online review. Because of this challenge social media success needs to be tracked at three different levels of reach, engagement, and conversion.

Reach: First the organization should track the number of LinkedIn connections, Facebook likes, Twitter followers, YouTube viewers/subscribers, and blog visitors. This will inform the organization if it is successful in attracting attention. This attention may be driven by paid media making potential consumers aware that owned media exits. It can also be generated by the content provided. For example, many YouTube viewers may mean the organization is very successful at producing videos that attract the attention of the public. However this does not necessarily translate into sales.

Engagement: A better measure of the value of the organization's social media is engagement. Engagement is measured by tracking the number of clicks on links embedded in social media posts. This indicates that the person desires further information. Rather than just liking the organization, sharing of information with others is a better indication of interest. Likewise retweeting information indicates that the potential consumer is helping to market the product to others. Comments on blogs or ratings of YouTube videos are also a sign of engagement.

Conversion: However it is not reach or engagement that provides revenue to the organization. Conversion is when customers purchase the product. The organization needs to track the steps that lead to conversion, such as requests for downloads of product information. Signing up for webinars could be another step toward conversion that should be tracked. Finally the organization may provide a form that the potential consumer fills out to obtain more information. Conversion is a signal that a potential consumer is taking the desired action, which is usually an online sale.

Integrating with other marketing plan components— social media should not stand alone

It is natural that attention is being paid to social media as a promotional method. However traditional paid and the organization's owned social media still are critical. Social media

should not be viewed as distinct but as integrated with other forms of promotion. Organizations continue to increase their social media marketing budgets each year. One of the strategies that can ensure that this integration takes place is for the organization to maintain a focus on the target market segment by using the correct social media platforms. A second means is to cross-post information and content between social and traditional media. Finally, marketing employees should not work in separate departments.

A traditional marketing plan starts with a focus on a target market segment. This segment is defined by demographic factors, geographic location, and psychographic characteristics. All the promotional methods are geared toward communicating the product's benefits to this group of likely potential consumers. Social media marketing has a broad reach in hopes that anyone who engages may promote to other likely purchasers. However it still must be focused on the target market segment. It can be quite easy to produce an online video that will attract the attention of young males who then share it with friends. However if the target market segment is not young males all of the effort is of little assistance in meeting marketing goals. Even more so then when creating words and visuals for traditional owned media, there is the temptation for marketers to post on social media what the they find of interest rather than what will be of interest to the target market segment.

In addition to having the correct content, it must be posted on the appropriate social media platform. What is appropriate will vary by country and culture. In addition different demographic and psychographic groups will tend to use unique platforms. The organization needs to focus its efforts on the platform most used by its target market segment and not be distracted by the launch of every new social media site.

Although paid, owned, and earned media are distinct with different purposes, they should be used to jointly communicate. For example, paid media, such as ads, can be communicated on owned media sites. Of course, this should not be the only content provided, but well-designed paid media should also be shown on websites and used in social media postings. In addition any sales incentives such as contests, discounts, or gifts should be promoted both on paid and owned media. Lastly cross-posting

can go the other way. Earned media positive reviews can be used in the paid media promotion and also posted on owned media.

When social media first started to be used in marketing it was common to use someone with specific skills to provide content. If this was not possible, the social media marketing effort was outsourced, often to a specialized firm. As more companies are using social media this segregation has continued. Unfortunately it is difficult to integrate all media efforts if all employees, not just those in marketing, are not aware of everyone else's online social media activities.

By having marketing employees work together it is easier to ensure that all paid promotion contains information on how to access the organization's owned social media. Likewise when someone is writing content for owned social media, they need to be aware of any public relations efforts that the company is undertaking. Lastly whoever in the company who is responding to comments on earned media, needs to be aware of the company's marketing efforts as comments may reference them either positively or negatively.

THINK-ACT-PLAN: Social media platforms

Think: What is a company's social media site that you use? Describe your own process of reach and engagement. How did the site try to convert you?

Act: Go onto a Facebook site for a company. What elements of the site encourage engagement?

Plan: What social media platforms will be appropriate to reach your organization's target market segment?

Creating the strategic marketing plan

You are now ready to add to your plan an analysis of what organizational frames will need to be changed to ensure success. In addition an implementation schedule should be completed with tasks, dates, and names.

REFERENCES

Adams, R.L. "How to Develop an Effective Marketing Strategy." *Forbes.* June 1, 2017. https://www.forbes.com/sites/robertadams/2017/06/01/how-to-develop-an-effective-marketing-strategy/#300ff5ce2324. Accessed March 19, 2020.

Allen, Tyler. "If You Only Have $100 to Spend on Marketing Your Music, Here's What to Do." *SonicBids Blog.* January 29, 2015. https://blog.sonicbids.com/if-you-only-have-100-to-spend-on-marketing-your-music-heres-what-to-do. Accessed March 18, 2015.

Aramyan, Pavel. "5 Advantages of Gantt Charts for Your Marketing Department." *Easy Projects.* n.d. https://explore.easyprojects.net/blog/5-advantages-of-gantt-charts-for-your-marketing-department. Accessed April 2, 2020.

Baumgartner, Jeffrey. "A Process for Innovation Planning." *Innovation Management.* January 6, 2020. https://innovationmanagement.se/imtool-articles/a-process-for-innovation-planning/. Accessed February 22, 2020.

Blanchard, Ken, and Scott Blanchard. "6 Steps for Successfully Bringing Change to Your Company." *Fast Company.* August 1, 2013. Accessed April 22, 2015.

Bolman, Lee G. *Reframing Organizations: Artistry, Choice, and Leadership.* San Francisco, CA: Jossey-Bass, 2017.

da Silva, Chandal Nolasco. "4 Metrics You Must Measure for Social Media Success." *Mention.* February 18, 2020. https://mention.com/en/blog/social-media-success/. Accessed March 29, 2020.

Erskine, Ryan. "Stop Delegating Social Media to Your Interns." *Entrepreneur.* April 29, 2017. https://www.entrepreneur.com/article/292307. Accessed April 30, 2020.

Evans, Michael. "6 Steps to Developing a Small Business Marketing Budget." *Forbes.* May 2, 2017. https://www.forbes.com/sites/allbusiness/2017/05/02/6-steps-to-developing-a-small-business-marketing-budget/#7376a7ee355c. Accessed March 18, 2020.

Grantham, Charlie. "Symbols of Meaning in the Modern Workplace." *Workplace Design Magazine.* June 2016. https://www.workdesign.com/2016/06/symbols-meaning-modern-workplace/. Accessed February 22, 2020.

Gulati, Ranjay. "Structure that's Not Stifling." *Harvard Business Review.* May to June 2018. https://hbr.org/2018/05/structure-thats-not-stifling. Accessed April 2, 2020.

Mirman, Ellie. "Marketing Leaders: Why You Should Run Social Media for Just One Day." *Plannable.* May 29, 2019. https://planable.io/blog/social-media-manager/. Accessed April 14, 2020.

Moon, Garrett. "3 Marketing Timeline Tips to Crush Your Next Product Launch." *Smart Insights.* April 18, 2019. https://www.smartinsights.com/digital-marketing-strategy/product-launch/. Accessed March 2, 2020.

Moorman, Christine. "Results." *CMO Survey.* February 2020. https://cmosurvey.org/results/. Accessed March 18, 2020.

Rogers, Kristie. "Do Your Employees Feel Respected?" *Harvard Business Review.* July to August 2018. https://hbr.org/2018/07/do-your-employees-feel-respected. Accessed April 30, 2020.

Rue, Noah. "Four Ways to Manage Creative Employees." *Innovation Management.* September 5, 2018. https://innovationmanagement.se/2018/09/05/four-ways-to-manage-creative-employees/. Accessed February 23, 2020.

Schein, Edgar H. *Organizational Culture and Leadership.* 4th ed. San Francisco, CA: Jossey-Bass, 2010.

Appendix: Marketing plan outline

The outline below is for a complete marketing plan for a new or existing organization. The chapter that covers the content is noted for each section.

EXECUTIVE SUMMARY

The executive summary is a synopsis of the overall marketing plan. It should provide an overview of the entire plan including goals/objectives, strategy elements, implementation issue, and expected outcomes. The executive summary is easier to write if you do it last, after you have completed the marketing plan.

MISSION, VISION, AND VALUES STATEMENT—CHAPTER 1

A. Mission statement
B. Vision statement
C. Values statement

PLAN INTRODUCTION—CHAPTER 2

A. Name of organization
B. Product produced
C. Product benefits provided
D. Customers targeted

SITUATION ANALYSIS—CHAPTER 3

A. Internal environment
 1. Financial resources
 2. Human resources
 3. Cultural analysis
B. External analysis
 1. Customers
 2. Competitors

3. Economic conditions
4. Technological advancements
5. Socio-cultural changes

RESEARCH PLAN—CHAPTER 4

A. Research question
B. Research subjects
C. Method of conducting research
D. Research findings (if research has been completed)

SWOT ANALYSIS AND GOALS—CHAPTER 5

A. Internal strengths and weaknesses
B. External opportunities and threats
C. Competitive advantage
D. Strategy
 1. Goals
 2. Objectives
 3. Tasks

CUSTOMER SEGMENTATION—CHAPTER 6

A. Target customer segment
 1. Geographic
 2. Demographic
 3. Psychographic
B. Product positioning

PRODUCT—CHAPTER 7

A. Product description
 1. Core
 2. Actual
 3. Augmented

PRICING—CHAPTER 8

A. Product price or prices
B. Pricing method used
C. Pricing tactics planned

DISTRIBUTION—CHAPTER 9

A. Distribution method
 1. Retail
 2. E-commerce
 3. Direct
B. Intermediaries chosen

PAID/OWNED MEDIA—CHAPTER 10

A. Marketing message
B. Forms of paid media used
C. Forms of owned social media used

EARNED MEDIA—CHAPTER 11

A. Co-promotion/co-production methods
B. Online communities targeted or created
C. Content to be produced
D. Analytics to be utilized

IMPLEMENTATION—CHAPTER 12

A. Organizational culture changes
B. Budget for first year of plan
C. Timeline and assignments

Index

Printed in Great Britain
by Amazon